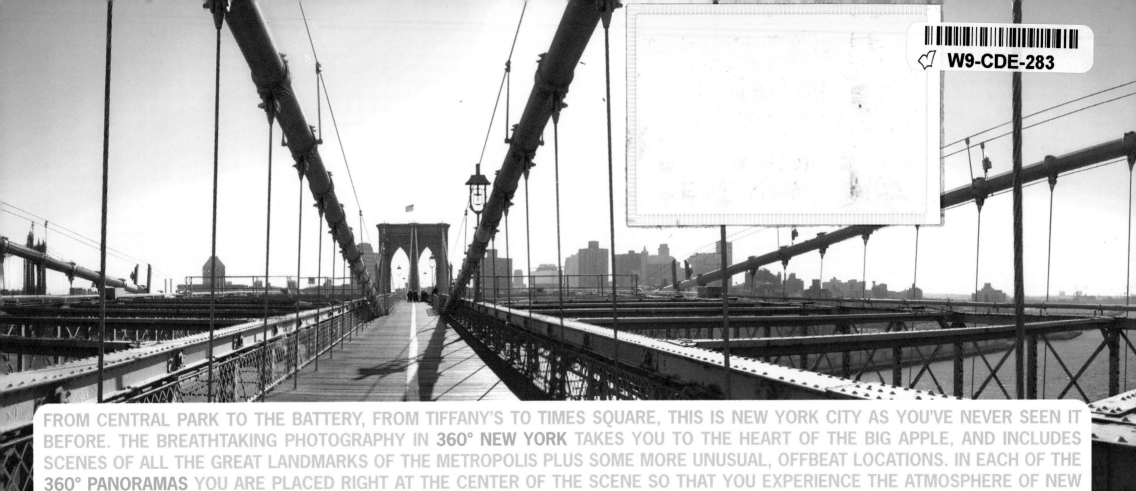

FROM CENTRAL PARK TO THE BATTERY, FROM TIFFANY'S TO TIMES SQUARE, THIS IS NEW YORK CITY AS YOU'VE NEVER SEEN IT BEFORE. THE BREATHTAKING PHOTOGRAPHY IN **360° NEW YORK** TAKES YOU TO THE HEART OF THE BIG APPLE, AND INCLUDES SCENES OF ALL THE GREAT LANDMARKS OF THE METROPOLIS PLUS SOME MORE UNUSUAL, OFFBEAT LOCATIONS. IN EACH OF THE **360° PANORAMAS** YOU ARE PLACED RIGHT AT THE CENTER OF THE SCENE SO THAT YOU EXPERIENCE THE ATMOSPHERE OF NEW YORK MORE COMPLETELY THAN EVER BEFORE ON THE PRINTED PAGE. INCLUDED AMONG THE MANY WONDERFUL PHOTOGRAPHS ARE THE EMPIRE STATE BUILDING, THE BROOKLYN BRIDGE, THE STATUE OF LIBERTY, AND GRAND CENTRAL TERMINAL.

°NICK WOOD PHOTOGRAPHER NICK WOOD HAS HAD A CAMERA IN HIS HAND FOR MORE THAN 20 YEARS. BASED IN A STUDIO AT CLAPHAM COMMON IN LONDON, HE SHOOTS WITH BOTH DIGITAL AND FILM CAMERAS. MOST OF HIS COMMISSIONED WORK INVOLVES PHOTOGRAPHING LARGE-FORMAT LANDSCAPES, THE BUILT ENVIRONMENT, AND PORTRAITS OF PEOPLE IN THEIR WORKPLACE. HIS FASCINATION WITH TRAVEL AND 360° PHOTOGRAPHY HAS LED TO THIS COLLECTION OF IMAGES.

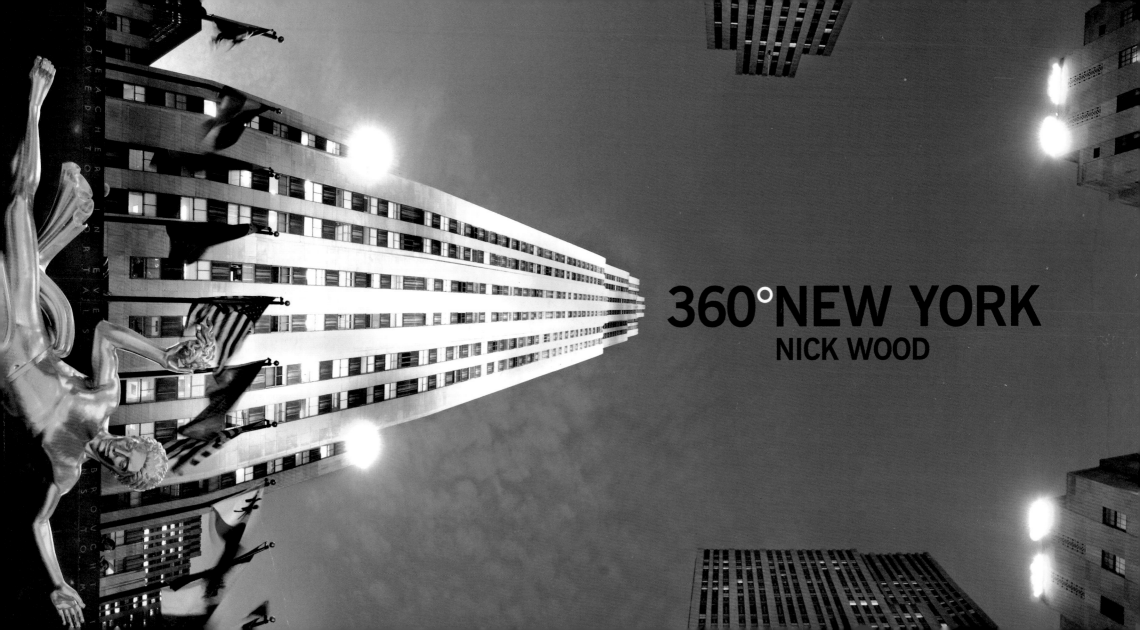

360°NEW YORK
NICK WOOD

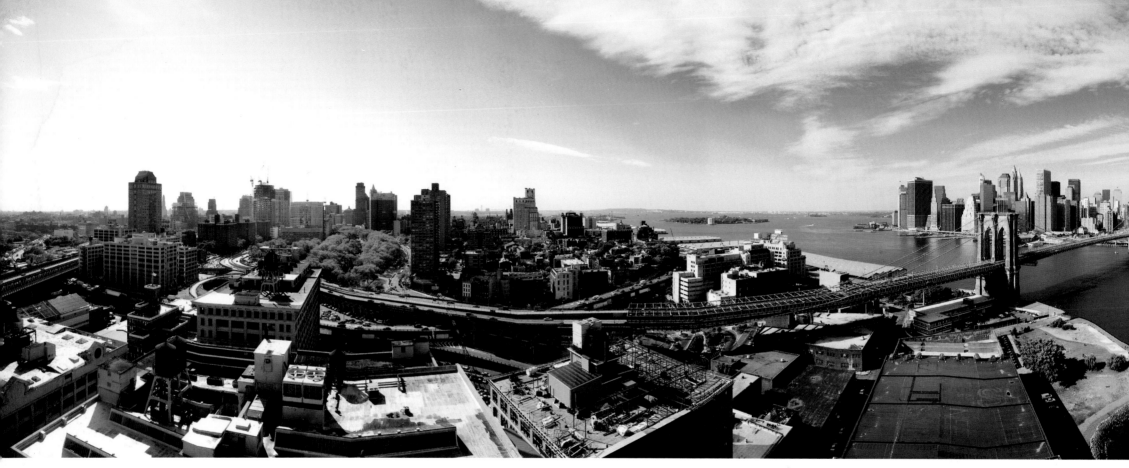

THIS PAGE:
View of Manhattan
from the roof of
the Clock Tower
Building, Brooklyn
PREVIOUS PAGE:
Rockefeller Plaza
OVERLEAF:
Statue of Liberty

Library of Congress
Cataloging-in-
Publication Data

Wood, Nick (Nicholas John)
360 New York / Nick Wood.
 p. cm.
Includes bibliographical
references and index.
 ISBN 0-8109-4624-6
 1. Photography, Panoramic—
New York (State)—New York.
2. Travel photography—New
York (State)—New York.
3. Panoramas—New York
(State)—New York. 4. New
York (New York)—Pictorial
works. 5. Wood, Nick
(Nicholas John)—Journeys—
New York (State)—New York.
6. Photographers—Great
Britain. I. Title: Title: Three
hundred sixty degree
New York. II. Title.

TR661.W66 2003
779'.474'71—dc21

2003008687

Photography © copyright
Nick Wood 2003
Text and design © copyright
Carlton Books Limited 2003

Published in 2003 by
Harry N. Abrams,
Incorporated, New York.

Printed and bound
in Singapore

10 9 8 7 6 5 4 3 2 1

Harry N. Abrams, Inc.
100 Fifth Avenue
New York, N.Y. 10011
www.abramsbooks.com

Abrams is a subsidiary of

LA MARTINIÈRE
G R O U P E

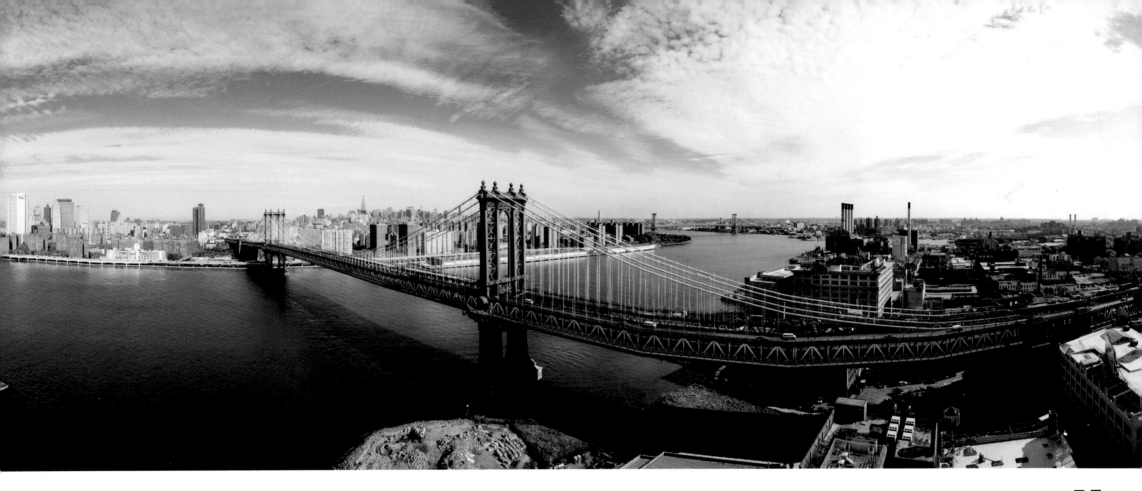

Harry N. Abrams, Inc., Publishers

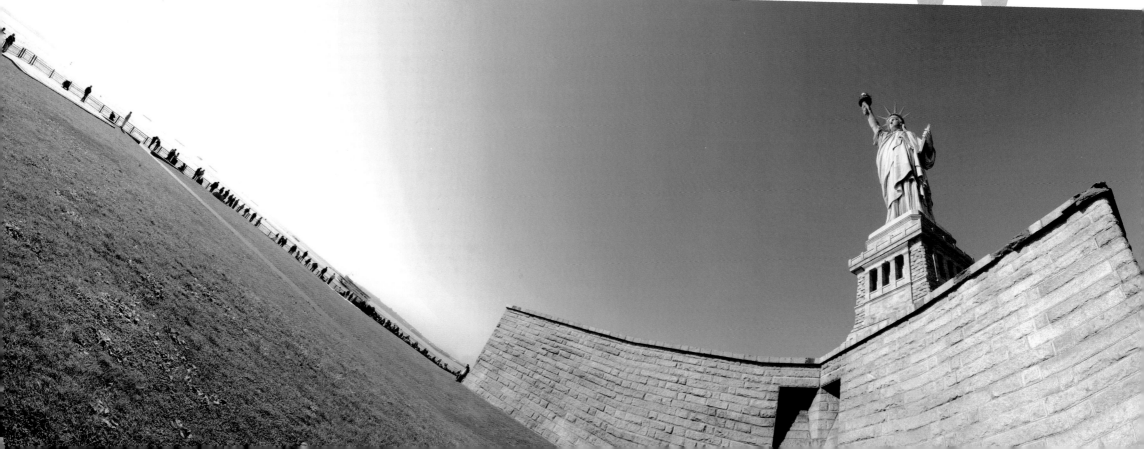

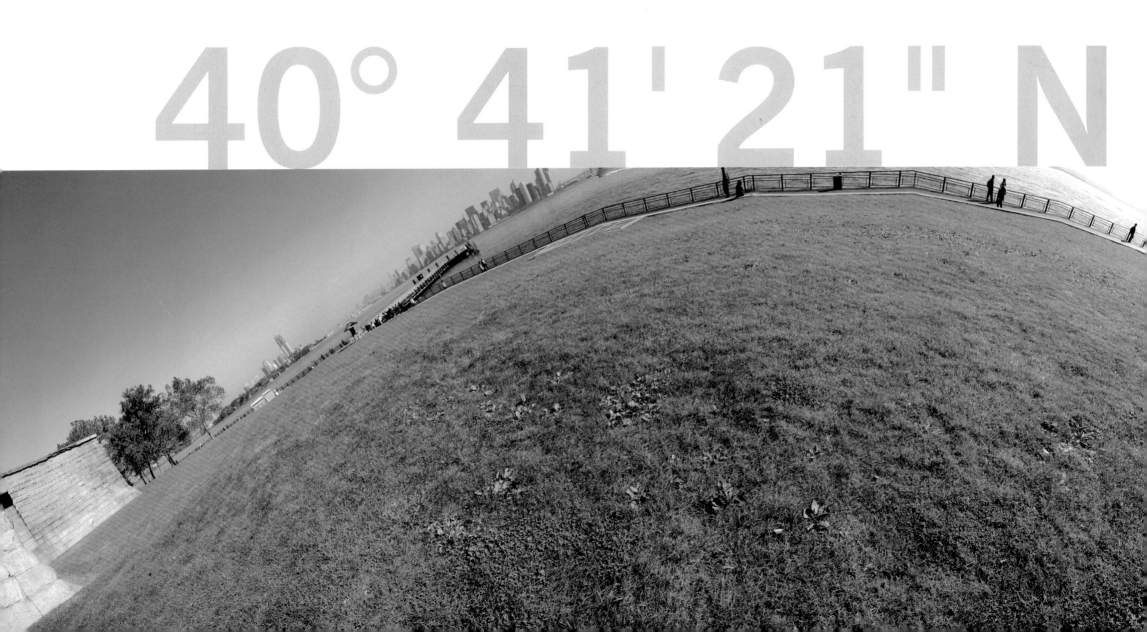

40° 41' 21" N

CONTENTS

 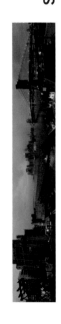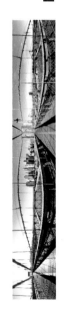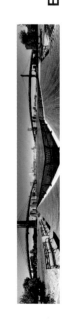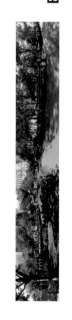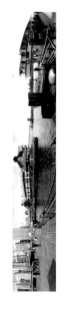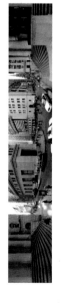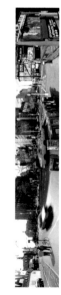

STRAND BOOK STORE 052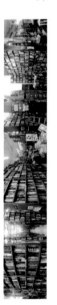

GREENWICH VILLAGE 056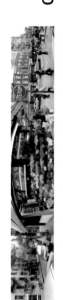

UNION SQUARE PARK 058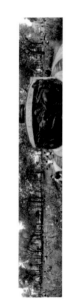

COMME DES GARÇONS 062

EMPIRE DINER 064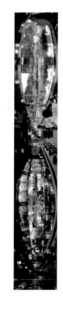

CHELSEA FIREHOUSE 068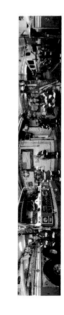

DAN'S CHELSEA GUITARS 072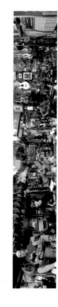

HOTEL CHELSEA 074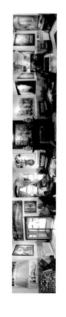

NYC CUSTOM MOTORCYCLES 078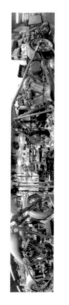

FLATIRON BUILDING 080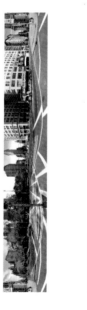

MADISON SQUARE PARK 082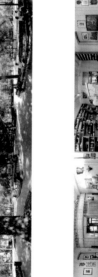

ARTIST'S LOFT 084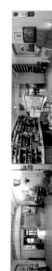

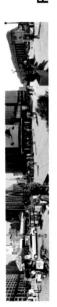
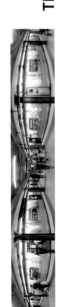
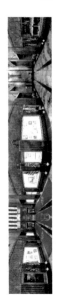

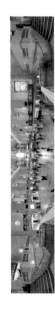
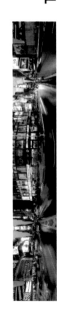
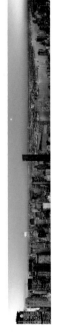
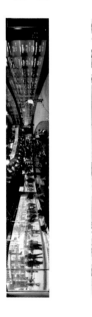
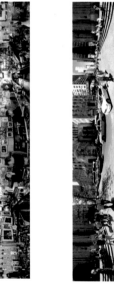
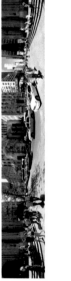
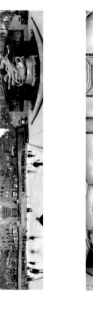

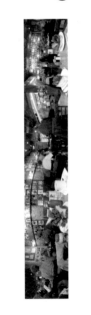
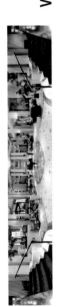
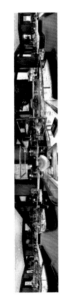
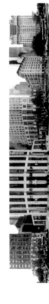
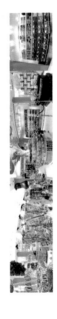
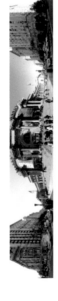
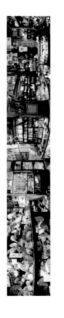
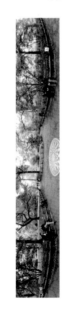
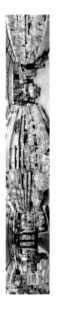
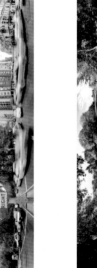

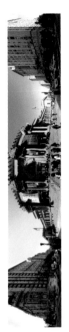

360° NEW YORK IS ...

experiencing an environment,
whether a view of the city skyline,
the interior of a restaurant or shop,
or a Central Park landscape, shot
in a complete circle ... **360°**

The images contained in this
book were shot on a Nikon digital
camera, mounted vertically on
a special tripod. By turning the
camera and shooting an image
every 22.5°, sixteen images are
created that taken together cover
360°. These sixteen shots are
then stitched together in a
computer to produce the final
seamless image.

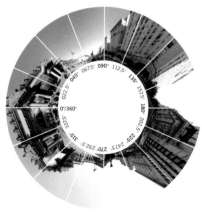

INTRODUCTION

NEW YORK IS ...

7.8 million people speaking **75** different languages

3.3 million commuters traveling into the city every day

2.6 million trees

1.4 million buildings

12,000 taxis

6,400 miles of roads

6,000 subway cars

4,500 buses

... and a great place to see in 360°

During my early days as a photographer, I once stuck a strip of prints together to produce a view of the river in my hometown. It was my first, crude attempt to produce a 360° image, and it was a world away from today's digital technology, which makes producing a photograph of this kind possible.

A good deal of the scenes I'm commissioned to photograph involve the landscape, the built environment, and the way people interact with them. It often occurs to me that it is a pity to select a chosen crop to shoot, when the entire view that surrounds me is more interesting. 360° images are a very "honest" form of photography: you experience the whole atmosphere, the whole space, the whole landscape, so why not shoot it in that way?

For both work and pleasure I have been a regular visitor to New York for many years, and it is clear to me that it is the perfect city for this method of photography. It is a city of sensory overload. Wherever you are in this remarkable metropolis, you are presented with an incredible visual experience, whether it is the clash of water and sky, the combination of glass and steel, or the chaotic sidewalks overflowing with people from all backgrounds and stores bursting with goods. It is a city of extremes—of intense light and deep shadow, scorching hot in the summer and icy cold in the winter, where acres of concrete fight for space with acres of outstanding green spaces. Some of the world's most beautiful architecture can be found on the island of Manhattan, from early twentieth-century experiments with skyscrapers, through 1930s Art Deco elegance, to the stark glass simplicity of the more recent buildings. If it can be built, it has been built in New York.

It is impossible to experience New York today without the memory of September 11, 2001. The city and its inhabitants responded to the tragedy at the World Trade Center with strength and compassion, and I have no doubt that whatever structure eventually grows from Ground Zero it will be both sensitive and iconic.

The sequence of images in this book commences in New York Harbor on the deck of the sedately paced Staten Island Ferry, which travels past America's famous green copper-clad icon—the Statue of Liberty. We then move on to Brooklyn, with its old fairground rides and famous Boardwalk at Coney Island and loft apartments close to the East River. Crossing Brooklyn Bridge, we come to the southern tip of Manhattan, where we become aware of the frantic pace of New York's financial district. Moving north through the streets of Greenwich Village, SoHo, and Chelsea, we come to the towers of Midtown, dominated by the Empire State and Chrysler buildings. The journey continues uptown, through Times Square and the fashionable retail area of Fifth Avenue before we end our journey in the peace and tranquility of Central Park.

360° NEW YORK also gets beneath the surface of the city, visiting some of the less familiar places that produce its special atmosphere—a twenty-four-hour diner that serves an all-American breakfast, a firehouse that's a home away from home, a dog-grooming salon that caters to the lucky few of the city's eight-million canines, shops that sell everything from dinosaur teeth to custom-built motorcycles …

It's this remarkable diversity that makes New York unique, especially when viewed in 360°.

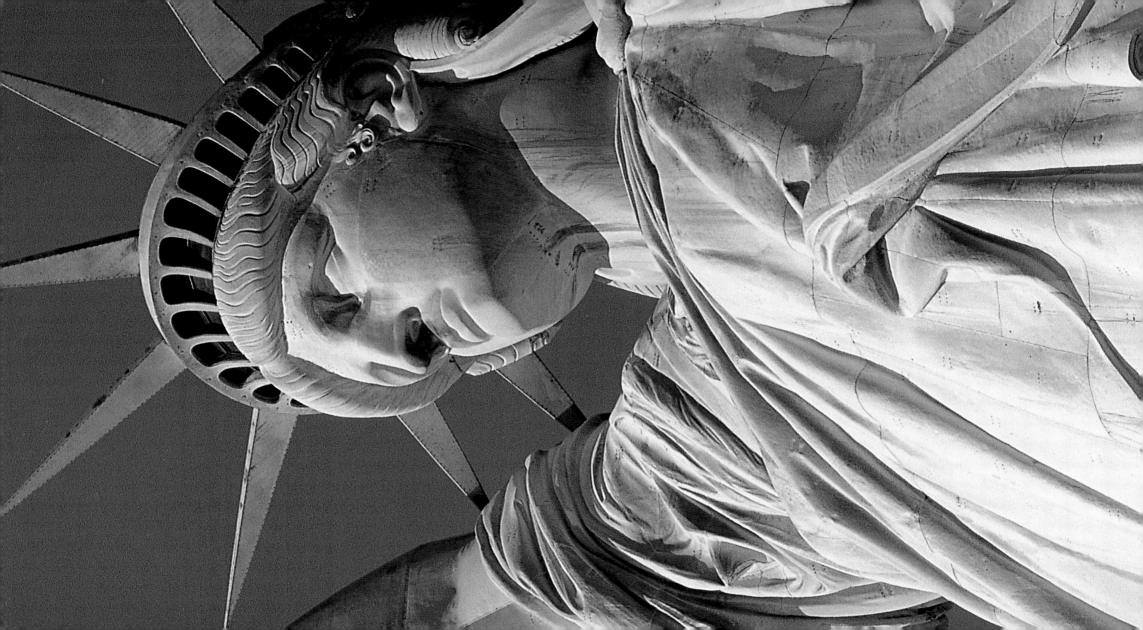

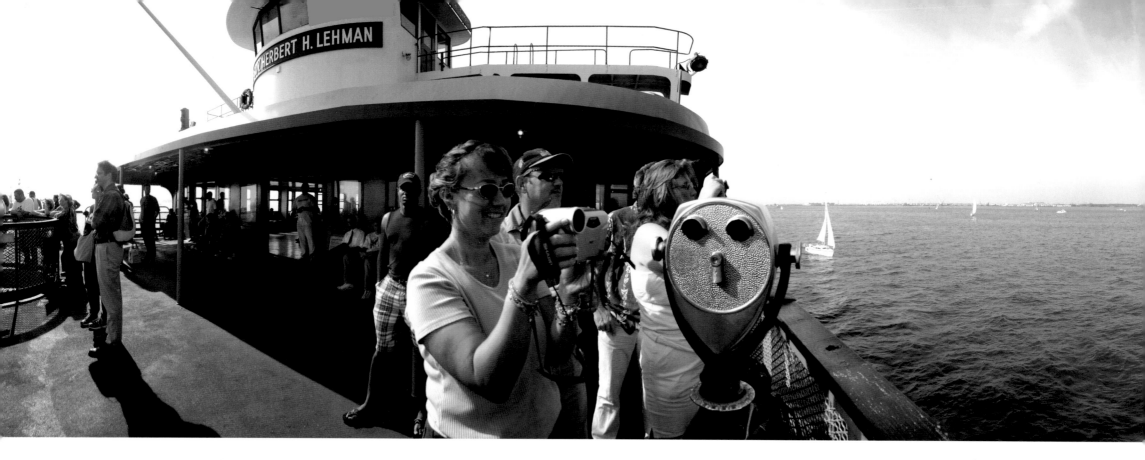

FERRIES HAVE PLIED NEW YORK HARBOR between Manhattan and Staten Island at least since 1817, when only the wealthy could afford a ride. The trip is one of the city's essential experiences and, what's more, today it's free. Twenty-four hours a day, 365 days a year, the bright yellow boats carry more than 20 million passengers annually. The five-mile journey offers a fabulous view of the Statue of Liberty and gives a real sense of the scale of Manhattan's bustling financial district.

STATEN ISLAND FERRY

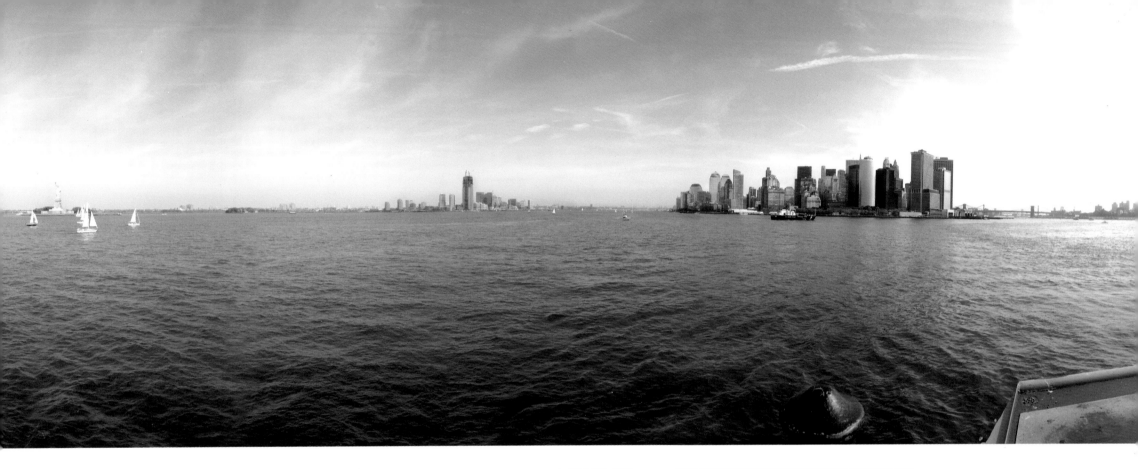

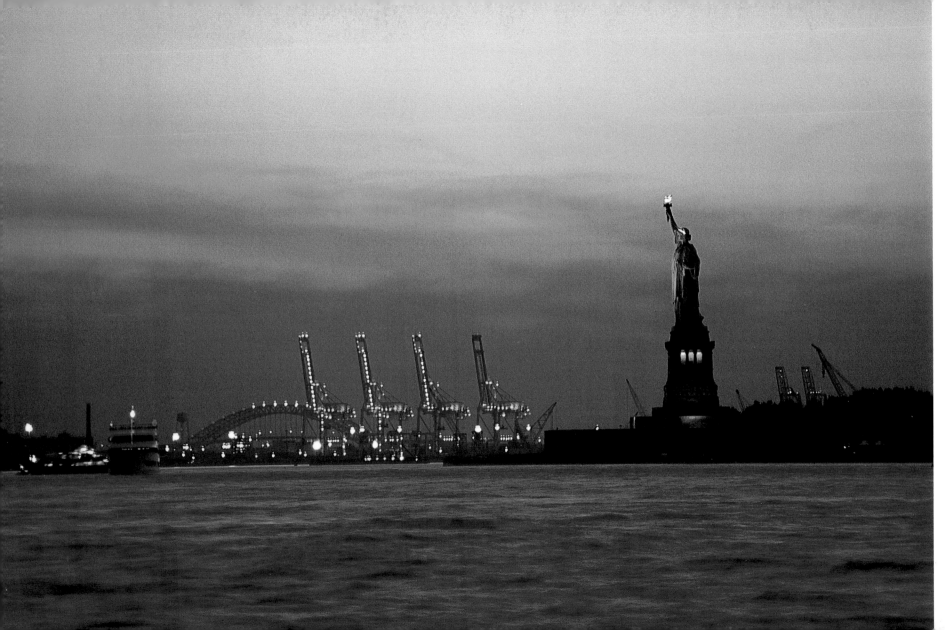

SHE WAS A GIFT to the people of the United States from the people of France to celebrate the centennial of American Independence. Designed by Auguste Bartholdi and engineered by Gustave Eiffel, the statue was first erected in Paris and then disassembled into more than three hundred copper sections and shipped to New York. It was reassembled, mounted on the pedestal that had been prepared in advance, and dedicated on October 28, 1886—ten years late and destined to become America's most famous monument.

IN THE 1920S Coney Island was known as the "Poor Man's Paradise"; today this kitsch seaside resort on the outskirts of Brooklyn is an occasional weekend destination. With its boardwalk and antiquated amusement parks, Coney Island is something of a historical curiosity, but it is a genuine New York treasure. The wooden Cyclone, built in 1927 and visible in the distance, is one of the oldest roller-coasters in the world. In the space of a two-minute ride it ascends 85 feet, takes six 180° turns, and reaches speeds of 60 miles per hour.

CONEY ISLAND

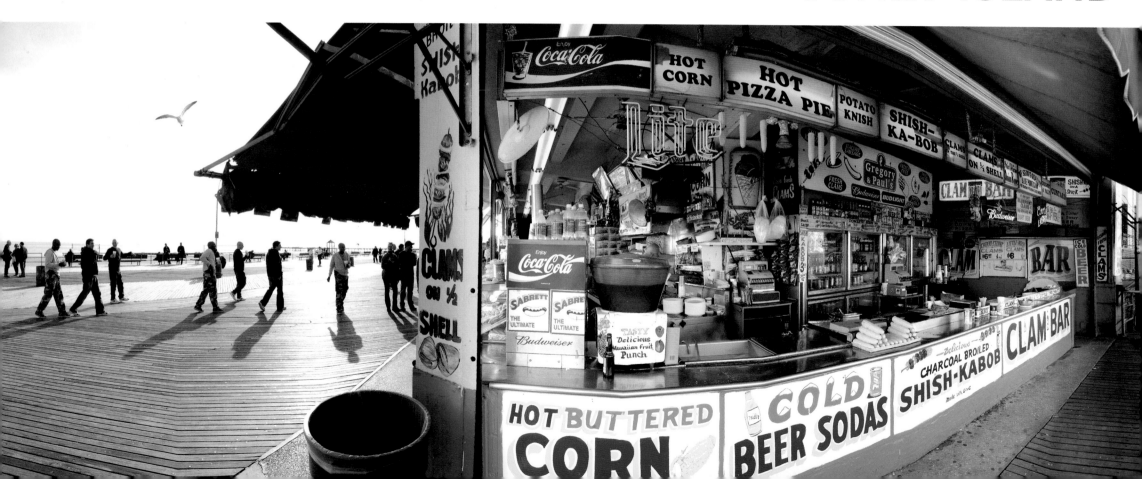

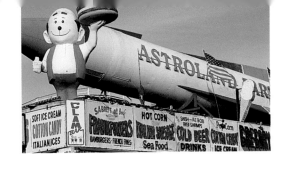

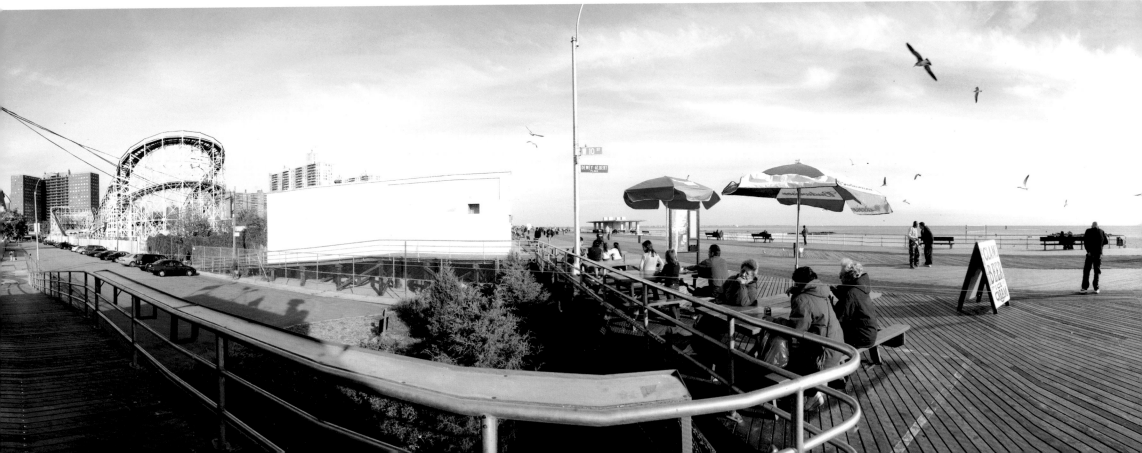

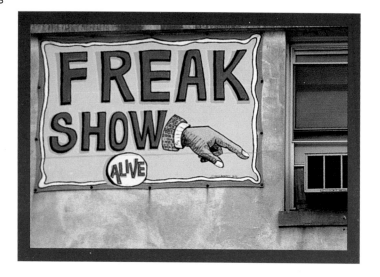

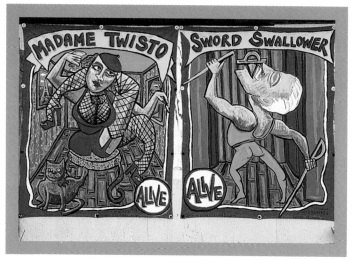

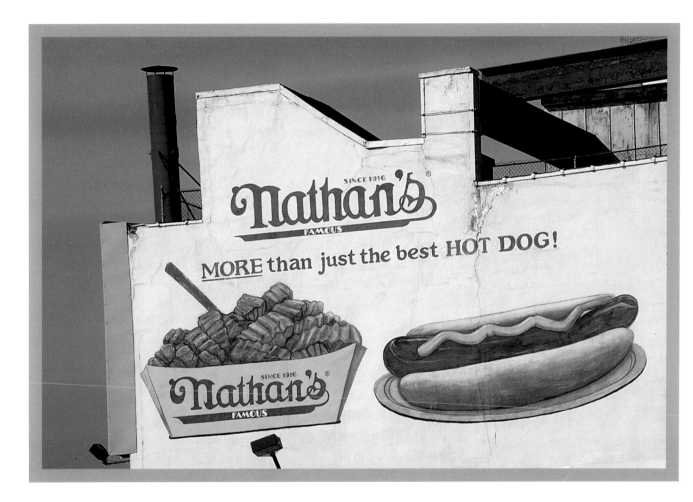

CONEY ISLAND IS HOME to all sorts of weird and wonderful freakshows and gaudy amusements. It is also the place where the hot dog was reputedly invented in the nineteenth century. The most famous purveyor of hot dogs is Nathan's Famous on Surf Avenue, which was established by Nathan Handwerker in 1916.

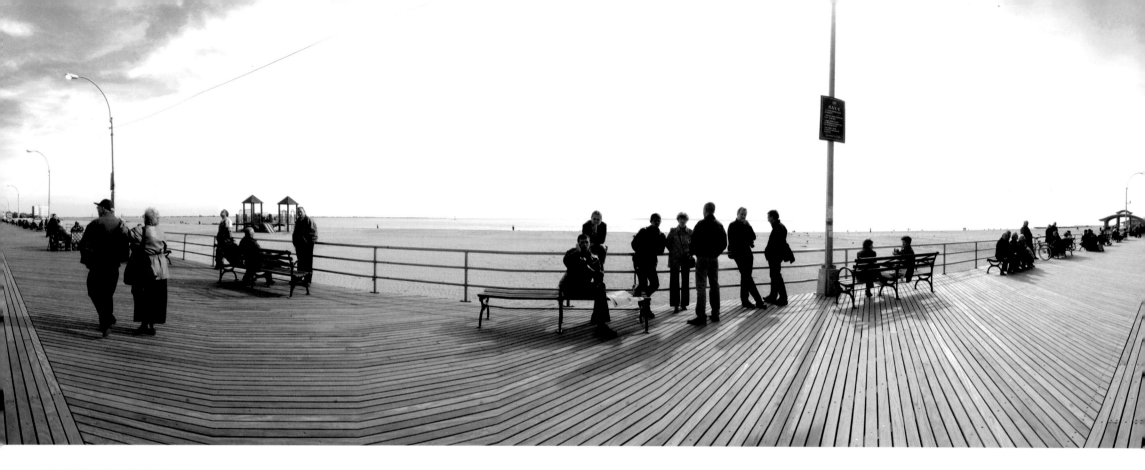

THE TWO-AND-A-HALF MILE Coney Island Boardwalk was built in 1923, three years after the subway from Manhattan reached the resort, and the summer crowds started to swell. The Boardwalk is quieter now. This photograph shows a section that passes Brighton Beach, which once boasted the world's largest concentration of senior citizens, enjoying the bracing ocean air. Following a mysterious law of urban growth and decay and rebirth, Brighton Beach, abandoned by the children of the Jewish immigrants who gave it character in the mid-twentieth century, became the destination of choice for Russian immigrants in the 1970s and 1980s.

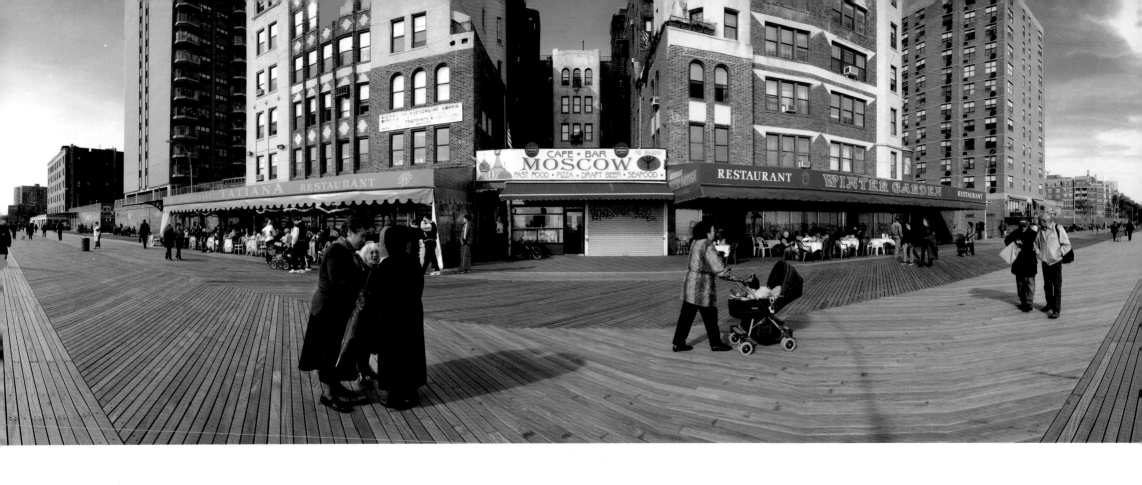

THE BOARDWALK

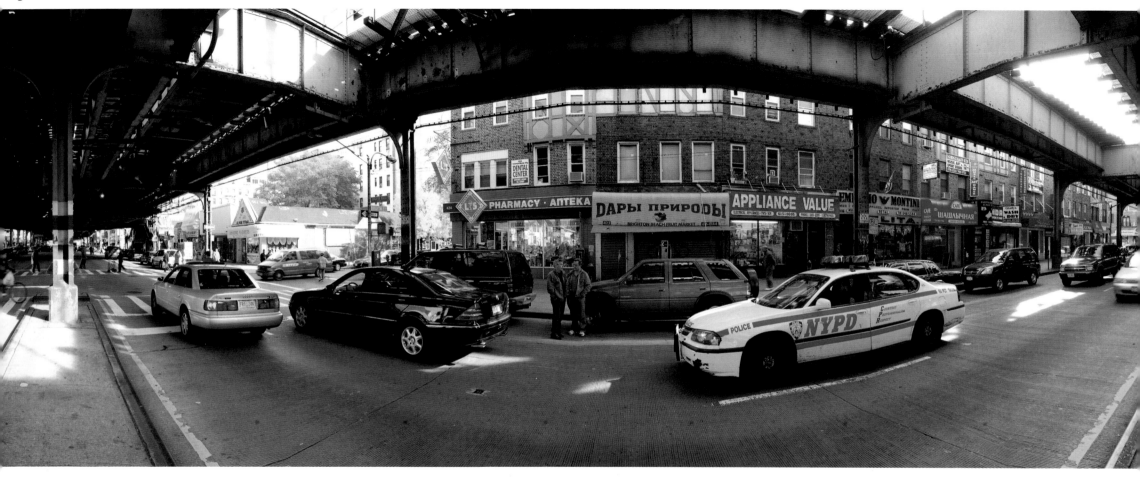

WITH SO MANY INHABITANTS OF RUSSIAN DESCENT, it's no surprise that Brighton Beach has acquired the name "Little Odessa," after the Black Sea resort where Muscovites flee in the winter. It's a colorful and vibrant place: the crowded Russian shops sell caviar and rye bread, while the subway rattles on overhead, echoing on the busy streets below. The area is packed with theaters and clubs that seem to hark back to another era, when Hollywood stars like Fred Astaire and the Marx Brothers used to play here.

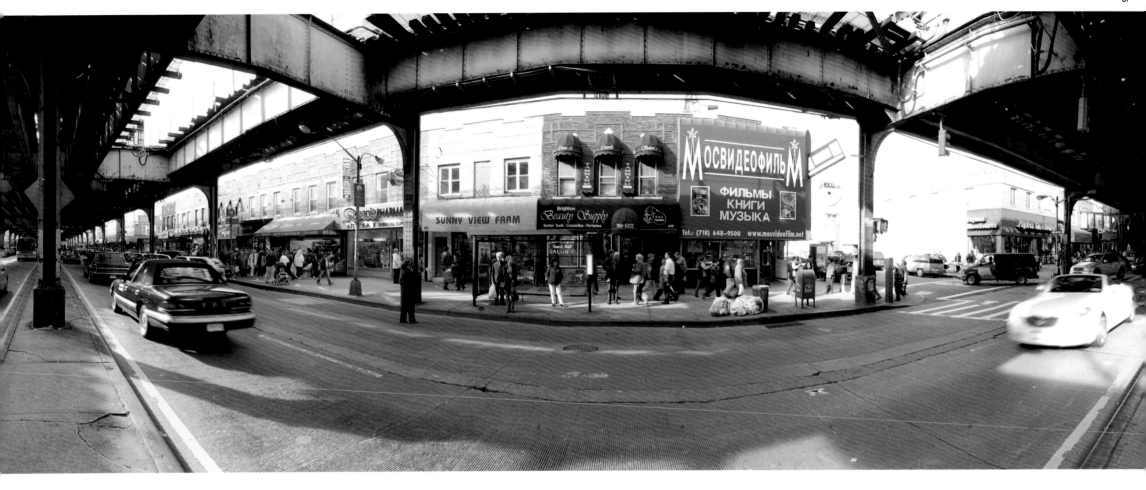

LITTLE ODESSA

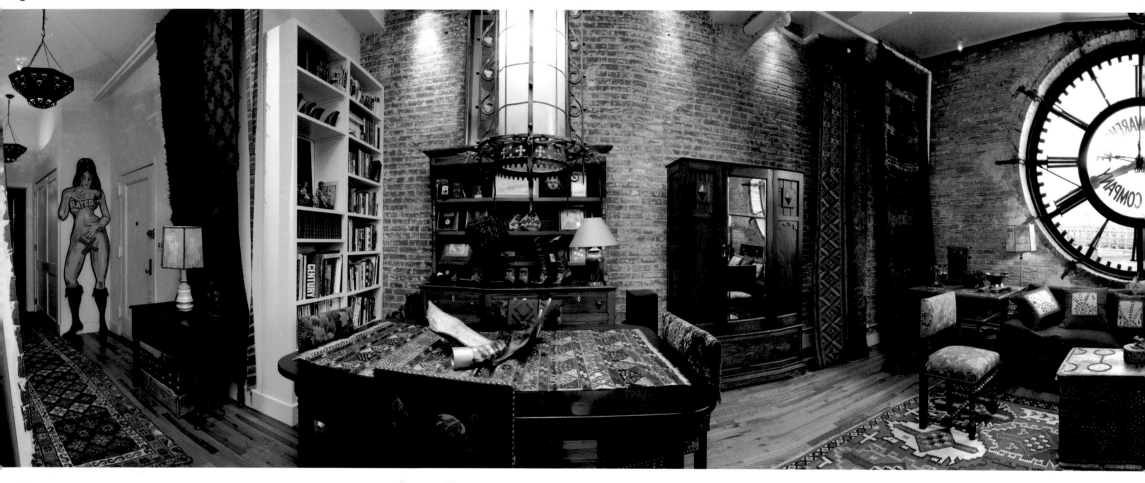

NO ONE WOULD DESCRIBE NEW YORK as a manufacturing city, but one hundred years ago it certainly was. Sturdy factories and warehouses—with strong walls of stone or brick, large windows, and open floor plans—scattered throughout the city attest to its industrial heritage. Beginning in the 1960s, a growing passion for living and working in these buildings has transformed neighborhoods and lifestyles in the city. This choice apartment was carved out of the clock loft at the top of the magnificent former Eagle Warehouse & Storage Company (1893–1910) in Brooklyn.

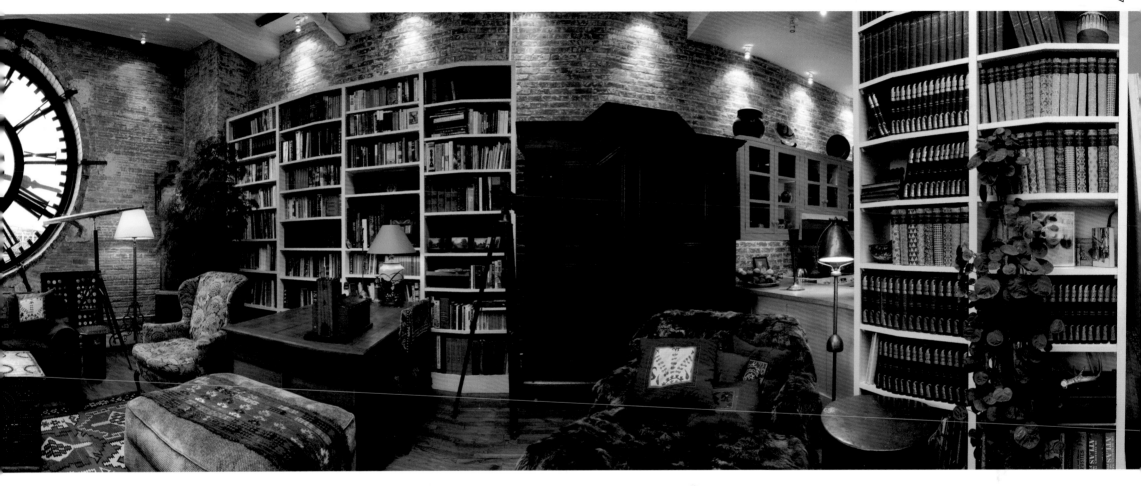

EAGLE'S NEST

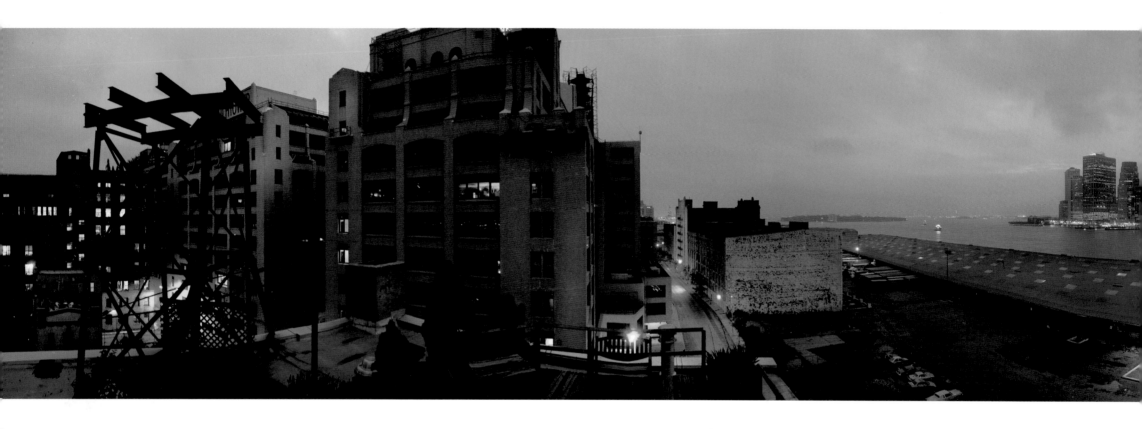

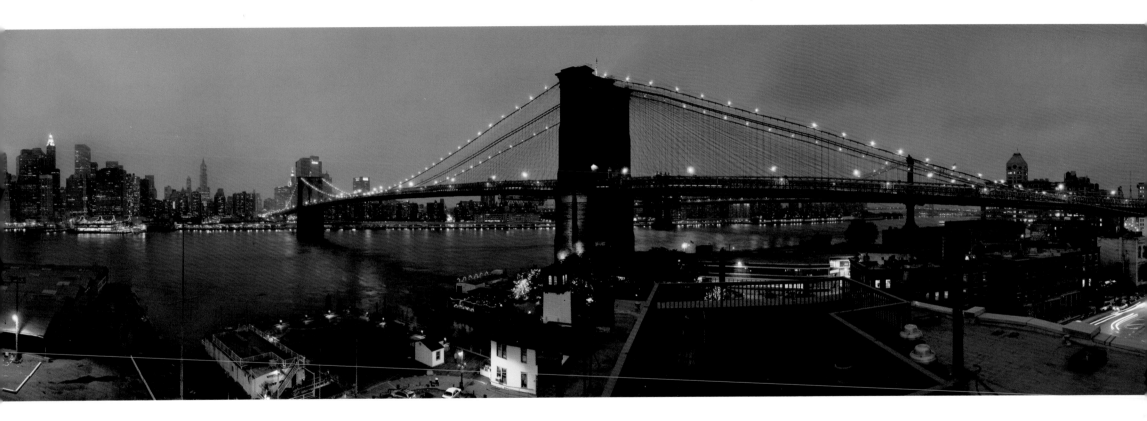

THIS IS BORDERLAND. A few blocks to the south, down the lighted street that winds out of sight in the center of the photograph, lies elegant Brooklyn Heights, with its stately Promenade overlooking the river. But on this spot a tiny principality of industry and infrastructure took root after the construction of the Brooklyn Bridge. Today, it is changing: look carefully and you will see the warm glow of newly renovated apartments in nearby buildings and, in the shadow of the bridge, the River Café, founded by urban pioneers in 1977. It was roughly where the café is now that George Washington escaped with his troops onto the river during the Revolutionary War and later the famous Fulton Ferry carried thousands of workers to Manhattan on their daily commute.

SKYLINE VIEW

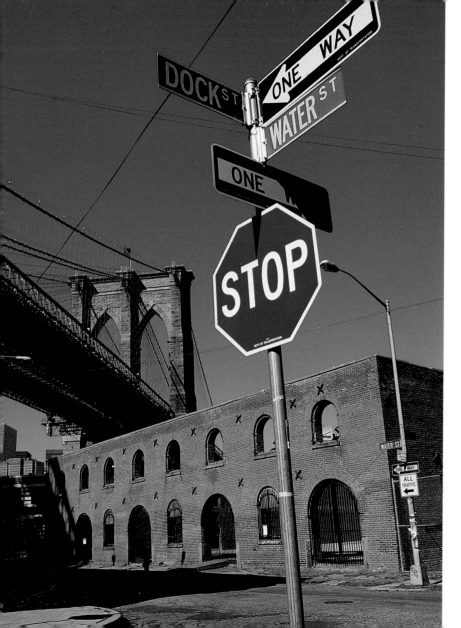

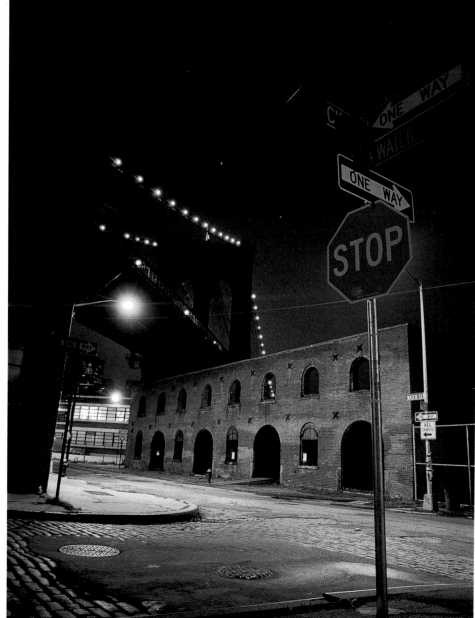

THE STREETS UNDER AND AROUND the Brooklyn and Manhattan bridges in Brooklyn have undergone a transformation in recent decades. Long a favorite area of urban archaeologists enchanted by such ghosts as the ruins of the 1860s Tobacco Inspection Warehouse (left), it was discovered by artists seeking affordable studio space in the 1970s and christened with the infelicitous name "DUMBO," for District Under Manhattan Bridge Overpass. The continuing regeneration of once-abandoned and rotting buildings has ensured that it is now one of the hippest locations in the city, and home to photographers, filmmakers, artists, and musicians. Here, at the expense of doing without the amenities of more established residential neighborhoods, they find spacious workspaces and, often, views of Lower Manhattan that cost a fraction of what they would in nearby Brooklyn Heights.

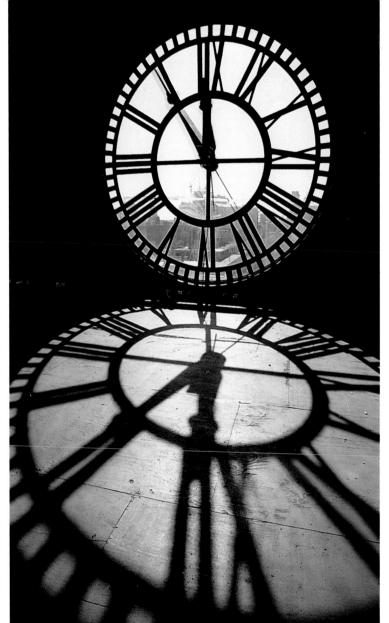
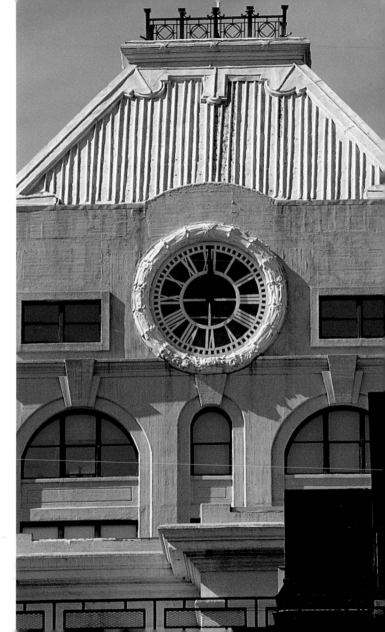

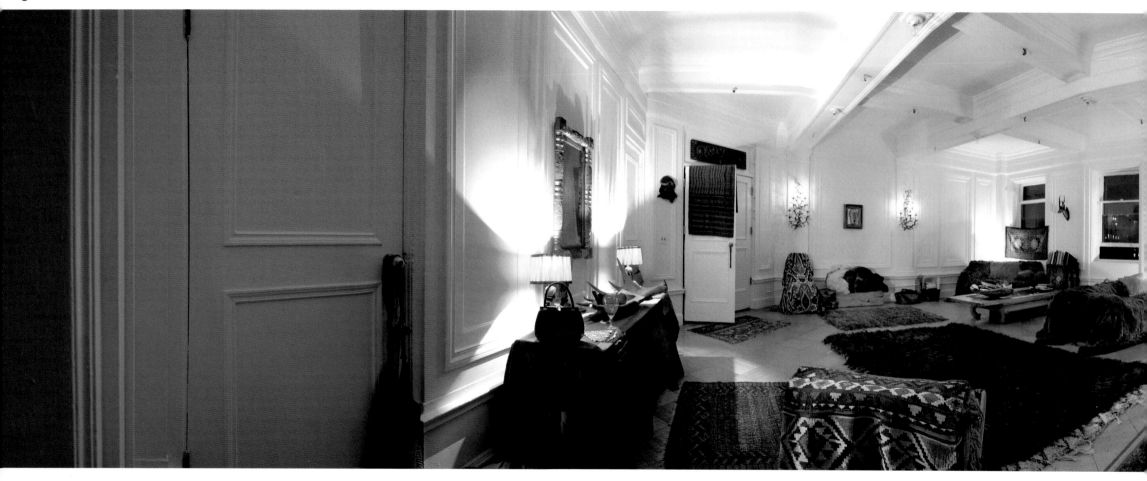

IN NEIGHBORHOODS LIKE Manhattan's SoHo and Brooklyn's DUMBO, people have reinvented the urban apartment, combining living and work spaces, merging functions of rooms, and using furnishings in unconventional ways. The owner of this apartment, with a view framed by the deck of the Manhattan Bridge, imports and collects rugs.

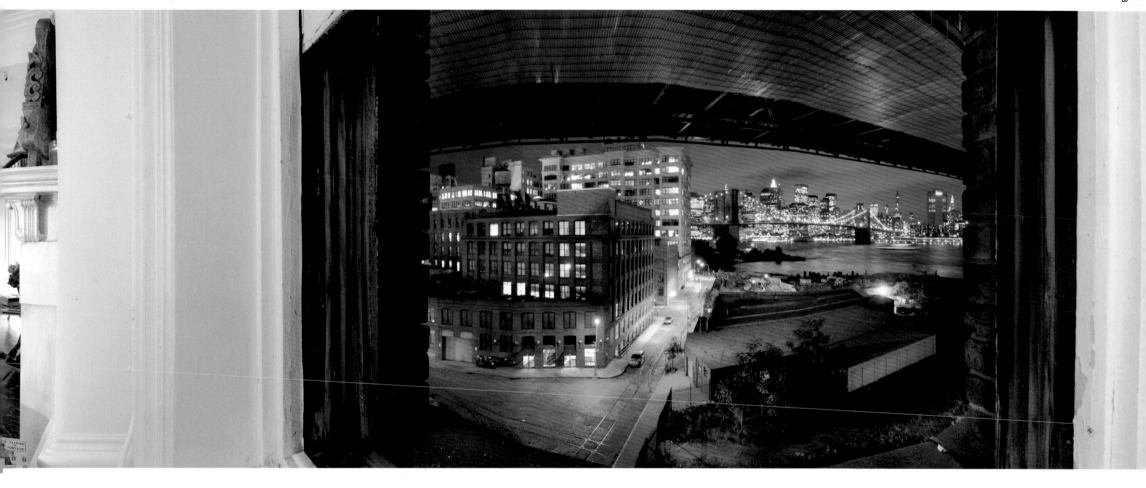

DUMBO APARTMENT

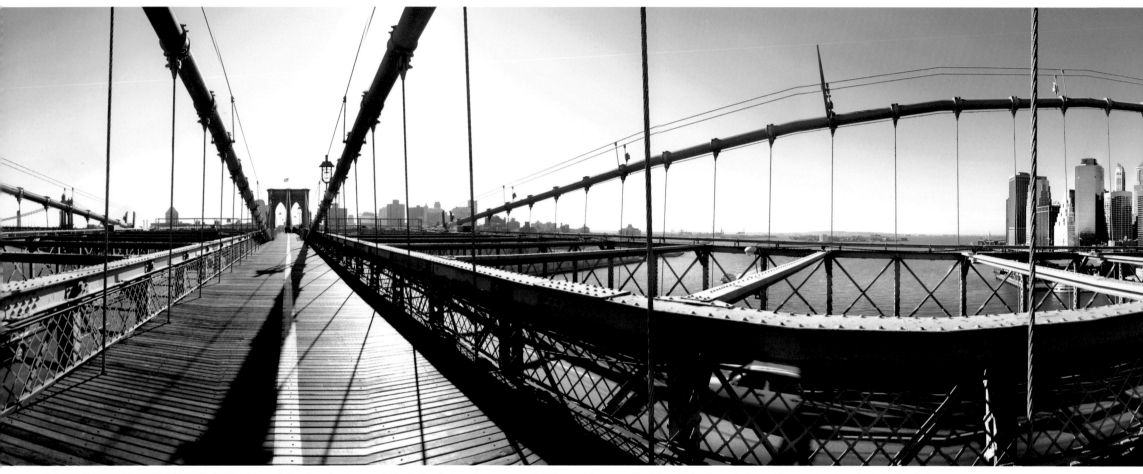

TO WALK ACROSS THE BROOKLYN BRIDGE toward the gleaming towers of Manhattan is to embark on one of life's great journeys. That it could be done at all must have seemed a miracle to the first crowd that surged out onto its broad promenade at 2:00 PM on May 24, 1883, when it was opened to the public. And it was something of a miracle that John and Washington Roebling—father and son engineers—were able to persevere in the face of tragedy and complete their project, for it was so far ahead of its time that forty-six years were to elapse before a longer suspension bridge was built anywhere in the world. The bridge is not only a great technological achievement, but it is also a visual triumph: its web of steel cables and Gothic towers make it instantly recognizable.

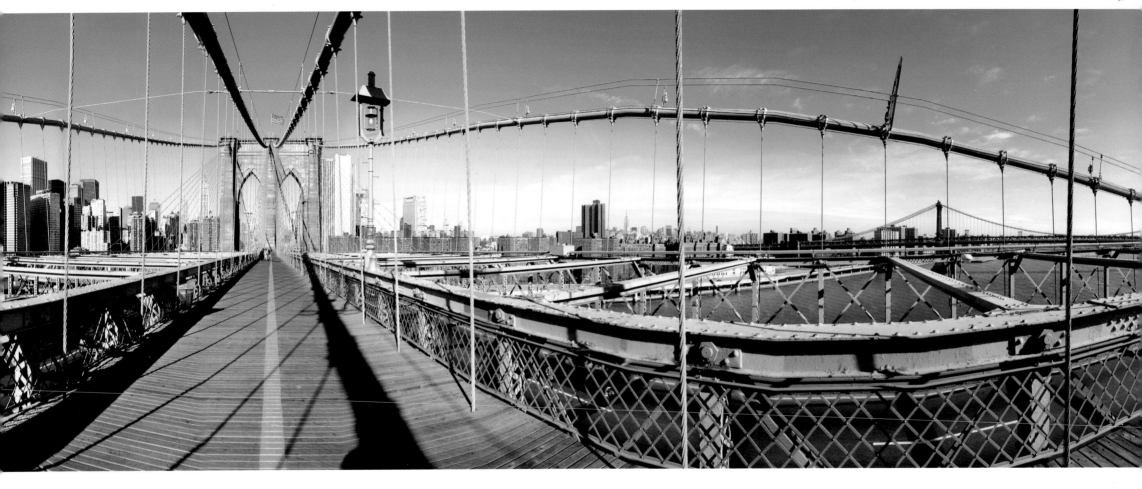

BROOKLYN BRIDGE

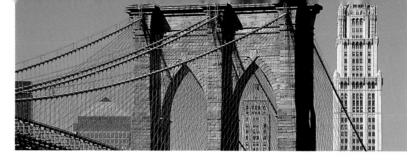

THREE RIVERS SEPARATE MANHATTAN from the surrounding lands: the Hudson, the East, and the Harlem. The first two are wide and swift, and far more difficult to bridge than the rivers that flow through the great cities of Europe. The East River was first to be spanned: the Brooklyn and Manhattan bridges are seen here. New York's bridges are, like its subway system, crowning achievements of city planning.

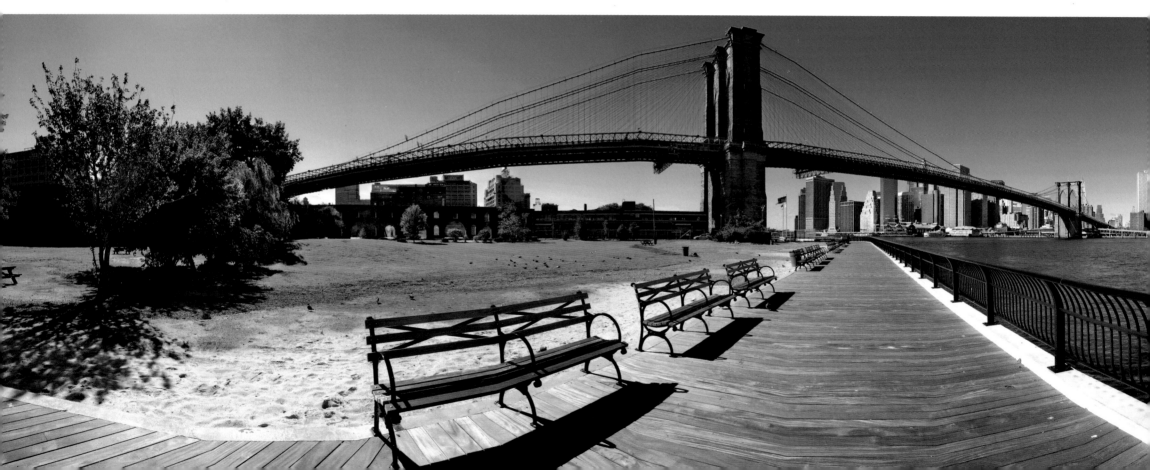

EAST RIVER

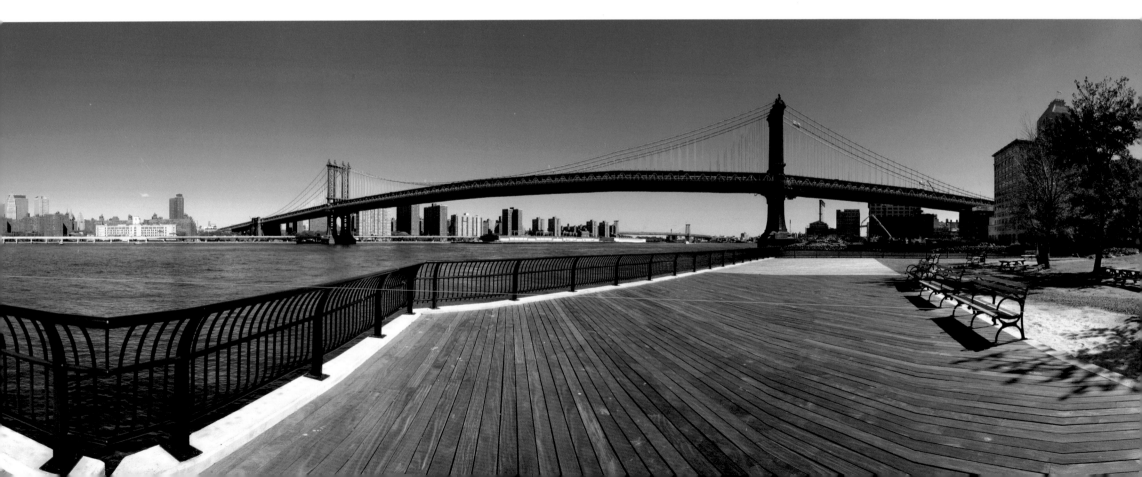

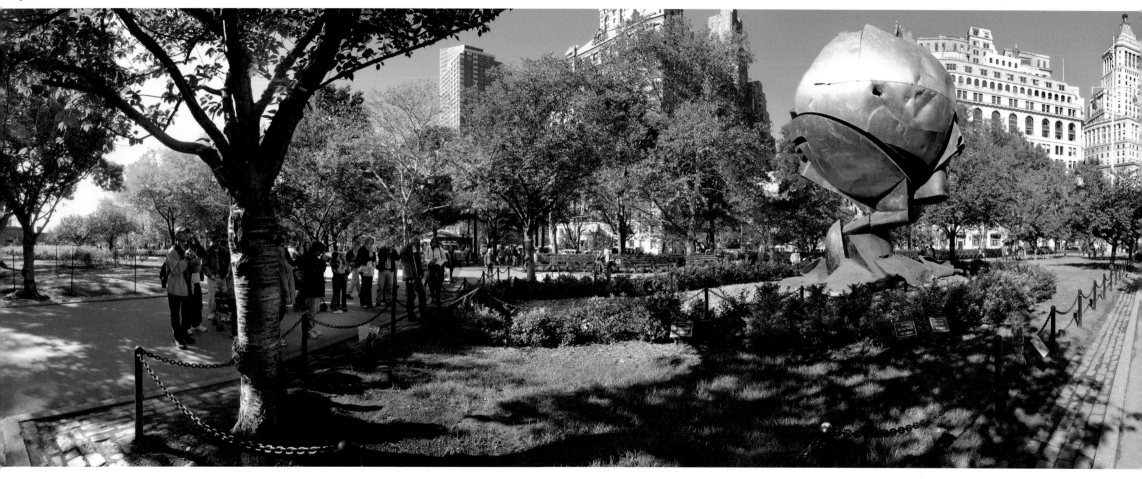

BATTERY PARK, at the southern tip of Manhattan Island, is a quaint reminder of the days when a handful of cannon could protect a city. Today, there are benches where there once were batteries, but there is also a proliferating number of memorials. The small park was already filled with them a hundred years ago, and it has several new ones since 9/11, including this steel and bronze sphere sculpted by Fritz Koenig in 1971 for the plaza of the World Trade Center and moved here after being recovered from the wreckage. Not surprisingly, some nearby residents would prefer more playgrounds.

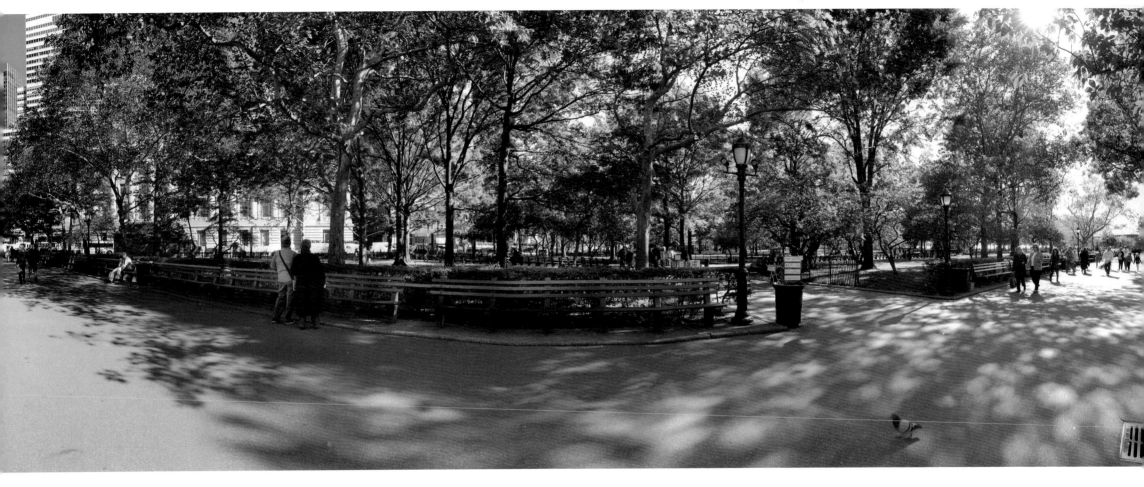

BATTERY PARK

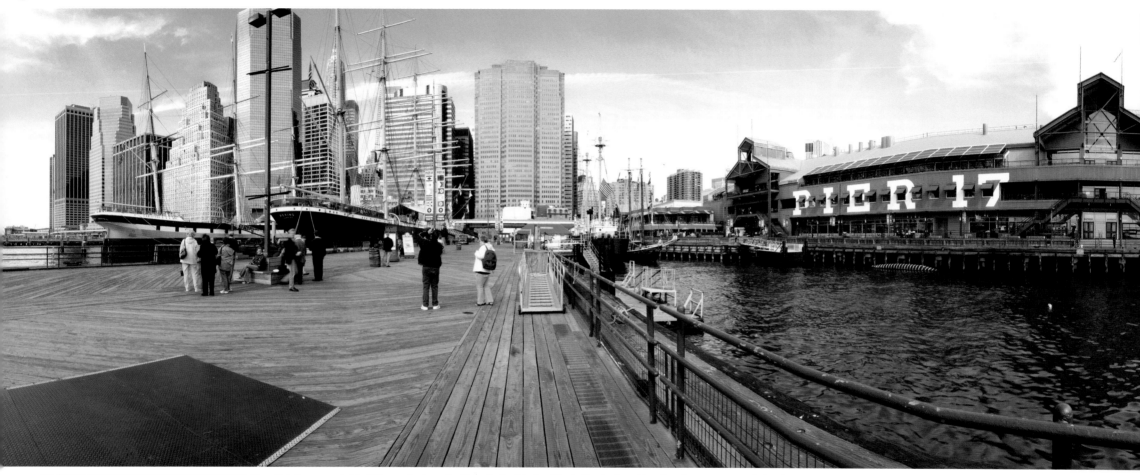

IN SPITE OF ITS WATERY SURROUNDINGS, New York has remarkably little practical use for its waterfront today. Manhattan is ringed by piers that were once vital to its economic survival and are now used for a variety of purposes, some quite eccentric, including a golf driving range. The heyday of the East River piers at South Street, which were turned into an outdoor museum/shopping mall in the 1980s, lasted from the 1820s to the 1860s—years of romantic wooden clipper ships. As sail gave way to steam, the Hudson River proved more suitable to shipping, and South Street faded into obscurity. The two sailing ships visible here are symbolic of the seaport's history: they are the *Wavertree* (1885) and the *Peking* (1911). Both have metal hulls and postdate the port's glory years.

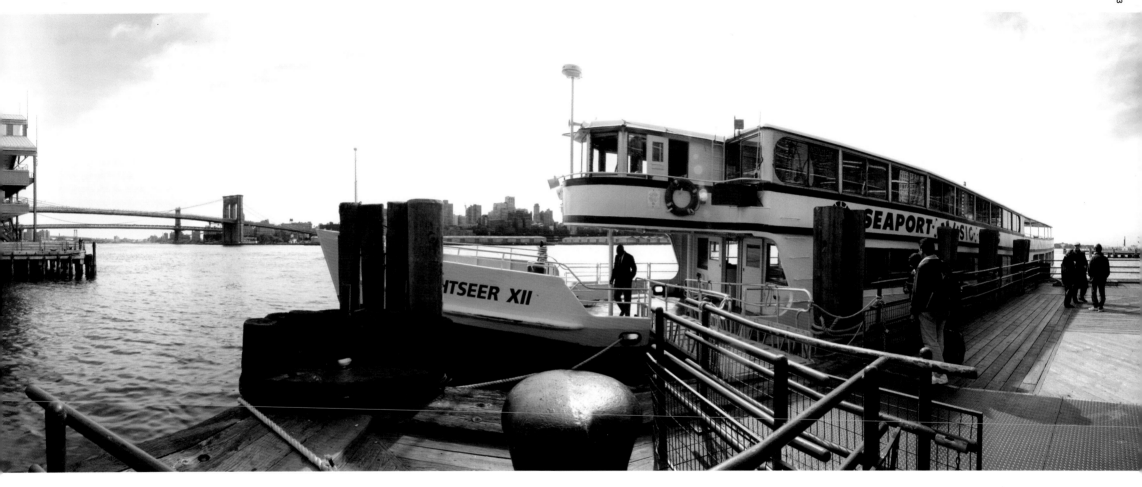

SOUTH STREET SEAPORT

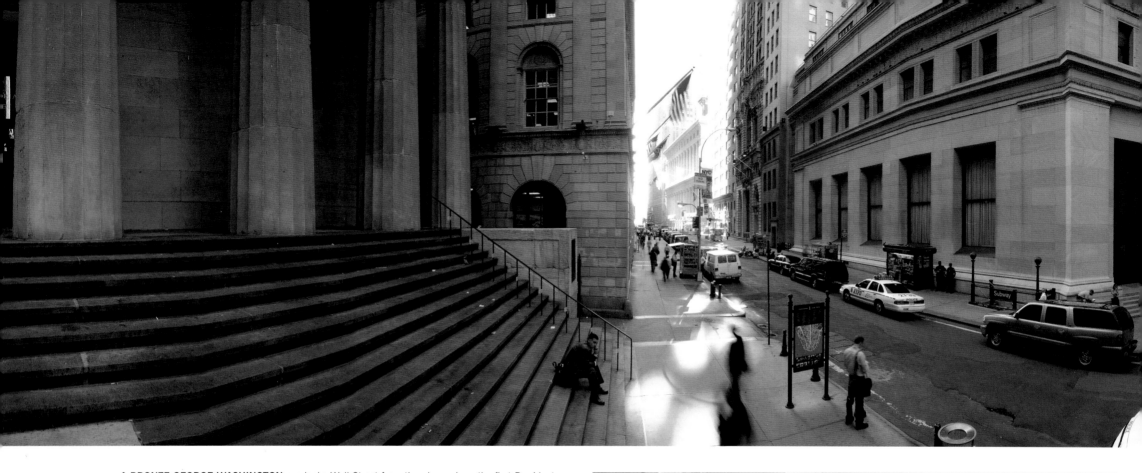

A BRONZE GEORGE WASHINGTON overlooks Wall Street from the place where the first President of the United States took the oath of office in 1789. In the busy nerve center of the world's financial markets, few pay attention to the father of his country. That's J. Pierpont Morgan's old bank with the monumental black doors, on the corner of Wall and Broad Streets, and the target of an anarchist's bomb that killed thirty-three in 1920. And down Broad Street, the New York Stock Exchange looms, its façade draped with an enormous American flag since it reopened for business on September 17, 2001, in the aftermath of a far more devastating attack.

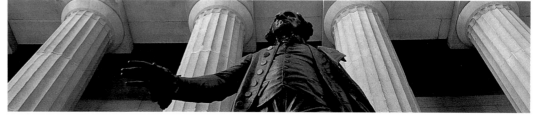

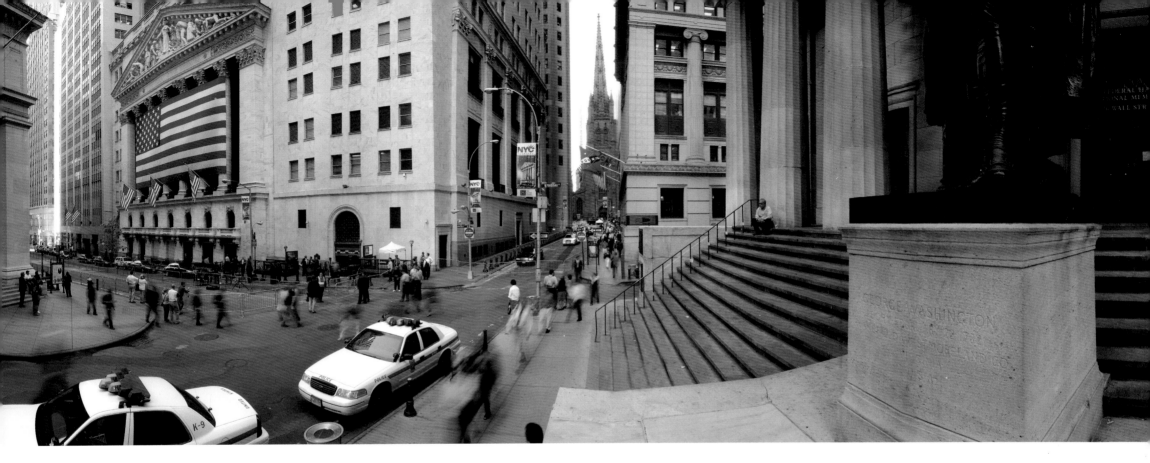

WALL STREET

WHERE DUTCH TRADERS established New Amsterdam, today huge glass and steel skyscrapers seem to rise out of the sea, playing with the light and casting shadows and broken reflections onto the streets.

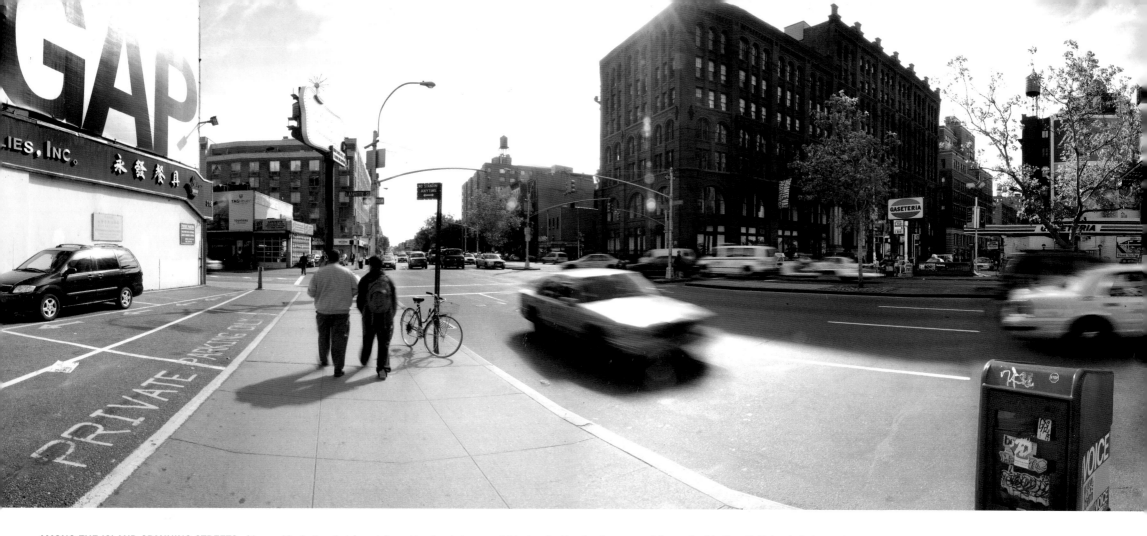

AMONG THE ISLAND-SPANNING STREETS of Lower Manhattan that form informal borders between neighborhoods, Houston (pronounced "house-ton" in New York) is relatively nondescript, but the blocks where it is crossed by Broadway and Lafayette streets have a certain rough glamour. Down the street, Donna Karan's mammoth "DKNY" billboard has marked the northeast edge of SoHo for as long as anyone can remember. And if you look very, very carefully, you can see the silhouette of the gilt statue of Puck on the corner of the beautiful red brick Puck Building (1885, and named after a humor magazine, of all things) across the street from the humble Gaseteria.

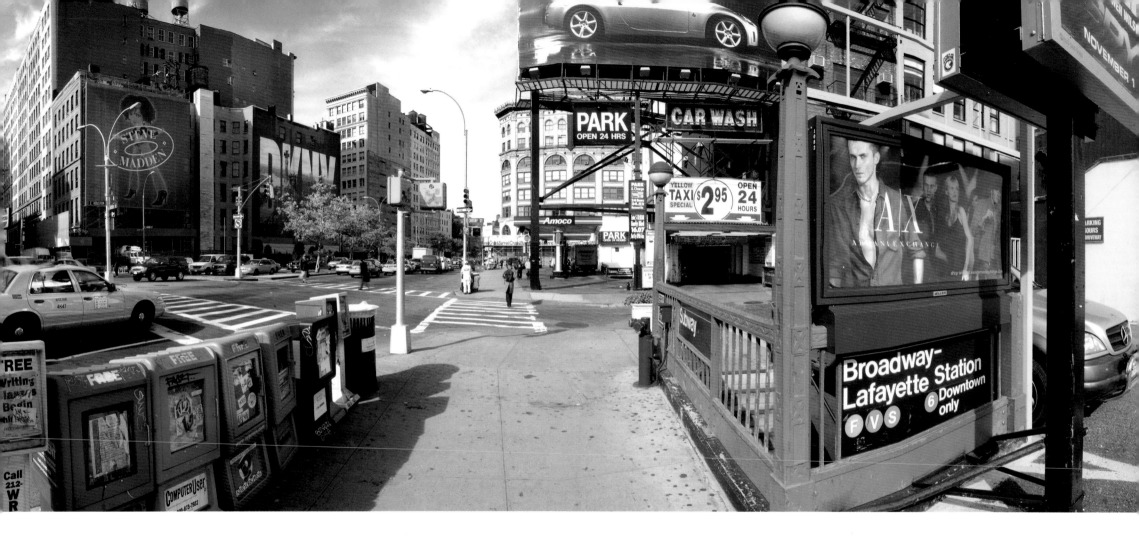

HOUSTON & LAFAYETTE

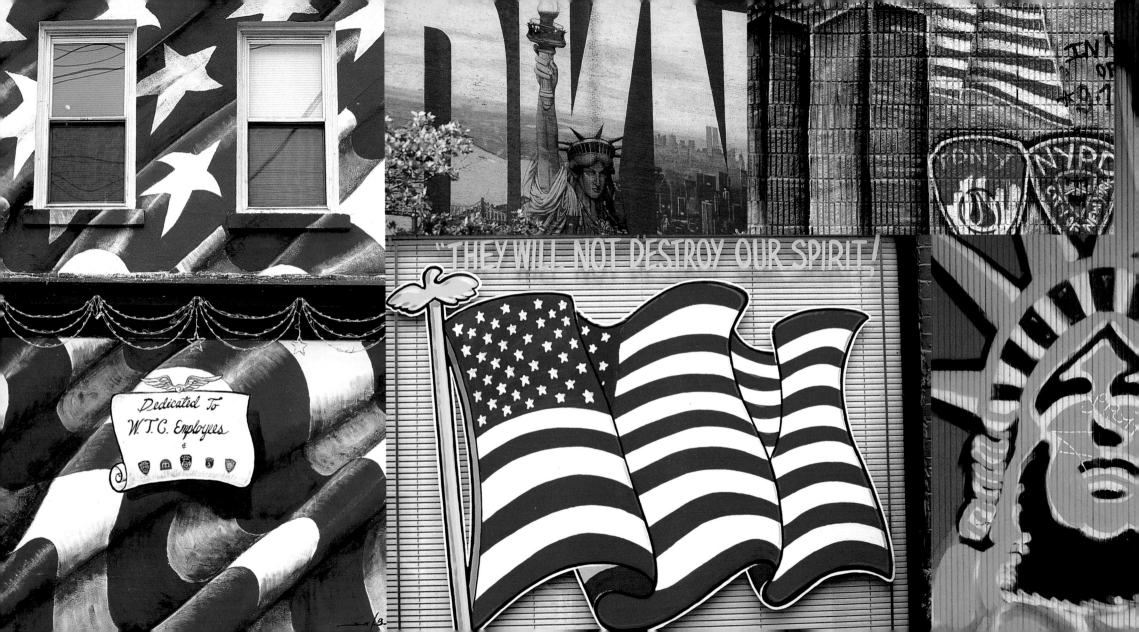

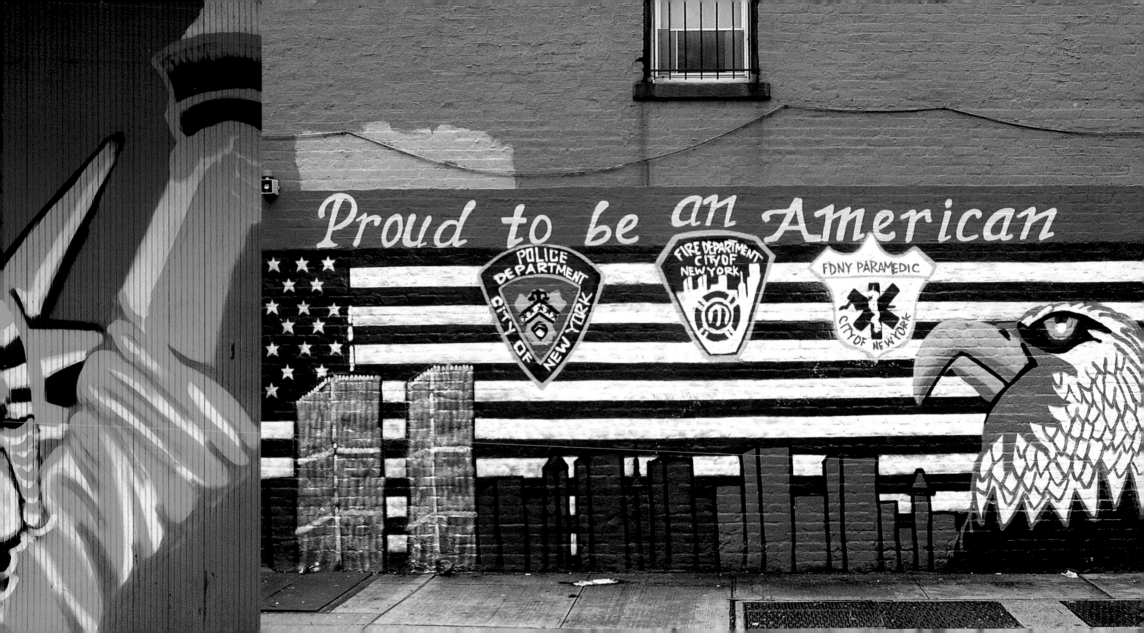

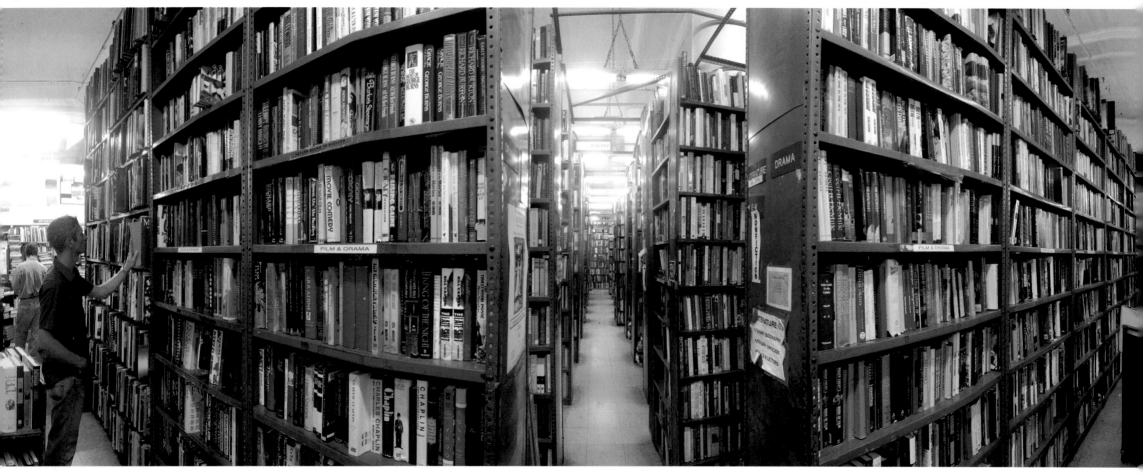

MANHATTAN IS FULL OF STREETS where stores devoted to a single trade, from diamonds to restaurant supplies, cluster together. The Strand Book Store (828 Broadway), founded in 1927, is a surviving outpost of the area once known as Book Row, centering on Fourth Avenue between East 9th and East 14th streets. Around 1950 there were as many as twenty-five used book shops nearby, and it was a browser's delight. New Yorkers who lament the passing of Book Row can console themselves by logging on to the Internet, where it seems that every book ever published can be purchased.

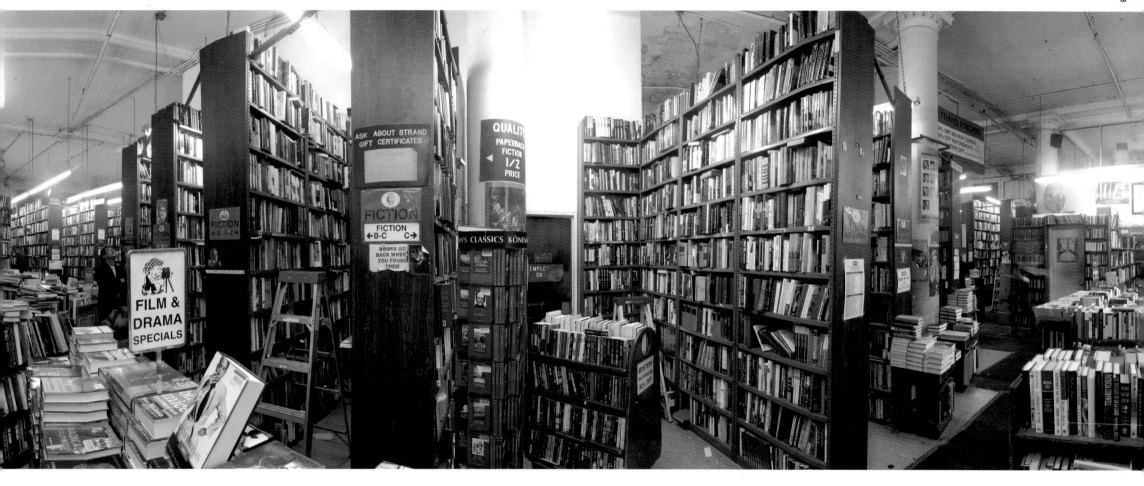

STRAND BOOK STORE

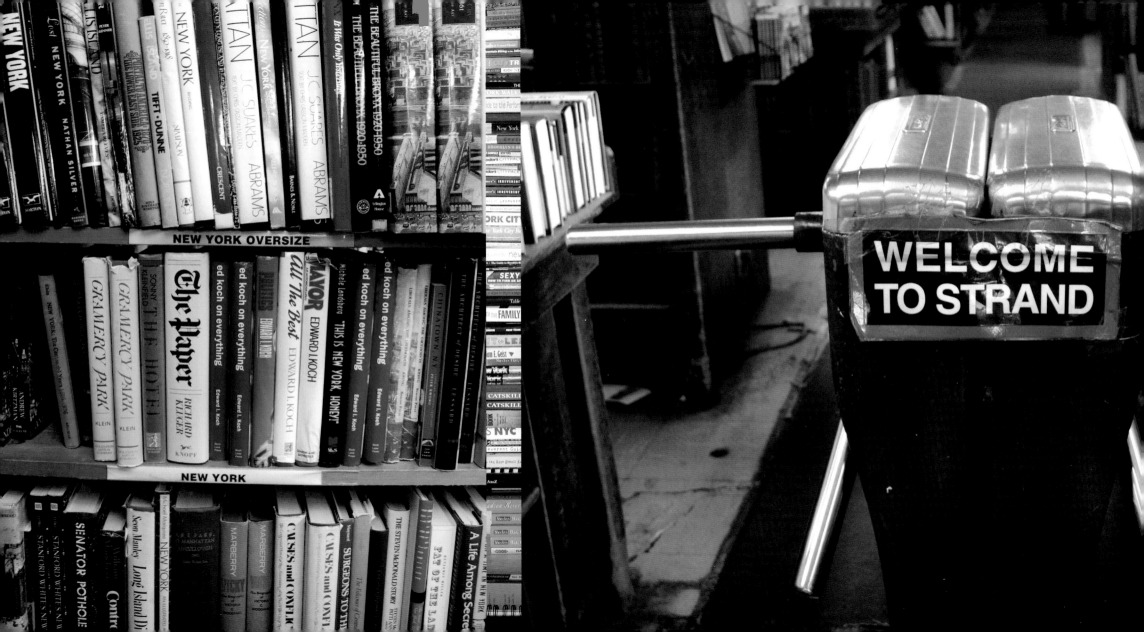

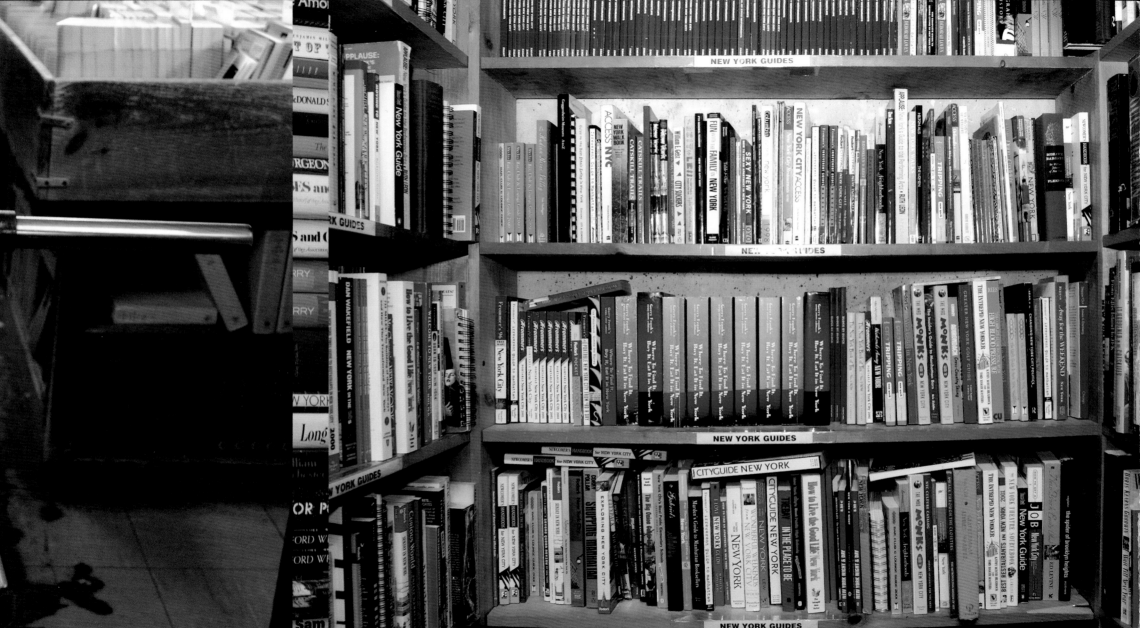

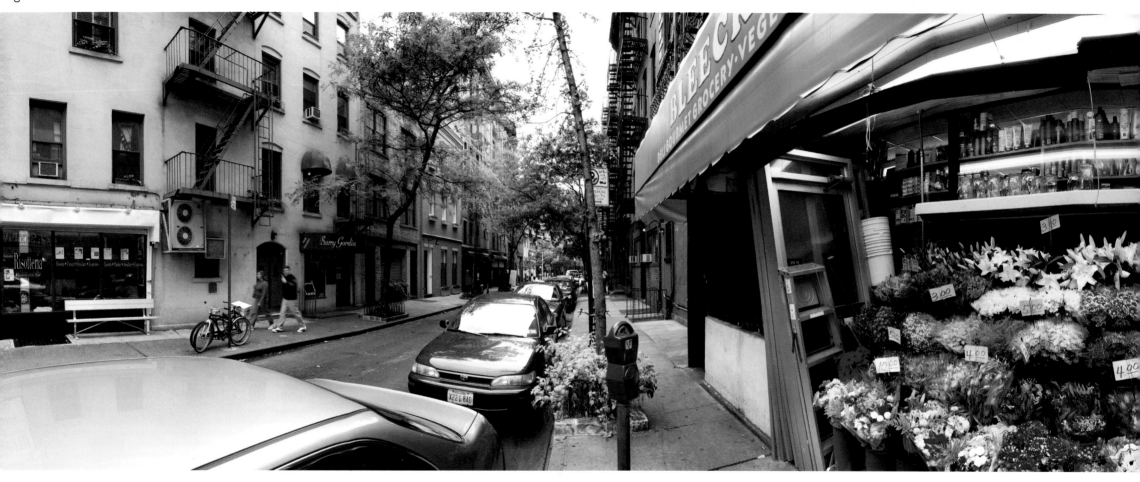

WHEN MANHATTAN ADOPTED the famous—or notorious—grid street plan proposed by the city's commissioners in 1811, tiny Greenwich Village was exempted. Thanks mainly to this lucky break, the area of meandering little streets lined with townhouses was able to nurture a distinctive character, attracting in the twentieth century writers, artists, musicians, radicals, and bohemians—most of whom would not be able to afford to live there now. This is the corner of Bleecker and Morton streets, in the heart of the Village.

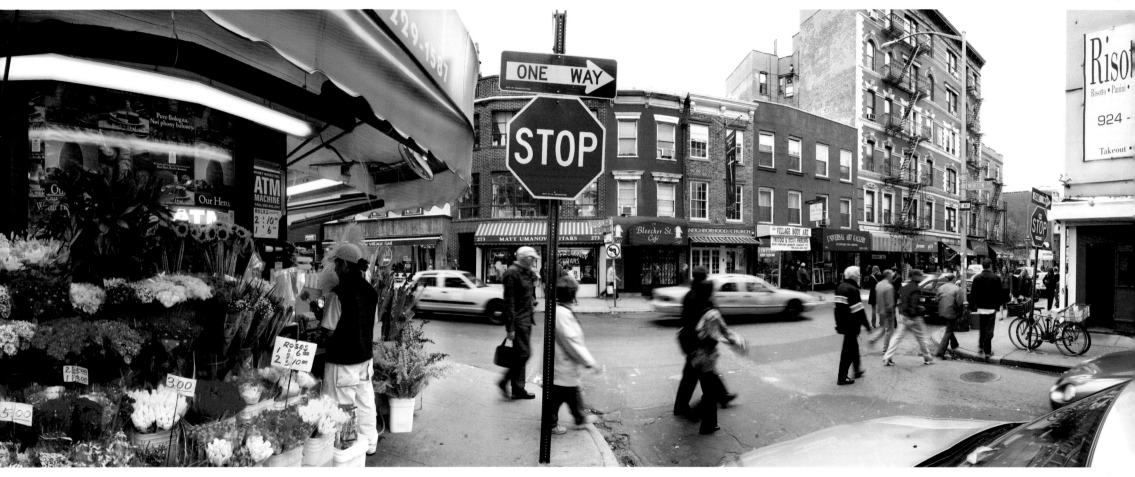

GREENWICH VILLAGE

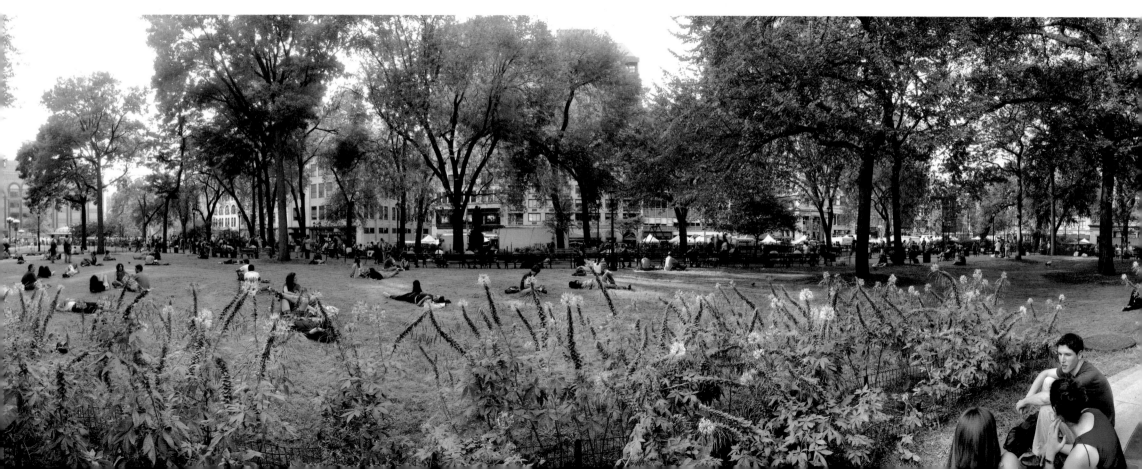

UNION SQUARE PARK

OH, THE GREEN FIELDS OF UNION SQUARE! Once a gathering place for protesters and strikers, today Union Square, at the confluence of Broadway and East 14th Street, is known for its Greenmarket. The buildings around the square once housed numerous artist's studios—barely visible to those who know where to look is the home of Andy Warhol's legendary silver Factory.

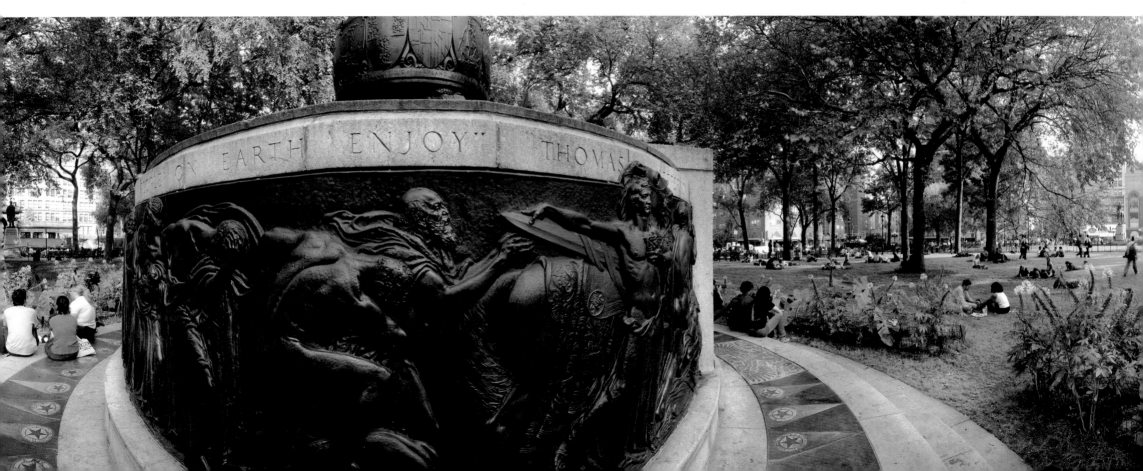

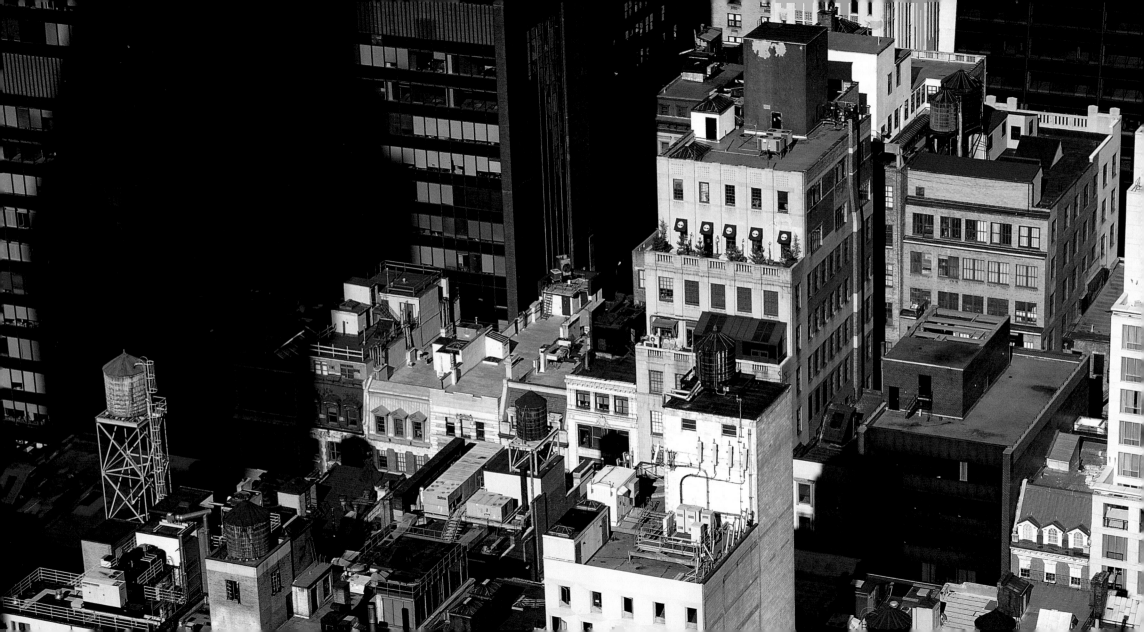

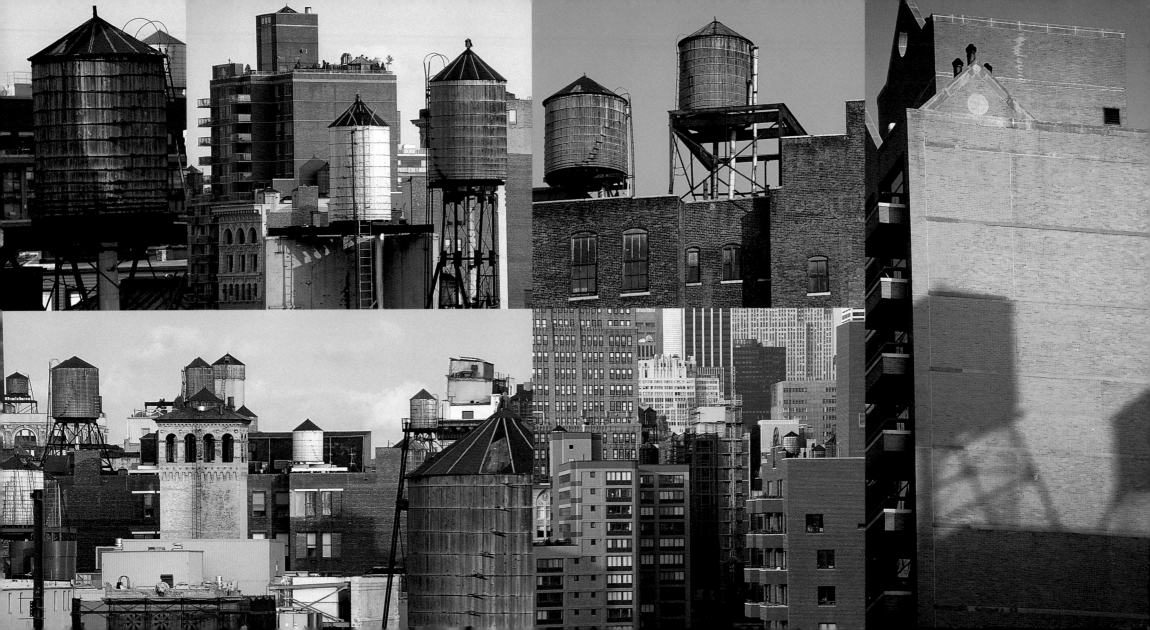

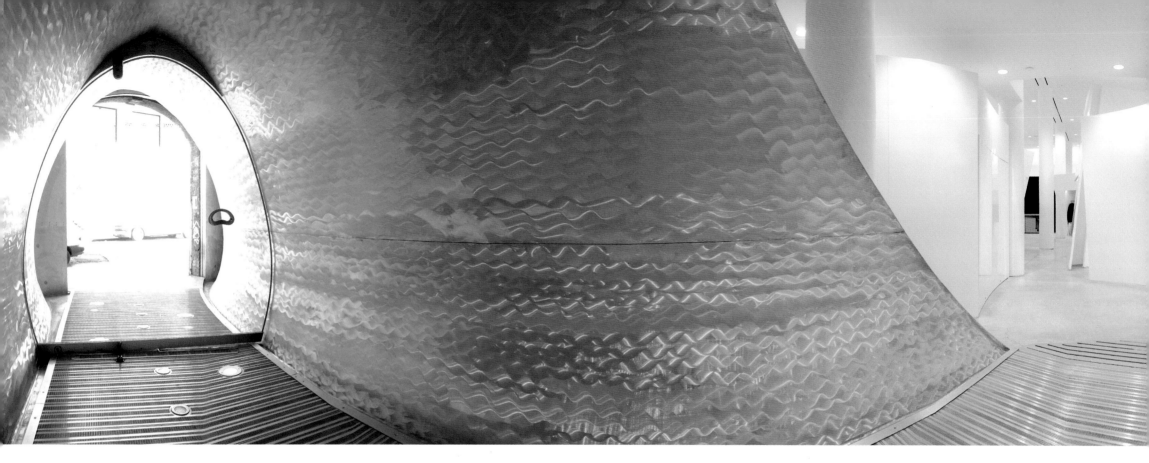

DON'T ASK A NEW YORK ARTIST what he thinks of a fashion boutique. In New York's SoHo district, underutilized industrial buildings attracted artists and galleries seeking cheap space, but commercial development eventually forced them to colonize elsewhere. Will it happen in Chelsea, Manhattan's latest art district? Comme des Garçons (520 West 22nd Street) opened this chic boutique designed by Future Systems, with its aluminum entry tunnel, in 1998, and the galleries are still thriving.

COMME DES GARÇONS

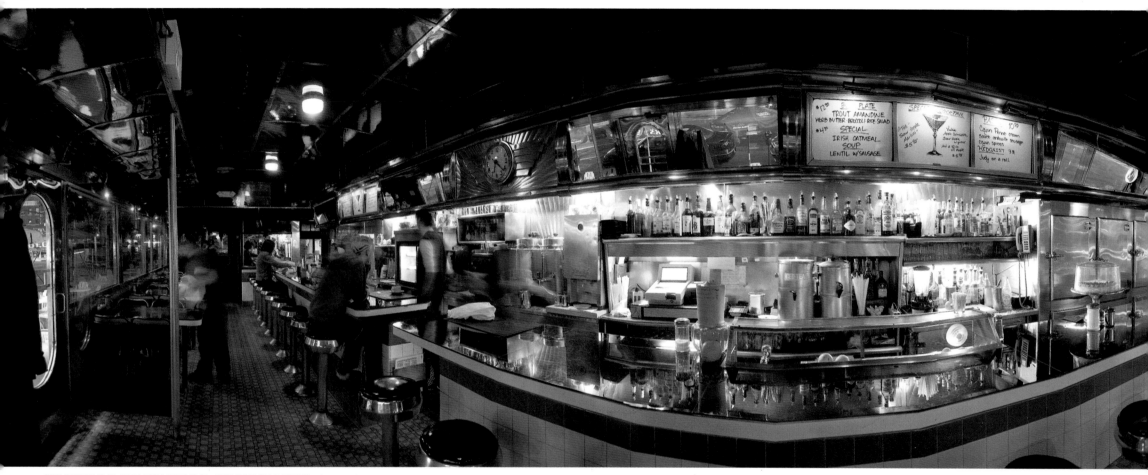

MANHATTAN IS NOT THE NATURAL HABITAT OF DINERS, those quintessentially American roadside eateries, but there is a scattering of classic railroad car diners on the far West Side, providing a romantic counterpoint to the abandoned New York Central Railroad line. It seems that New Yorkers are as susceptible to the flash of chrome and the nostalgia for simpler days as the rest of the world. The Empire Diner, at 210 Tenth Avenue since 1943, hit pay-dirt when Chelsea became fashionable in the 1990s, and who can begrudge the restaurant its good fortune? At the bottom of the menu, trendy customers can peruse the diner's quaint house rules: "no personal checks, be nice, don't shout, sit up straight, don't talk with your mouth full, elbows off the table, smile!"

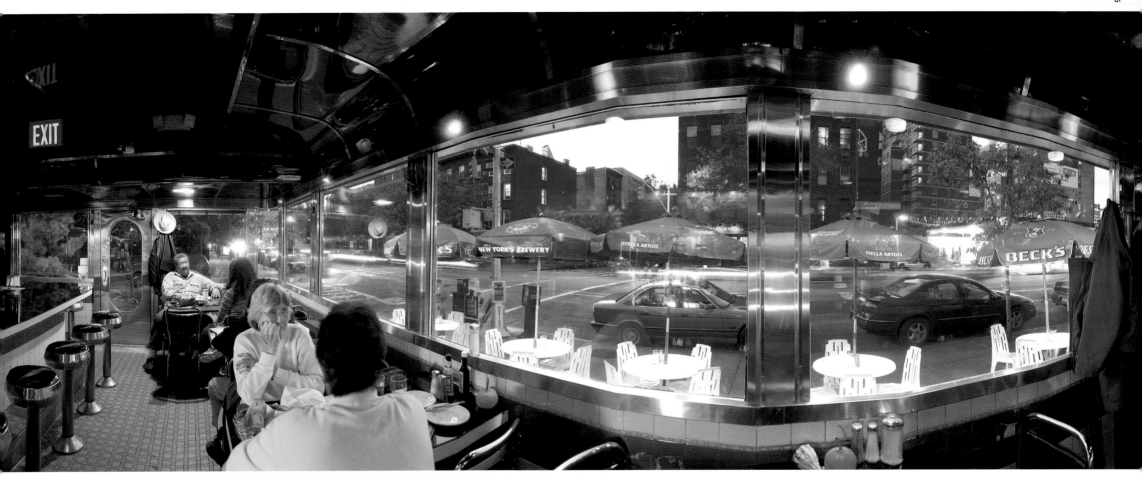

EMPIRE DINER

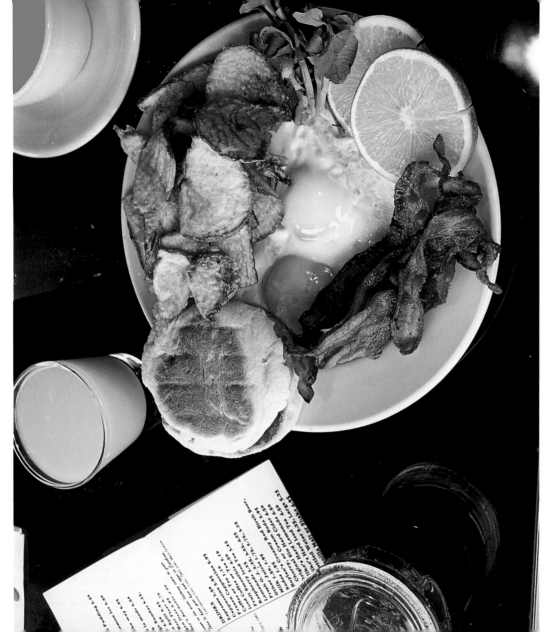

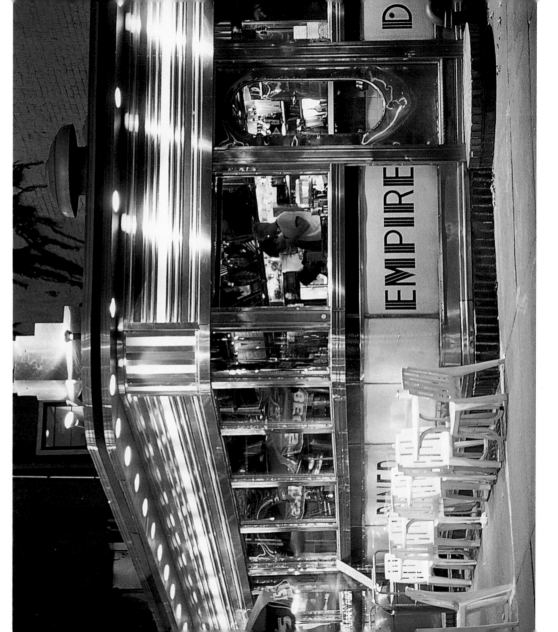

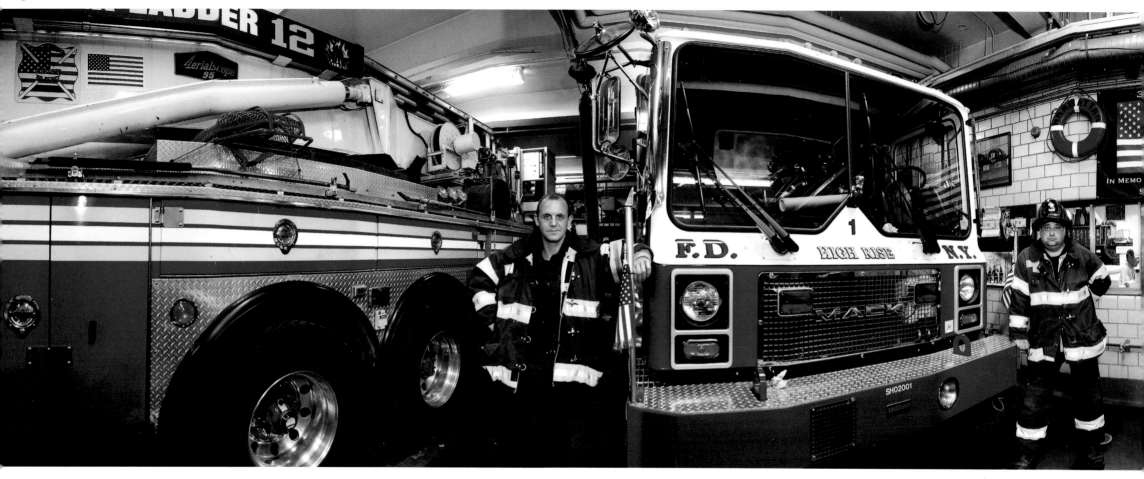

THERE ARE APPROXIMATELY FIFTY FIREHOUSES IN MANHATTAN. Virtually all are struggling with the legacy of 9/11. The Chelsea firehouse (142 West 19th Street) is home to Engine Company 3, Ladder Company 12, High Rise Unit 1, and Battalion 7, and covers an area stretching from Penn Station to the West Village. Ladder 12 and Battalion 7 lost five men at the World Trade Center. In 2002, the New York City Fire Department was called upon to respond to almost half a million incidents—2,946 were classified as serious fires, and more than 45,000 as malicious false alarms.

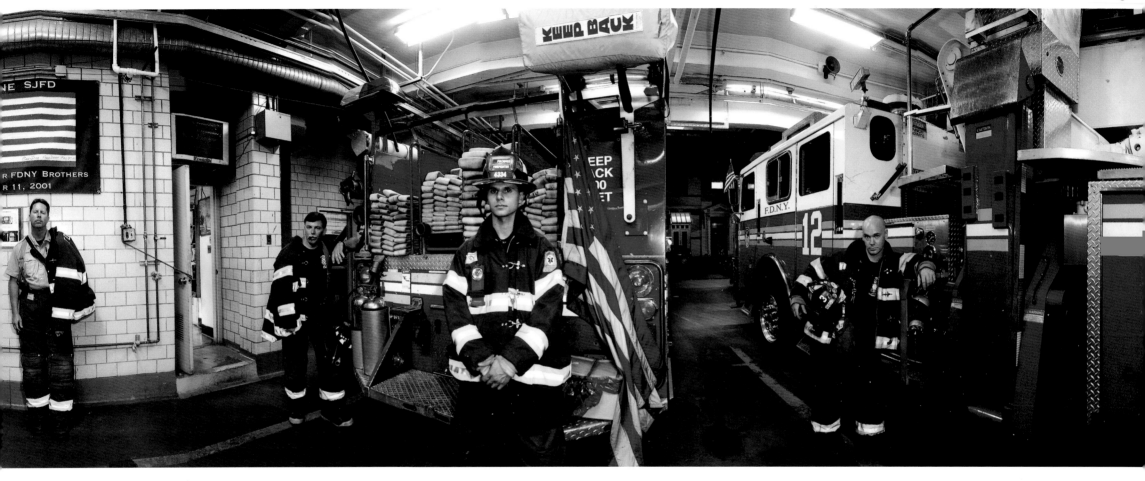

CHELSEA FIREHOUSE

Seagrave

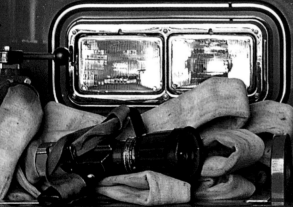F.D.N.Y.

SP 9711

SCHOOL'S OPEN, DRIVE CAREFULLY

3

FDNY
9-11-01

ALL GAVE SOME
SOME GAVE ALL

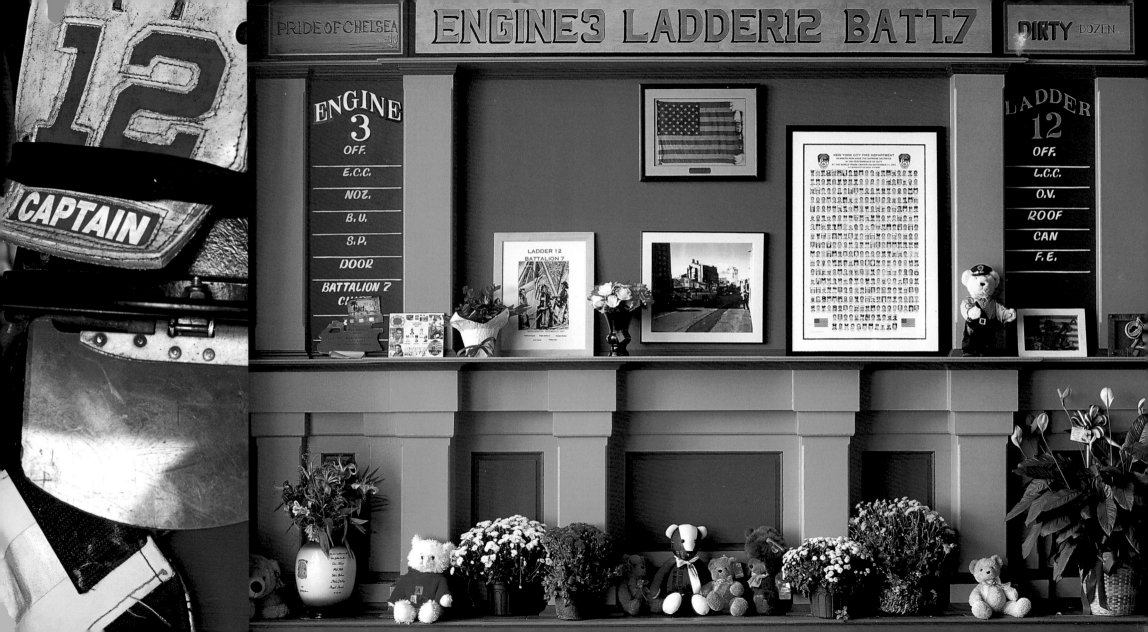

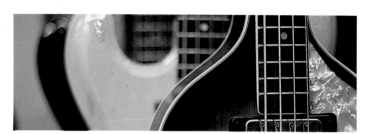

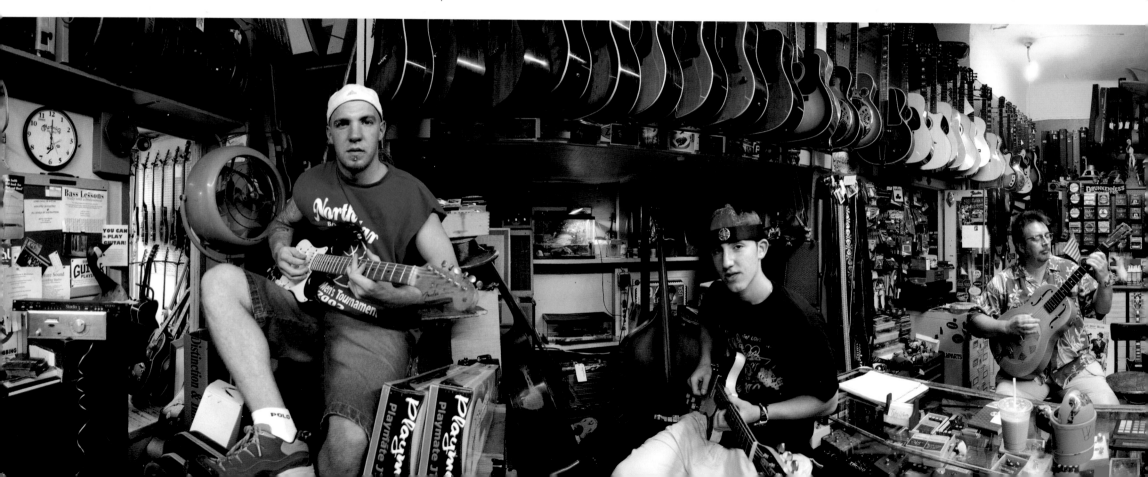

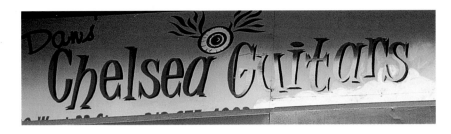

DAN'S CHELSEA GUITARS

DAN'S CHELSEA GUITARS (220 West 23rd Street) is an institution that is staffed by a group of guys who have one thing in common—they love vintage guitars. The client list reads like a Who's Who of the last forty years of rock music.

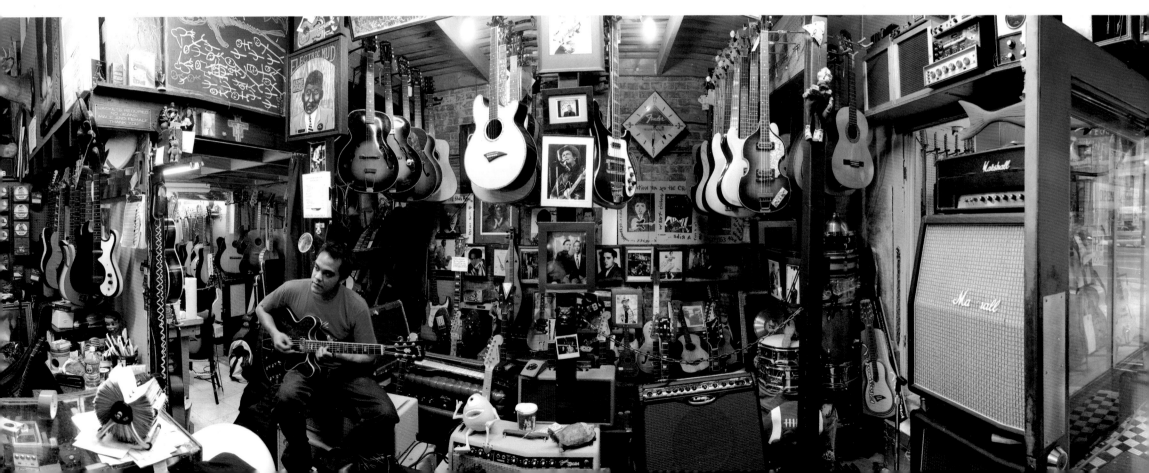

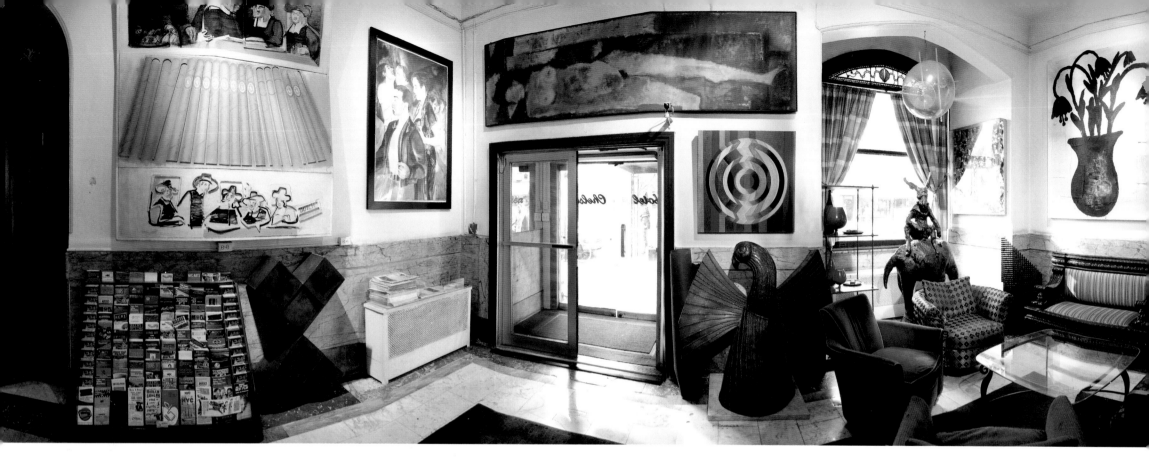

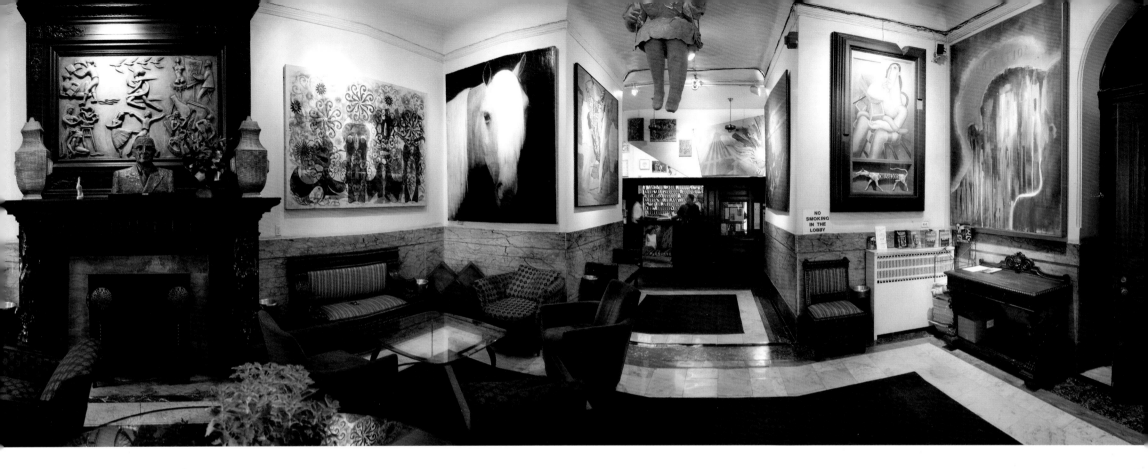

HOTEL CHELSEA

BUILT IN 1884 AT 222 WEST 23RD STREET, the Chelsea was one of the city's first cooperative apartment buildings and its tallest structure (eleven stories!) until 1902. In 1905 the building became a hotel, and it has been a retreat for artists, writers, and musicians ever since. If its walls could only speak! It was here that Dylan Thomas spiraled into an alcoholic stupor from which he never recovered and Sid Vicious murdered Nancy Spungen. It was here too that Arthur Miller wrote *After the Fall*, Arthur C. Clarke wrote the script for *2001: A Space Odyssey*, Bob Dylan wrote "Sad Eyed Lady of the Lowlands," and Joni Mitchell wrote "Chelsea Morning." And did we mention the ghosts of Sarah Bernhardt, Virgil Thompson, William Burroughs, Jimi Hendrix, to name just a few? You might encounter them on these stairs.

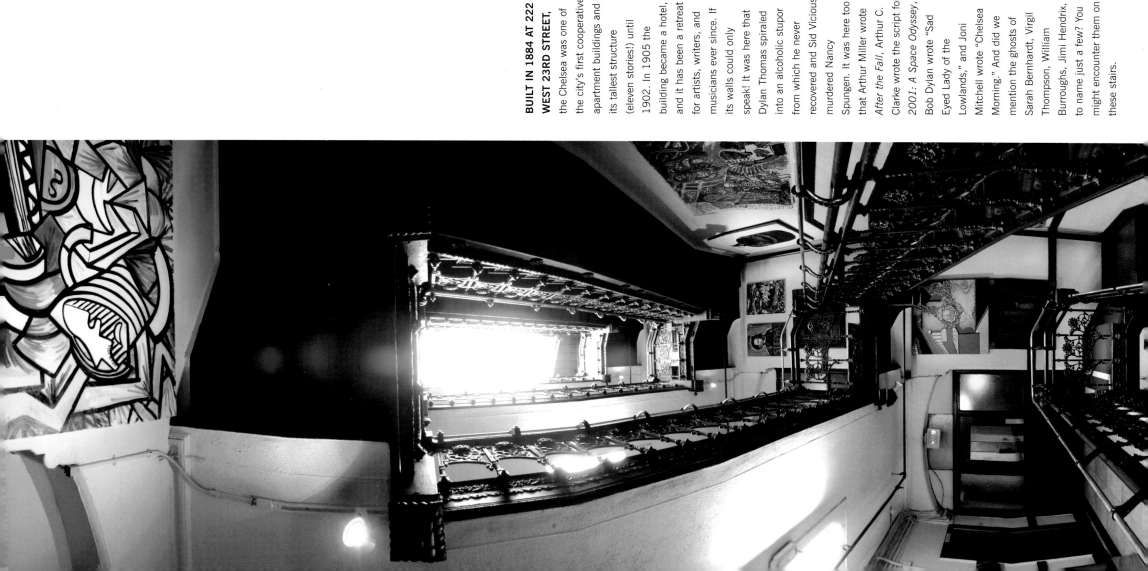

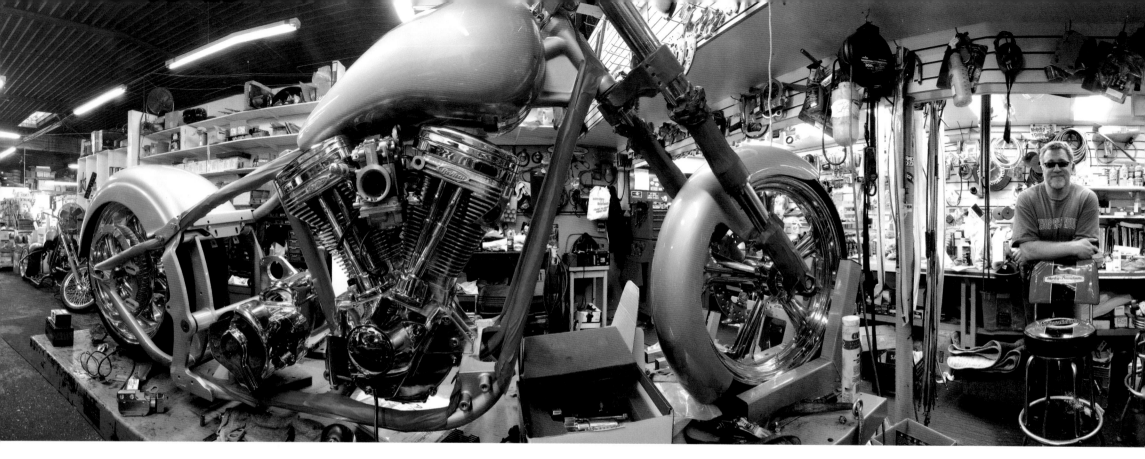
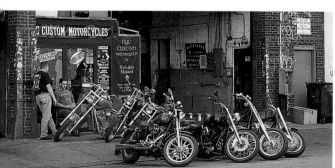

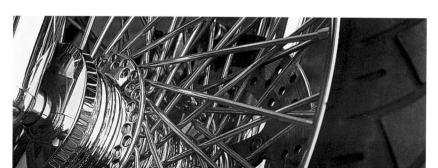

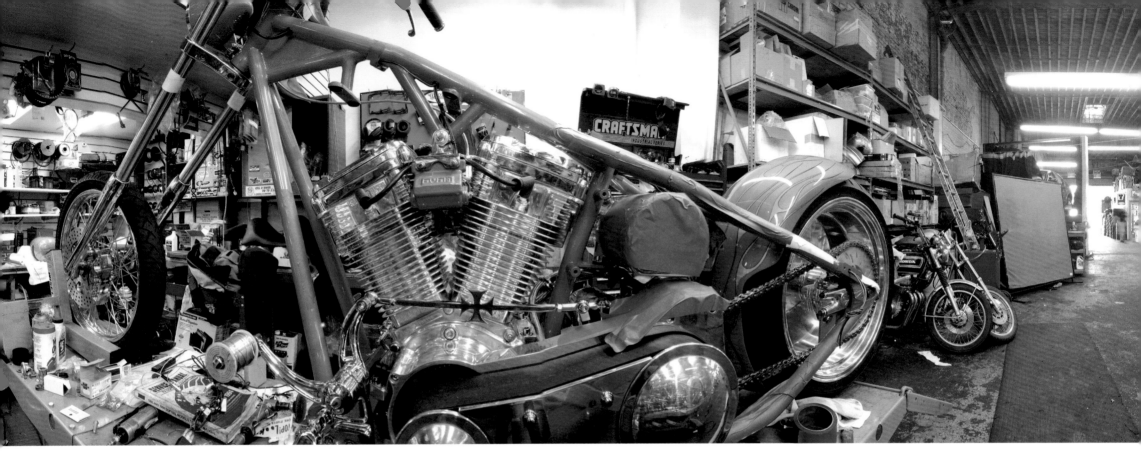

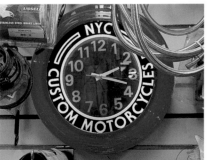

IF YOU WANT THE CODE GREY or the Orange Crush at NYC Custom Cycle, you'll spend as much as you would on a fine sports car, but you'll have a unique machine. The company began after Nick Genender, the owner, built his own motorcycle and discovered that others shared his passion for one-off bikes. He makes about twelve custom motorcycles a year.

NYC CUSTOM MOTORCYCLES

LIKE A SMALL SHIP IN HEAVY SEAS, the Flatiron Building (1902) almost disappears into the cityscape. Architect D. H. Burnham's steel-framed structure, twenty-one stories tall, was one of the world's first true skyscrapers. The Northward facing wedge was dictated by the plot, where Fifth Avenue and Broadway crossed 23rd Street, meeting at an acute angle, and New York lore has it that downdrafts caused by the narrow tower disarranged the skirts of passing women. Supposedly, a policeman coined the expression "23 skiddoo" to send gawkers on their way. Etymologists think it an unlikely source for the popular phrase.

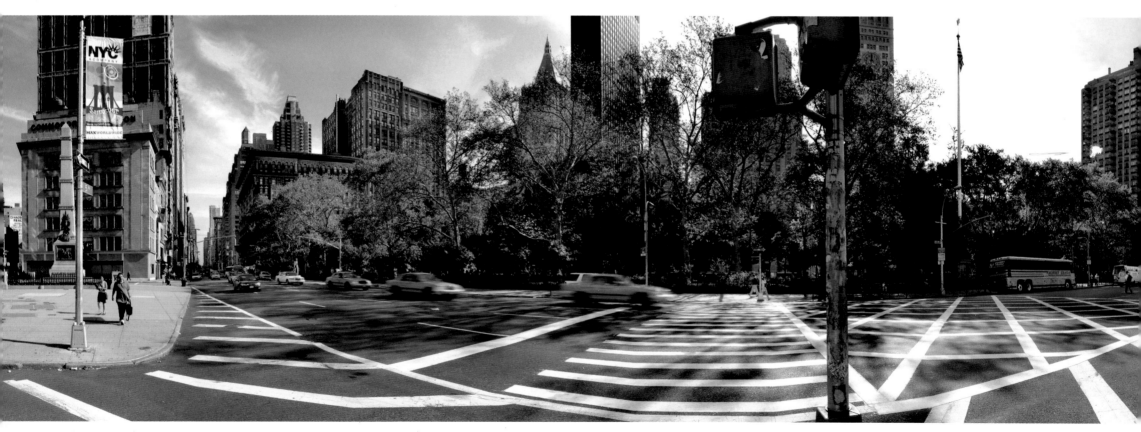

FLATIRON BUILDING

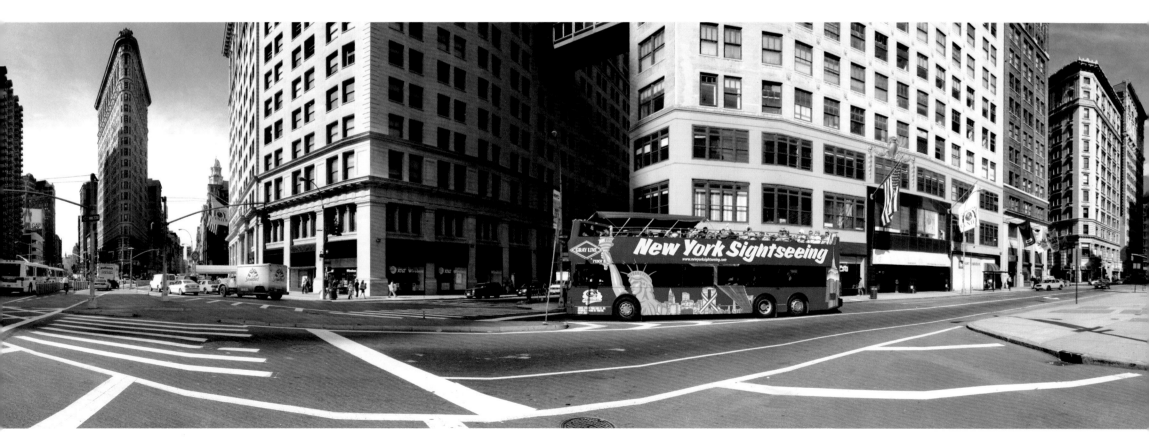

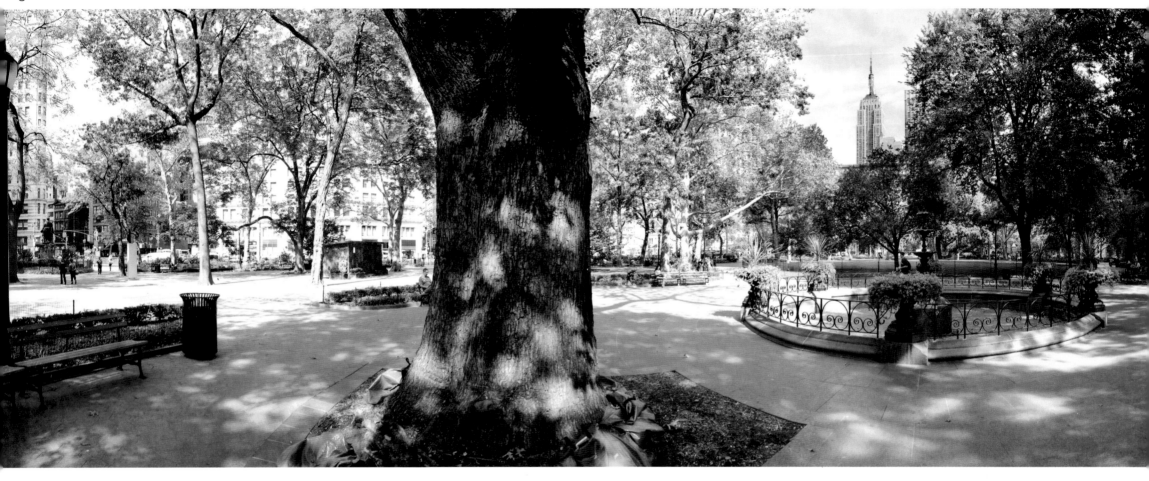

NEW YORK IS NOT A CITY that treasures its squares. The city fathers tucked them here and there as a gesture to tradition, but the true New Yorker hurries through them without stopping. Madison Square Park, where Broadway crosses East 23rd Street, is probably most famous for having given its name to Madison Square Garden, the arena that stood next to it until 1925, before hurrying uptown to follow the crowds.

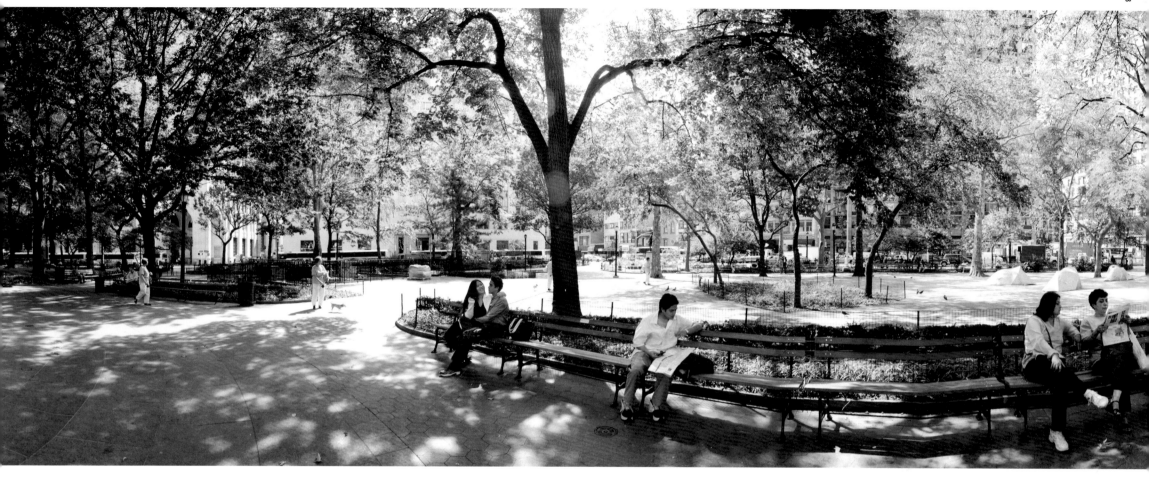

MADISON SQUARE PARK

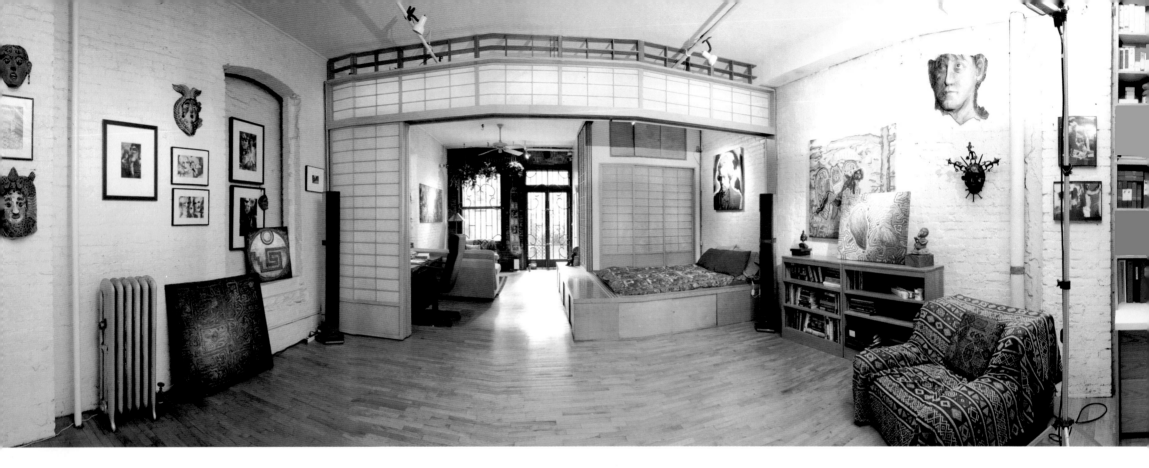

WE ARE IN THE GARMENT DISTRICT, in the West thirties, and within these walls immigrants sewing or cutting at long tables probably earned their first American dollars. Today, the former factory has been converted to lofts, its red brick painted a fashionable white. An artist works at his easel. Bright, bold and complex, his images echo the intensity and vibrancy of the city outside his windows. The painting seen here is called *Fallen*, and depicts Eve fleeing from the Garden of Eden in terror and regret after tasting the forbidden fruit.

ARTIST'S LOFT

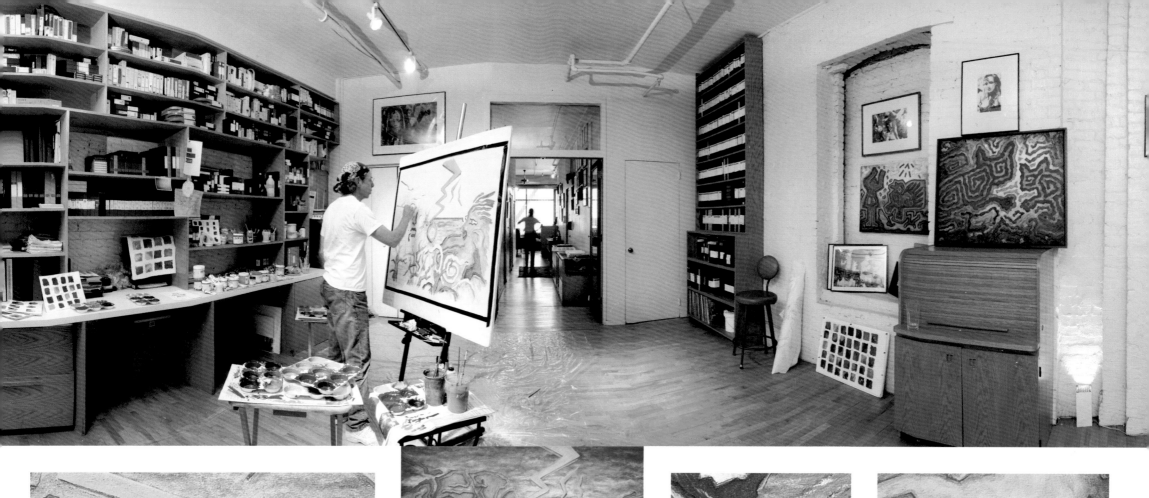

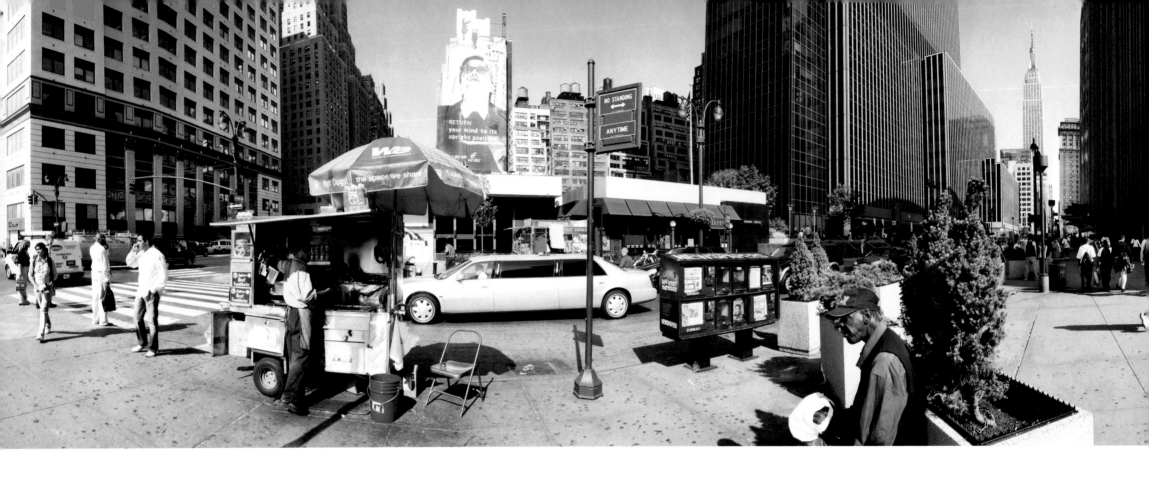

THE DOWNSIDE OF NEW YORK'S ceaseless change is that some great buildings have been carelessly torn down. Many who stop and look around at the corner of Eighth Avenue and West 33rd Street are painfully aware of the grandeur of what is gone. What is gone, precisely, is the glorious Beaux Arts Pennsylvania Station, which occupied this spot from 1910 to 1963, when the Pennsylvania Railroad Company demolished it. In a famous letter to the *Times*, the defensive president of the company asked if it made sense "to preserve a building merely as a 'monument'?" The city decided that it did: an effective landmarks preservation law was passed in 1965. Meanwhile, plans are afoot to move Penn Station from its present location under Madison Square Garden to the imposing James A. Farley Post Office, visible across Eighth Avenue.

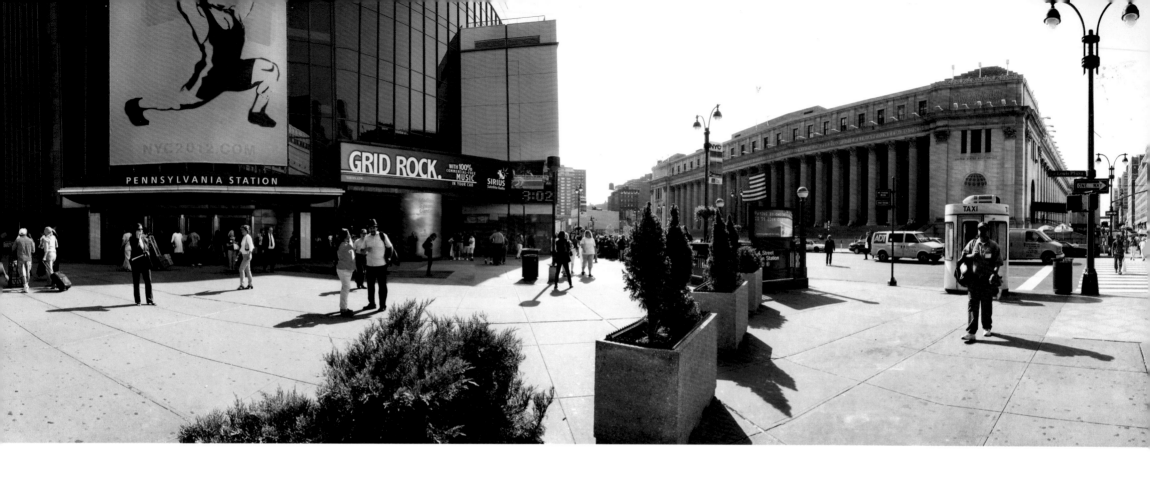

PENNSYLVANIA STATION

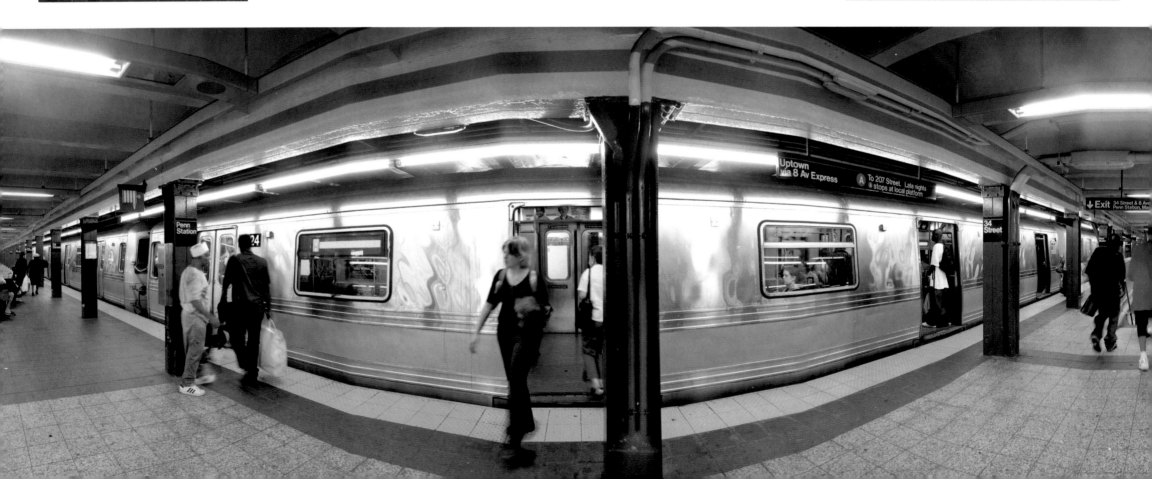

THE SUBWAY SYSTEM

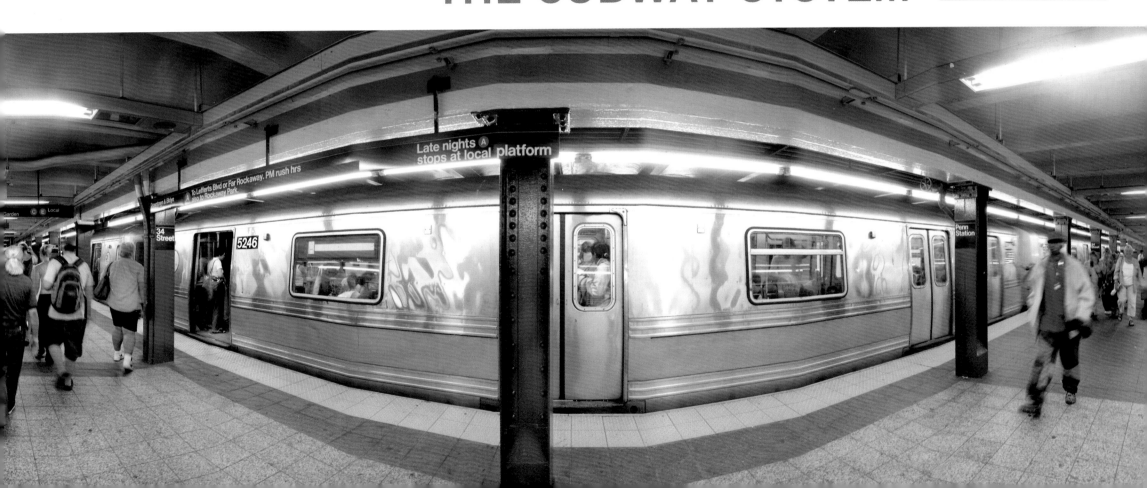

THE MIND BOGGLES at the resources and willpower expended to give New York City its subway system. The effort began with the twentieth century—1904 to be exact—and was largely completed by mid-century: approximately 650 miles of track connecting more than 450 stations. The generations that followed had to struggle to maintain what their predecessors had left them, but things are looking up today. The city began to invest real money in the system in the 1980s—note those gleaming new cars in the 34th Street Station on the A line on the preceding spread—and in the 1990s growth of the use of mass transit outstripped private cars by a factor of five. The New York City Transit Authority now carries 1.2 billion passengers a year on its trains and busses—more than Chicago, Washington, Boston, Philadelphia, and Los Angeles combined. On this spread you're catching glimpses of the Times Square Station, the busiest in the city.

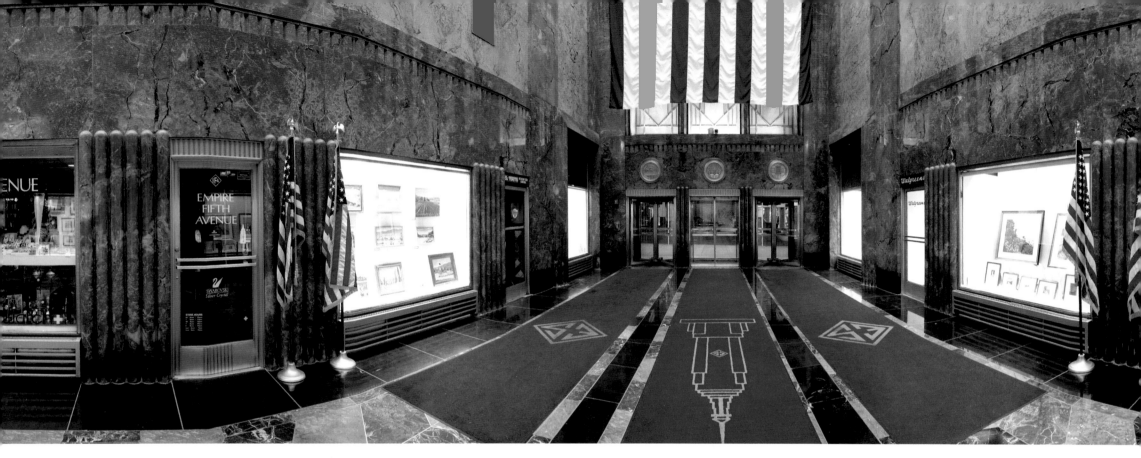

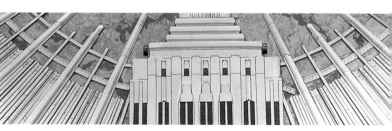

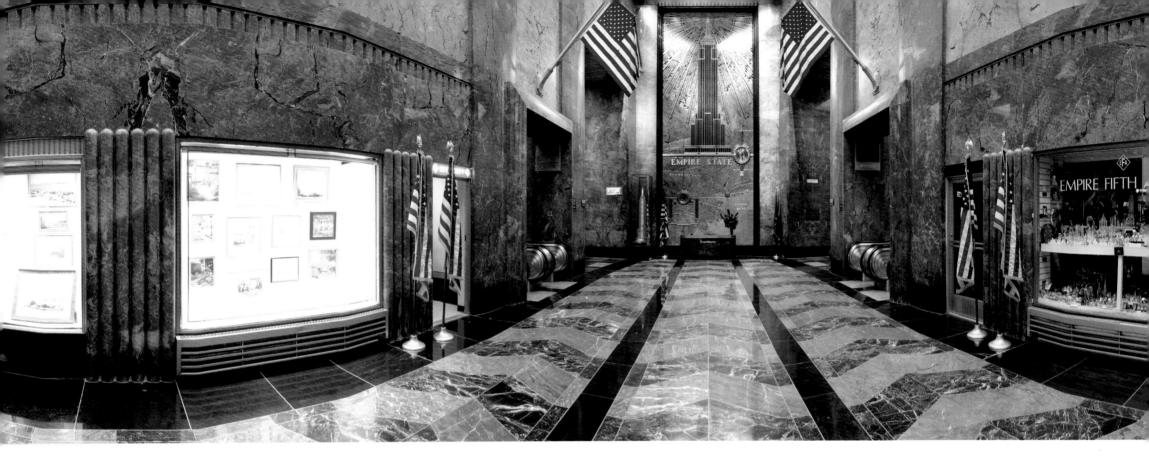

IT IS ARGUABLY THE MOST FAMOUS BUILDING of the modern age and, alas, once again—since 9/11—the tallest in New York City. An Art Deco masterpiece designed by William Lamb, the Empire State Building (350 Fifth Avenue) was completed in 1931, but it is really a product of the Roaring Twenties—a decade when developers had the audacity to imagine it and the dough to make it happen. In addition to being extremely handsome, it is efficient (its eighty-six stories were designed to have a maximum amount of rentable space) and it is sturdy (when a US bomber crashed into the 78th floor in 1945, it sustained minimal damage).

EMPIRE STATE BUILDING

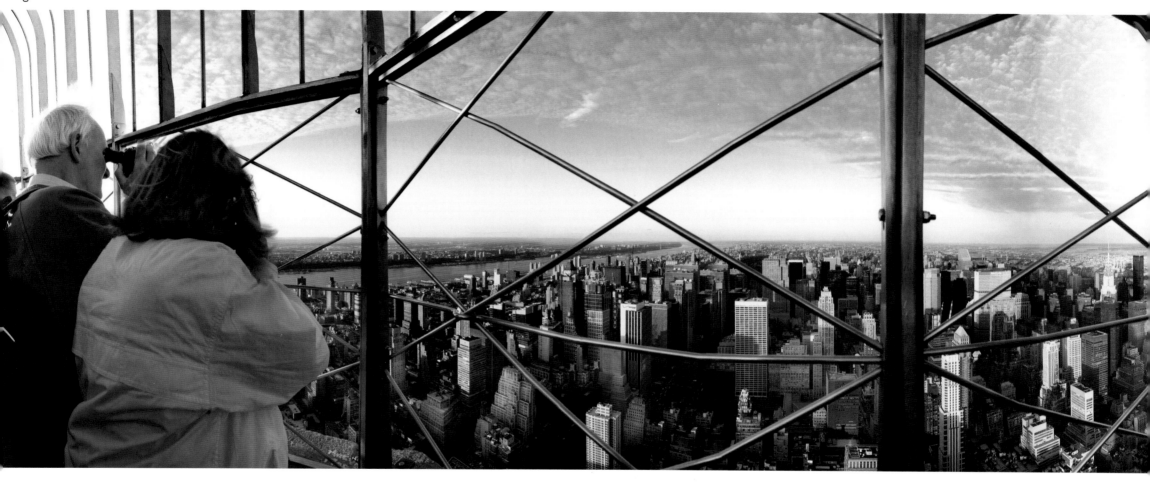

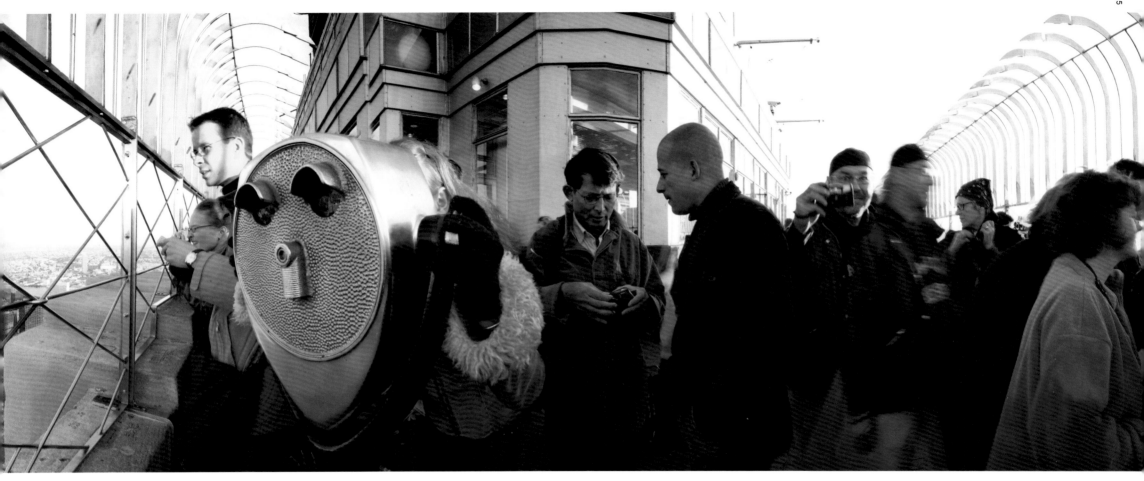

LOOK UP

THE VIEW FROM THE 86TH-FLOOR OBSERVATORY of the Empire State Building stretches for almost eighty miles on a clear day. Three-and-a half million people take the trip to the top each year. There are seventy-three elevators in the building and you can travel from the lobby to the 86th floor in just forty-five seconds. Above the observatory deck soars the tower, on top of which is a lightning rod that is hit more than one hundred times a year.

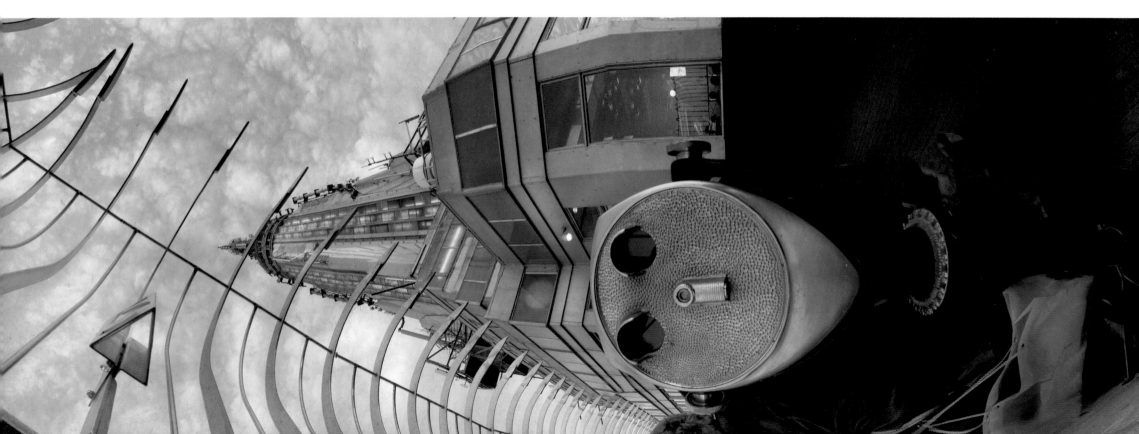

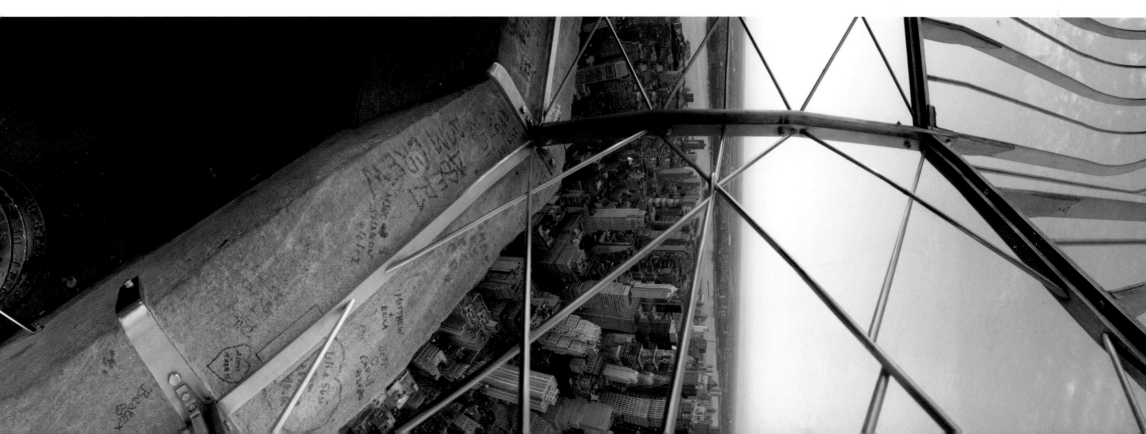

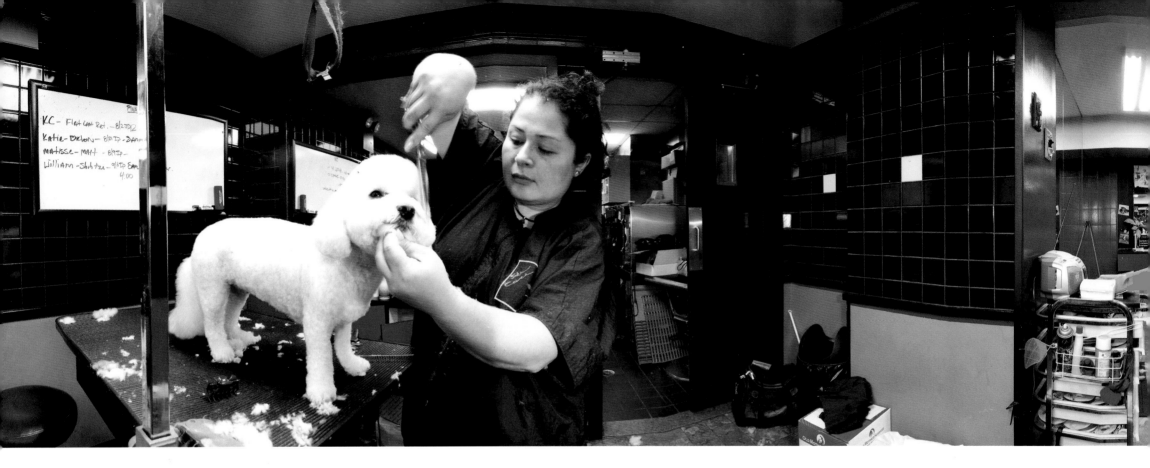

SOMETHING ABOUT BIG-CITY LIFE makes apartment dwellers want to treat their pets as they would, well, themselves. Ask Larry and Howie, the proprietors of Doggy Do and Pussycats, Too! (567 Third Avenue). And grooming is only the beginning. In the city, you can find vets that make house calls, lawyers to help with estate planning for pets, therapists to address pets' emotional problems, and dieticians to consult about pet's weight and eating disorders.

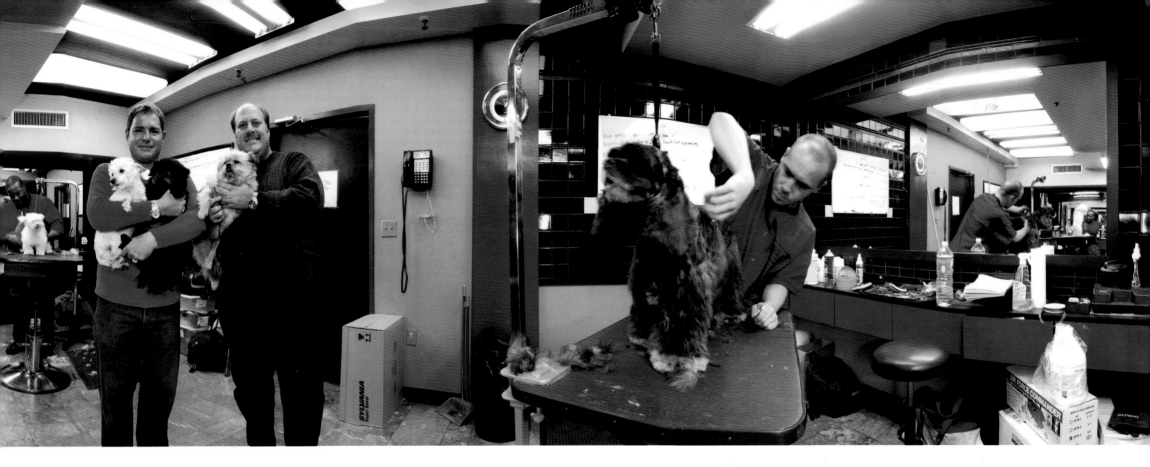

DOGGIE-DO & PUSSYCATS, TOO!

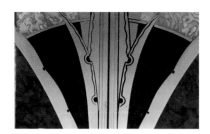
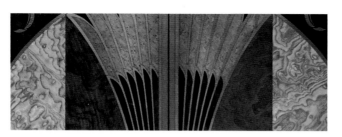
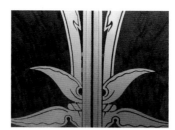
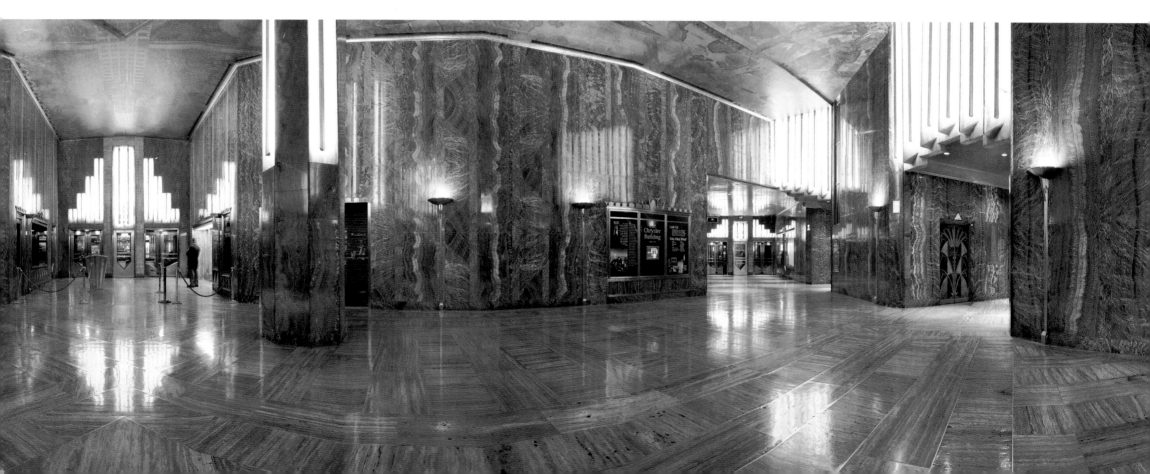

CHRYSLER BUILDING

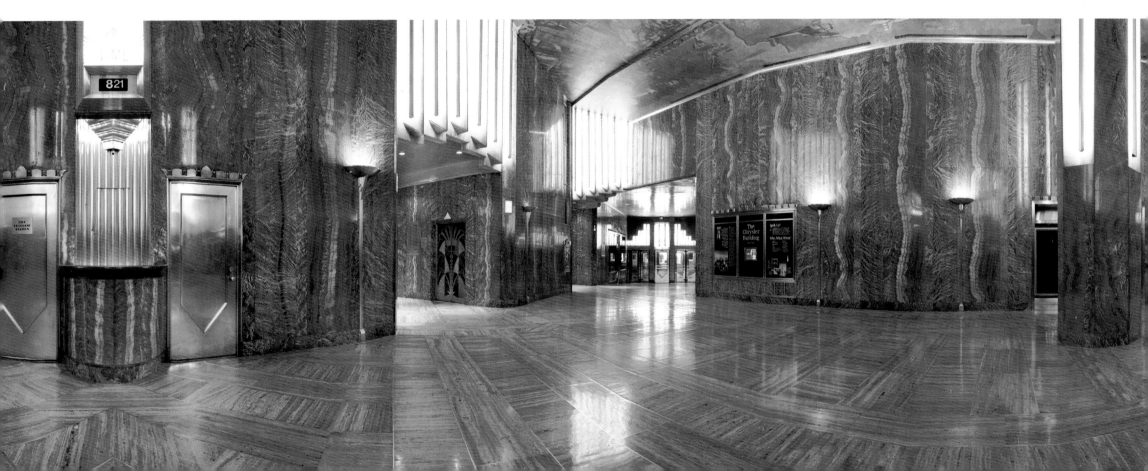

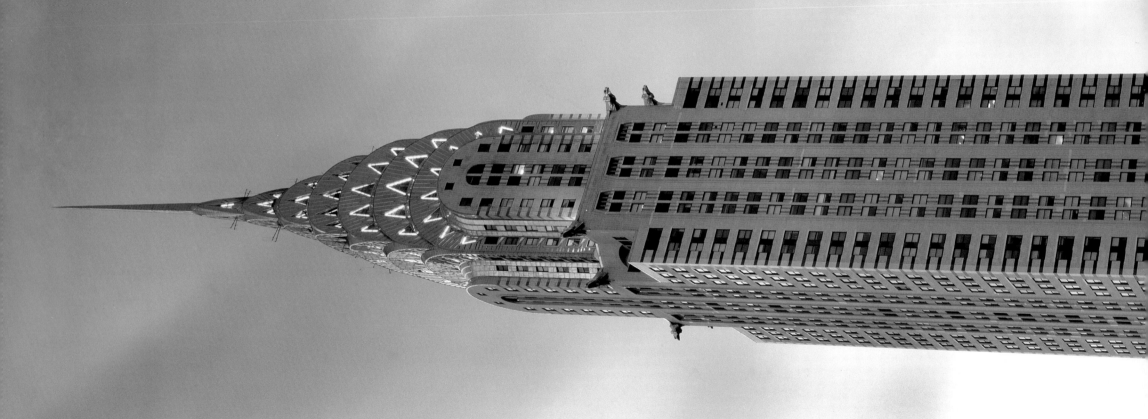

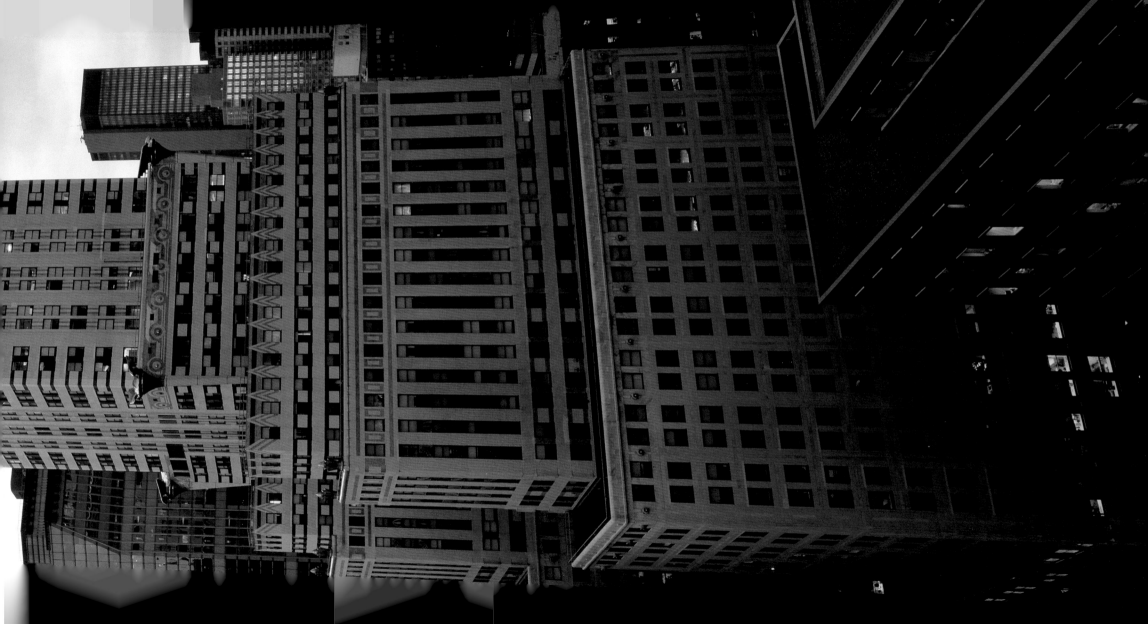

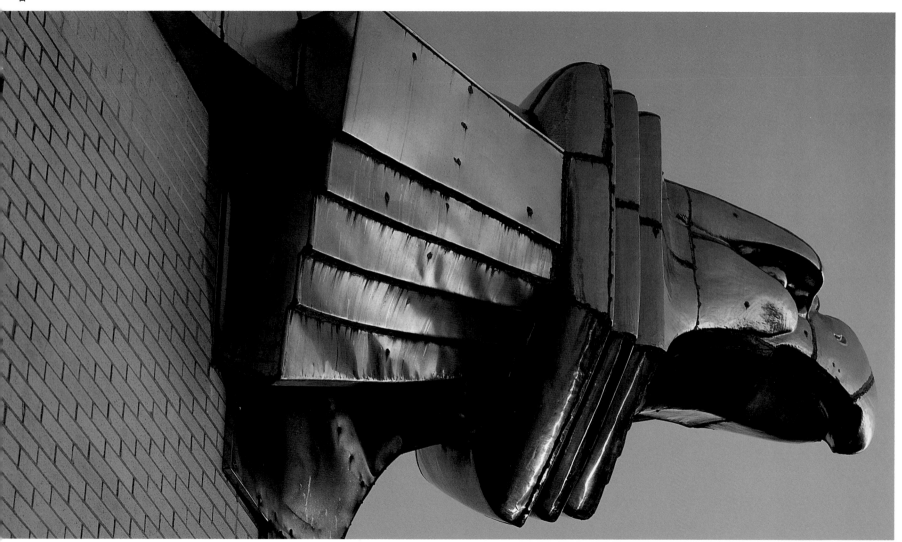

"MAKE THIS BUILDING THE TALLEST IN THE WORLD, taller than the Eiffel Tower," was Walter P. Chrysler's order to architect William Van Alen. And for a brief period of a few months, the Chrysler Building (1930) fulfilled it's owner's ambition. For a piece of the most valuable real estate in the world—adjacent to Grand Central Terminal at 405 Lexington Avenue—Van Alen designed what has come to be thought of as the world's most beautiful skyscraper. By day or by night, outside or in, it is an exquisite Art Deco creation. They make an imposing couple, the Empire State Building and the Chrysler Building: if the former is the strong silent type, the latter is a sheer romantic.

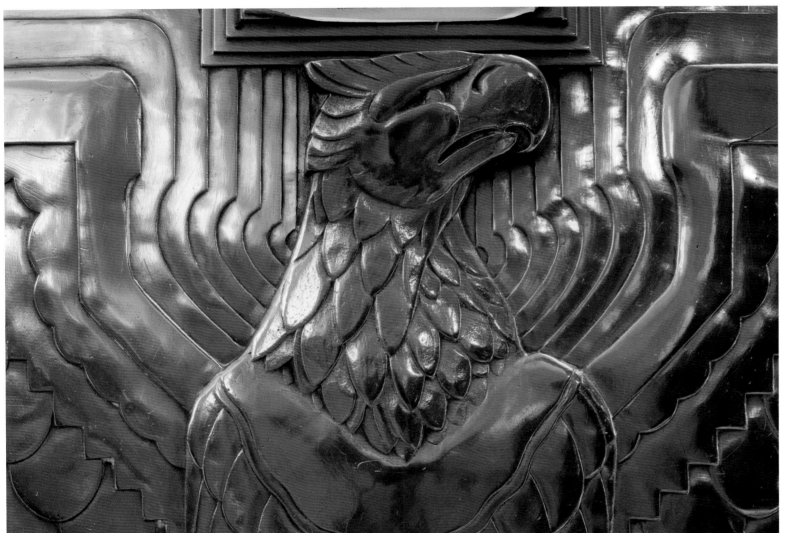

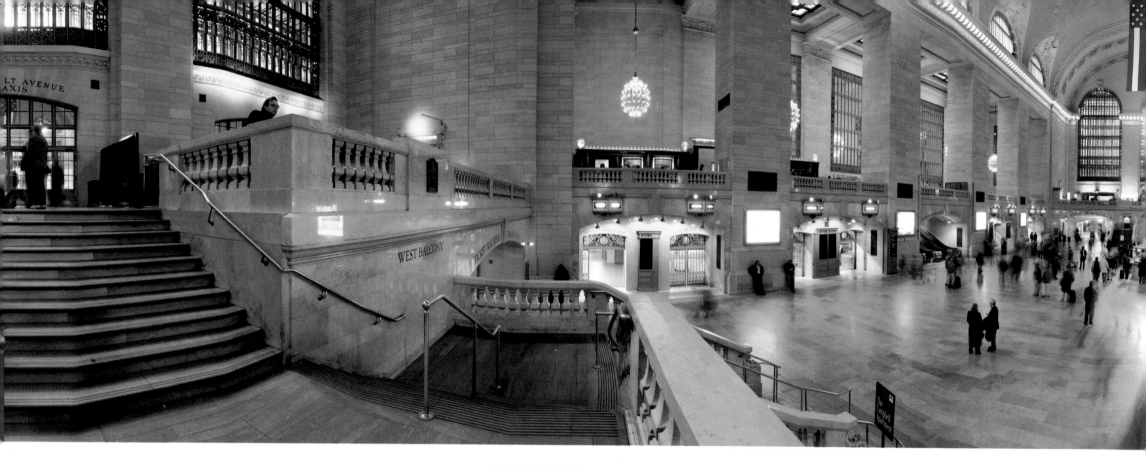

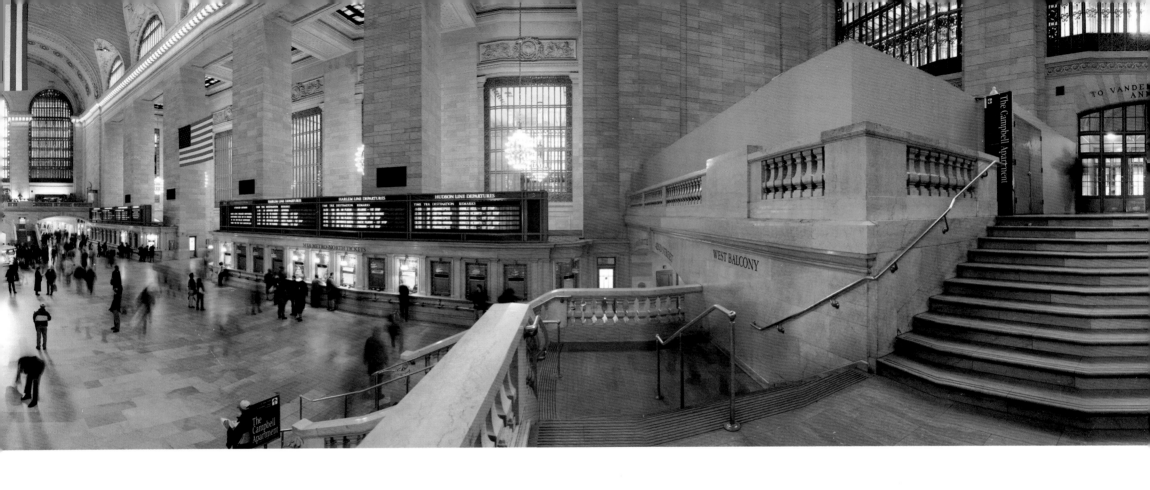

GRAND CENTRAL TERMINAL

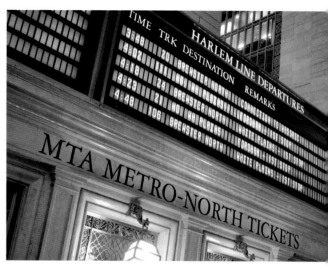

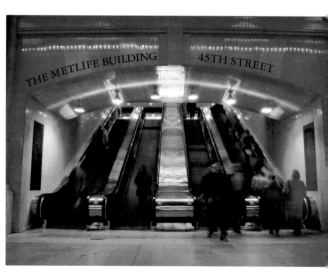

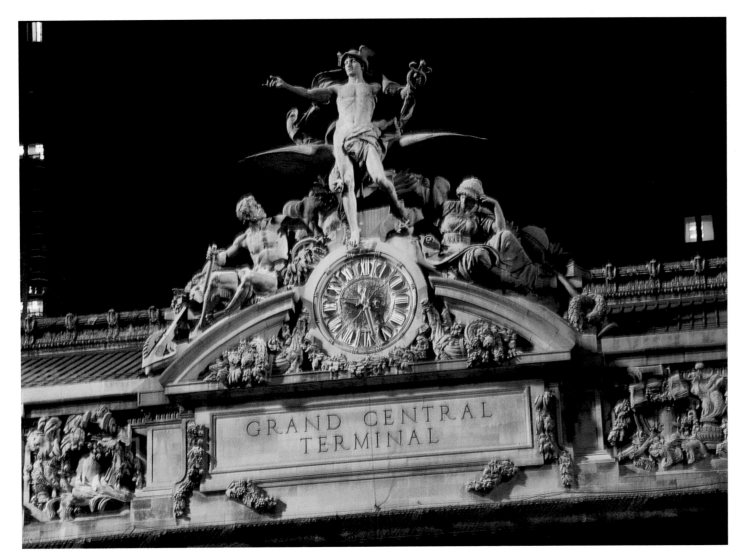

IN THE ABSENCE of the even grander Pennsylvania Station, New Yorkers must make do with Grand Central Terminal (1913), designed by the firm of Warren & Wetmore on East 42nd Street. In truth, it is not a great compromise: Grand Central naturally takes its place among the world's railroad stations. The terminal is famous for the great barrel-vaulted concourse seen in the photograph on the previous spread, but that is only the tip of the iceberg: what Warren & Wetmore wrought, with Vanderbilt backing, was a complex of commanding buildings once called "Terminal City" that were interconnected in more ways than one. Indeed, the paper generated by this vast, lucrative, and successful real-estate scheme would probably fill another vault the size of its concourse.

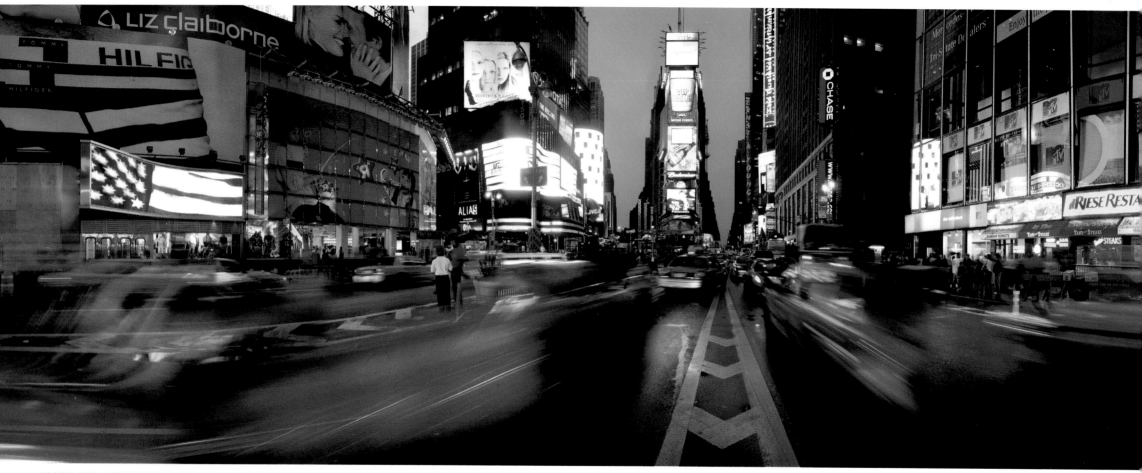

IF YOU ARE A SENTIMENTALIST, you may think of Times Square as New York's beating heart, expanding and contracting in time to flashing neon signs. If you are a realist, it is an indifferent lover, out to take your money and if you have a good time, then all the better for you. But whatever else it is, Times Square is not really a square at all, but a four block-long broad channel of buildings, formed by the confluence of Broadway and Seventh Avenue. In this photograph, you are standing in the middle of the channel: it is capped at the northern end by the Renaissance Hotel (right) and at the southern end by One Times Square (left). Of course, you do not see buildings; you see light and color and movement. And that finally is the irreducible point of Times Square.

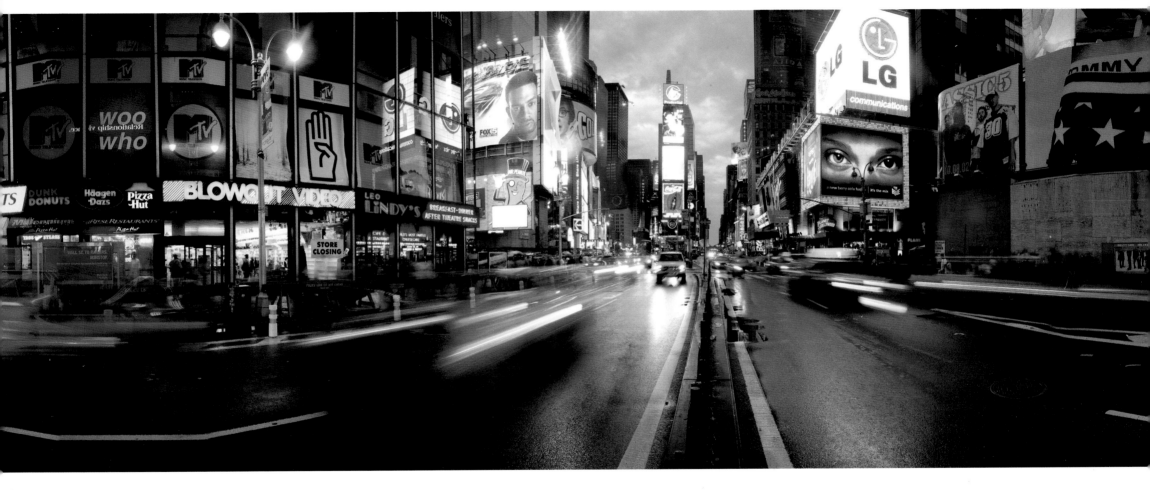

TIMES SQUARE

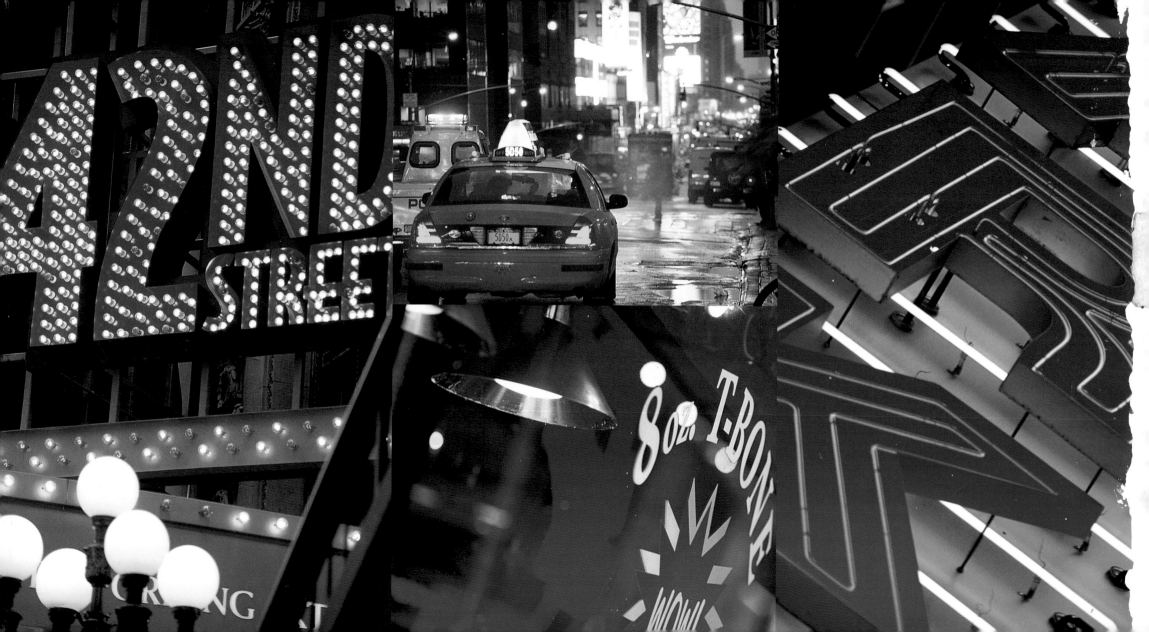

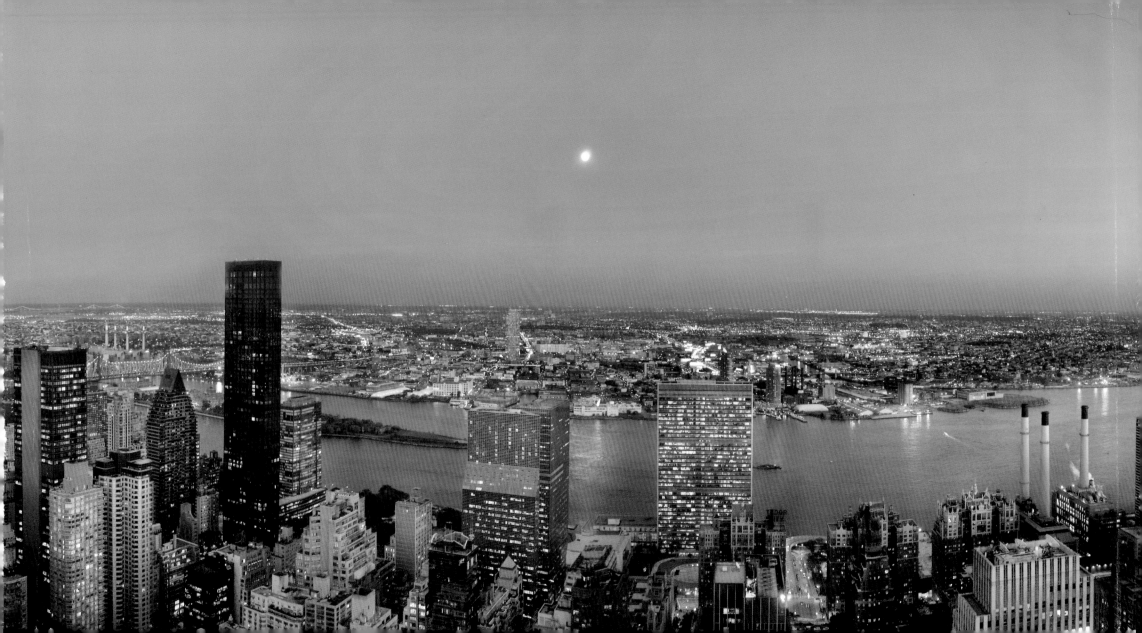

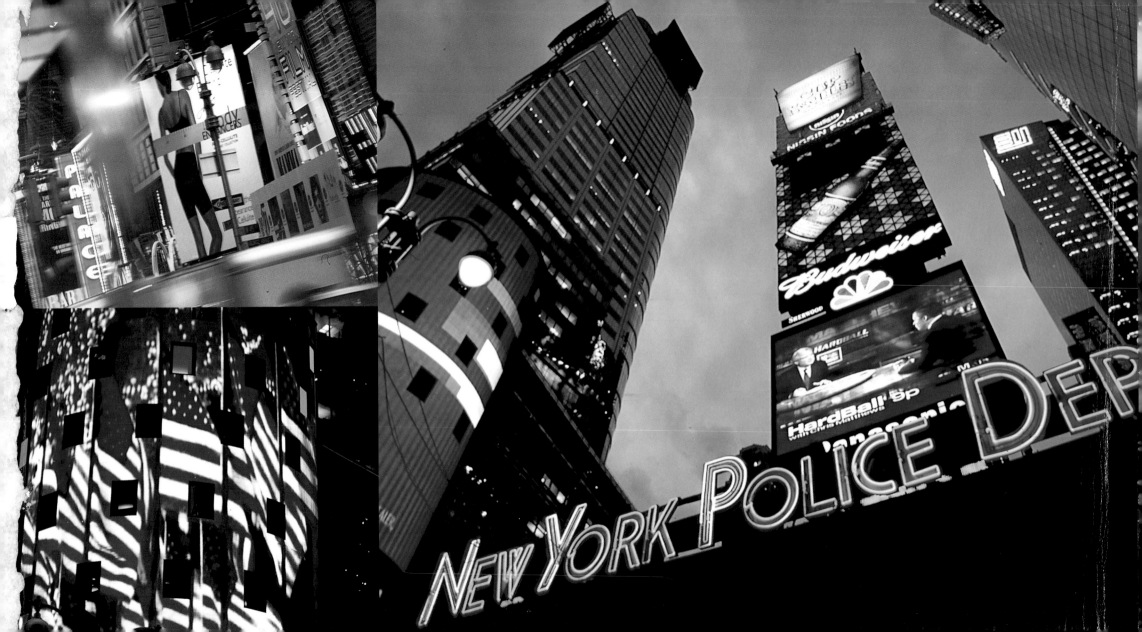

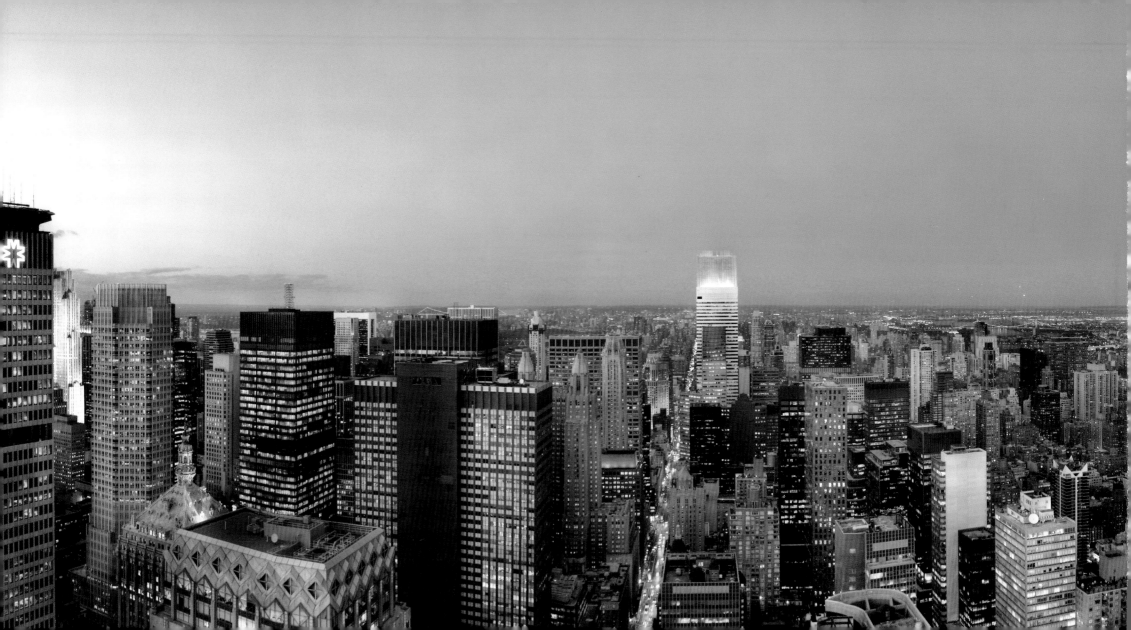

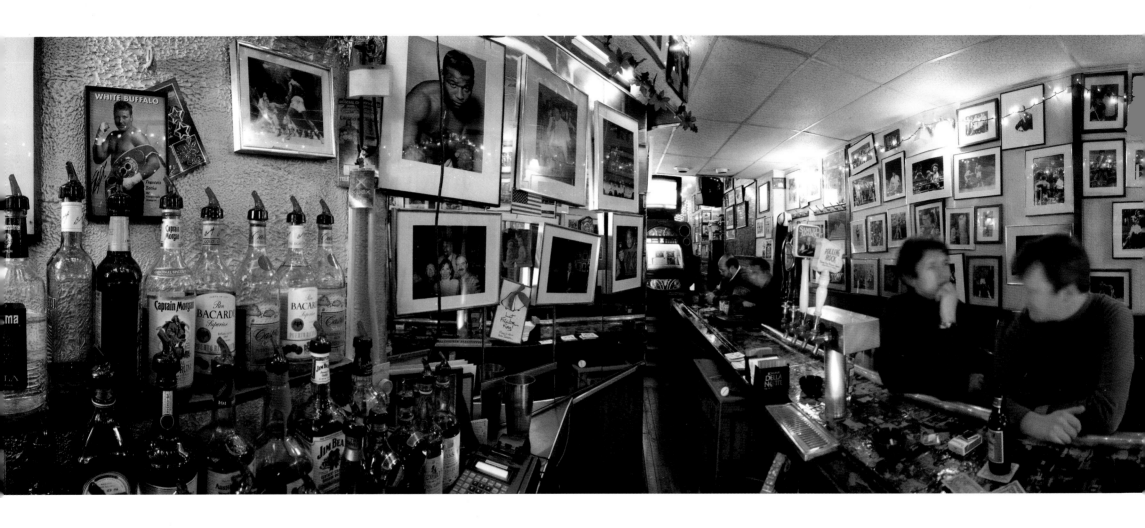

THE TIMES SQUARE OF LEGEND was the haunt of boxers and horn players and songbirds, down on their luck or flush with short-lived success. They drowned their sorrows in places like Jimmy's Corner, on West 44th Street. The "corner" here refers to a boxer's station in the ring; the joint is in the middle of the block. Jimmy Glenn is a former professional boxing trainer, and his bar is a shrine to the sport in the middle of the theater district.

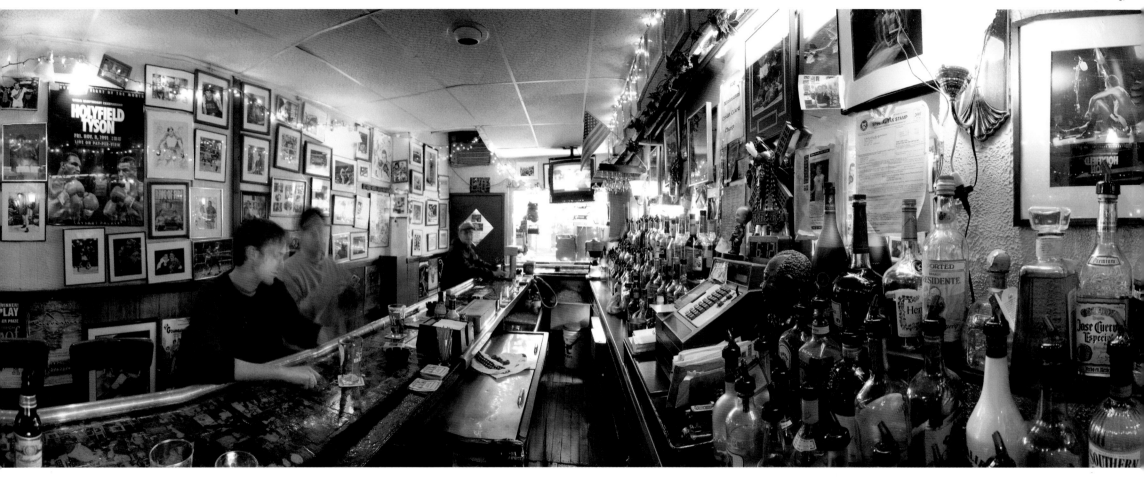

JIMMY'S CORNER

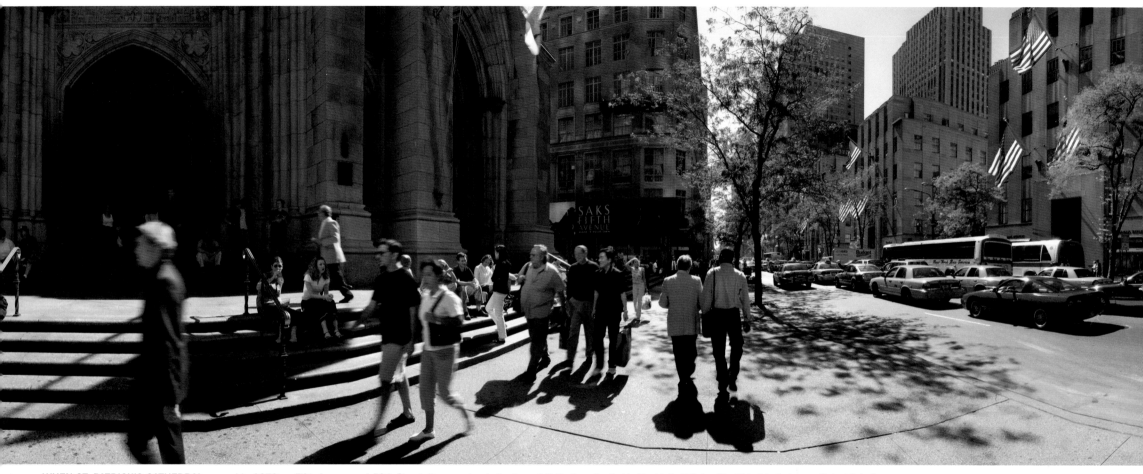

WHEN ST. PATRICK'S CATHEDRAL opened in 1879 on Fifth Avenue and 50th Street, it was not only the largest Catholic cathedral in the United States (it still holds that record), but it both towered over and blended in with the surrounding buildings—as we feel instinctively a cathedral ought to do. Fast forward to the twenty-first century, and we find the cathedral unchanged, but the buildings around it make it seem rather precious and small. This effect is strongest when you go into one of the neighboring skyscrapers and look down at it—cathedrals are not meant to be looked down on by mere mortals. Across the street from the cathedral porch, in Rockefeller Center, a pagan god, Atlas, carries the world on his shoulders.

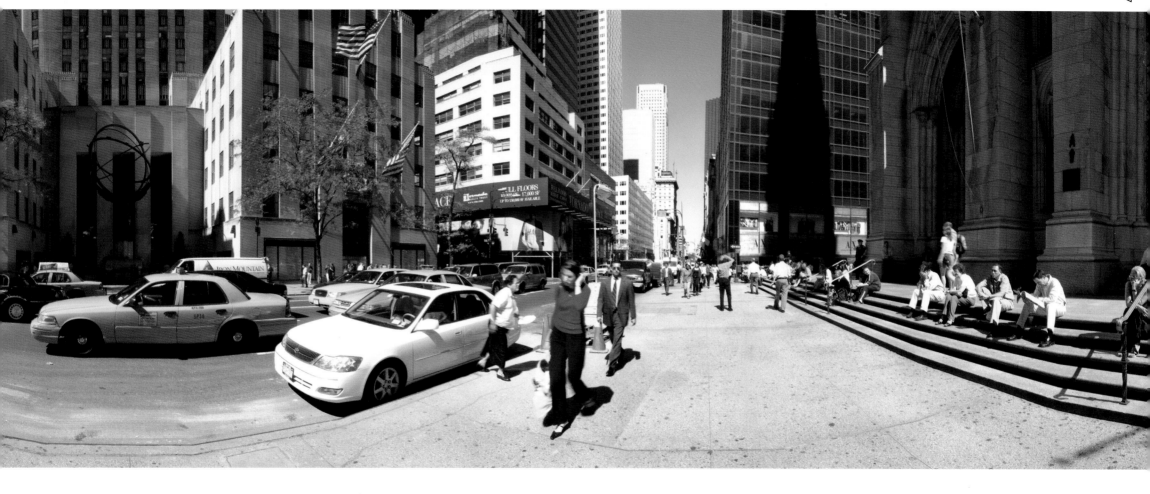

ST. PATRICK'S CATHEDRAL

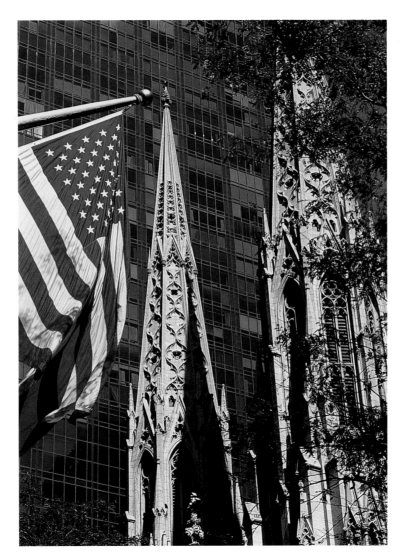

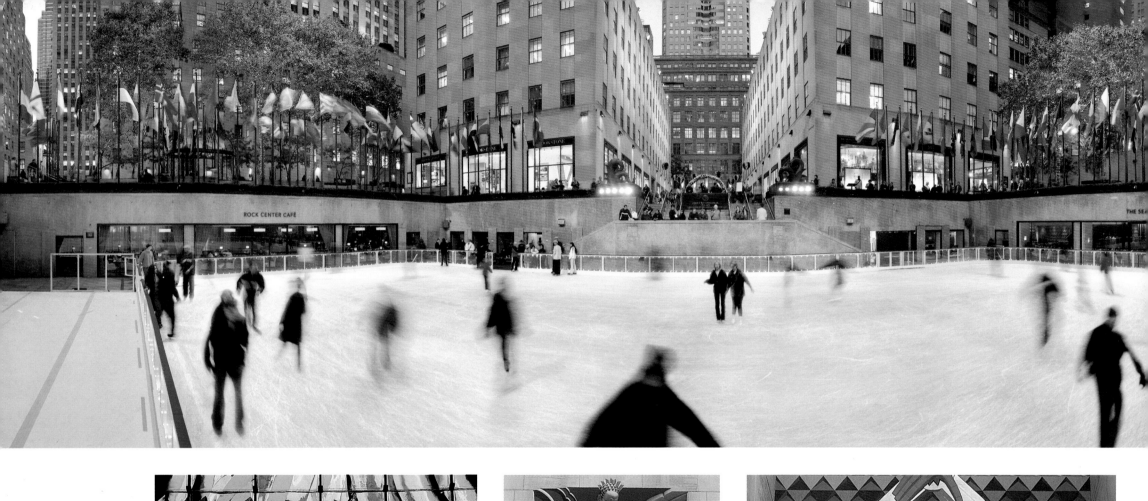

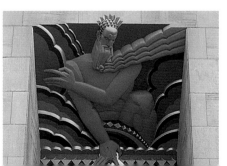

WISDOM AND KNOWLEDGE SHALL BE THE STABILITY OF THY TIMES

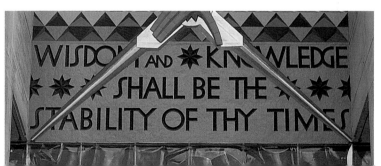

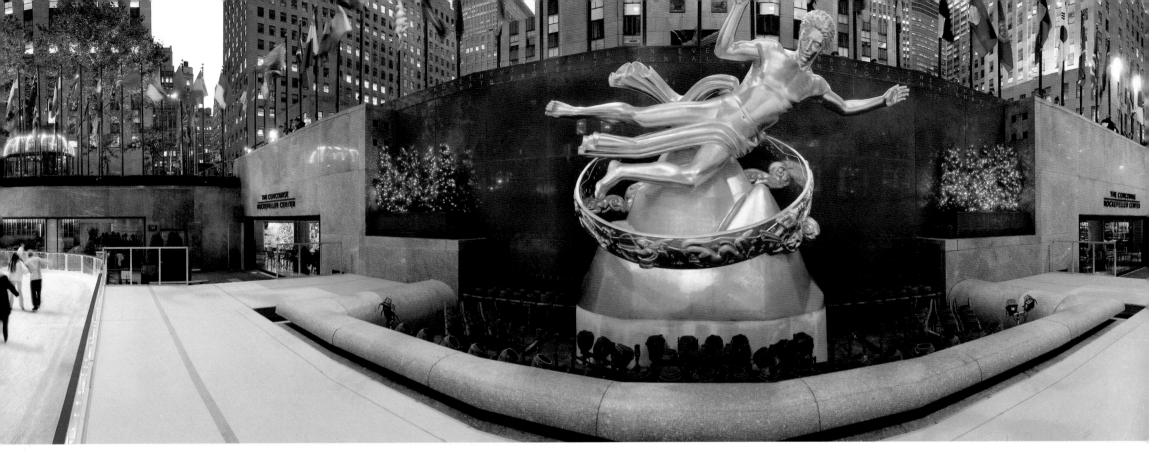

ROCKEFELLER CENTER

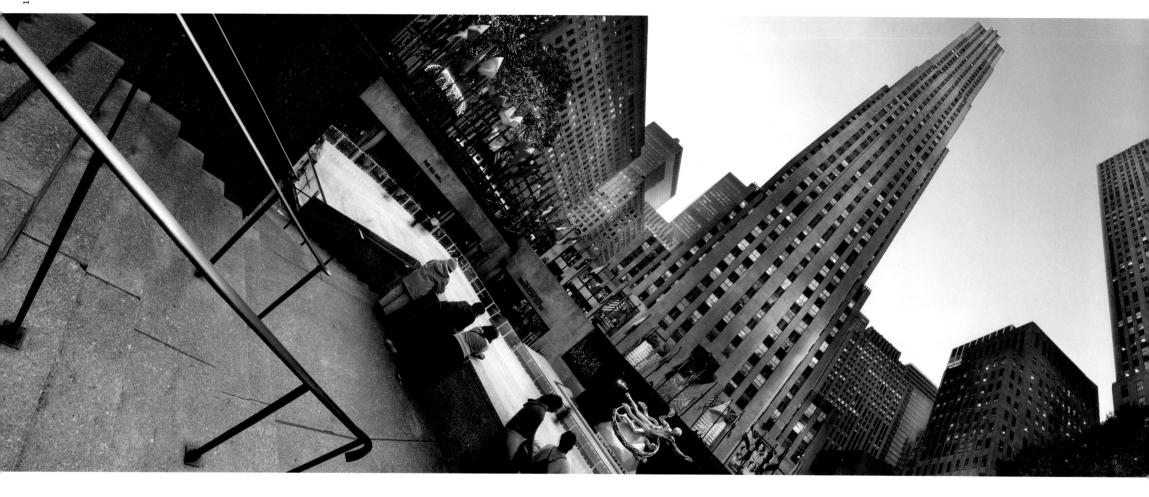

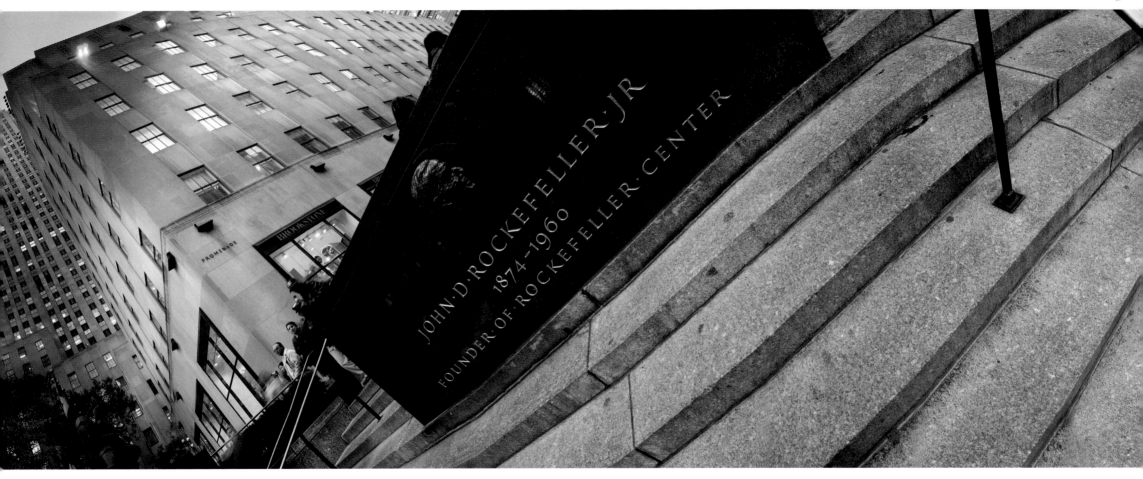

JOHN·D·ROCKEFELLER·JR
1874–1960
FOUNDER·OF·ROCKEFELLER·CENTER

THERE'S SOMETHING TELLING about the presence of this gemlike skating rink in the setting of Rockefeller Center, which is so big that sources cannot agree upon exactly how many buildings it encompasses, or when it was actually built (we'll put it at twelve buildings erected between 1931 and 1947)—it seems like it was intended to remind us that while the Rockefellers could think really, really big thoughts, they also possessed exquisite taste. Mere mortals are welcome to skate in these lovely surroundings, but it's hard to imagine what sort of beings could put together a deal like this in the middle of the world's biggest city. Hats off to John D. Rockefeller, Jr., financier, and Raymond Hood, architect.

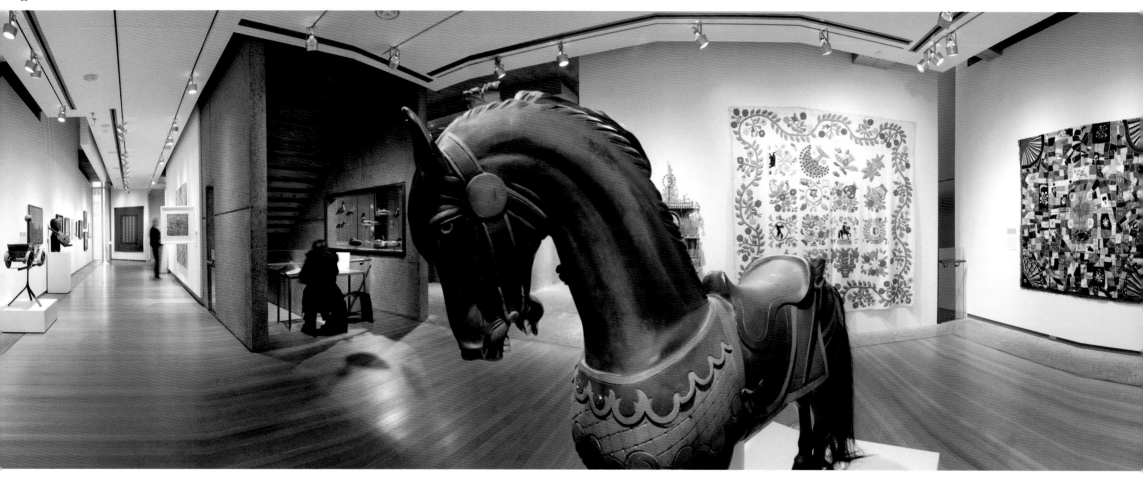

NEW YORK GETS A NEW MUSEUM or a museum in New York gets a new home practically every year. The American Folk Art Museum, founded in 1961, settled into its new building at 45 West 53rd Street in December 2001. A few weeks earlier, the brand new Neue Gallerie, devoted to German and Austrian art, opened for business in a renovated 1914 mansion at 1048 Fifth Avenue uptown. Both boosted morale in a city still shocked by 9/11. The folk-art museum, in particular, struck a welcome chord, dedicated as it is to the traditional visual arts of the American people: the collection contains quilts, flags, carvings, and paintings, all by self-taught artists.

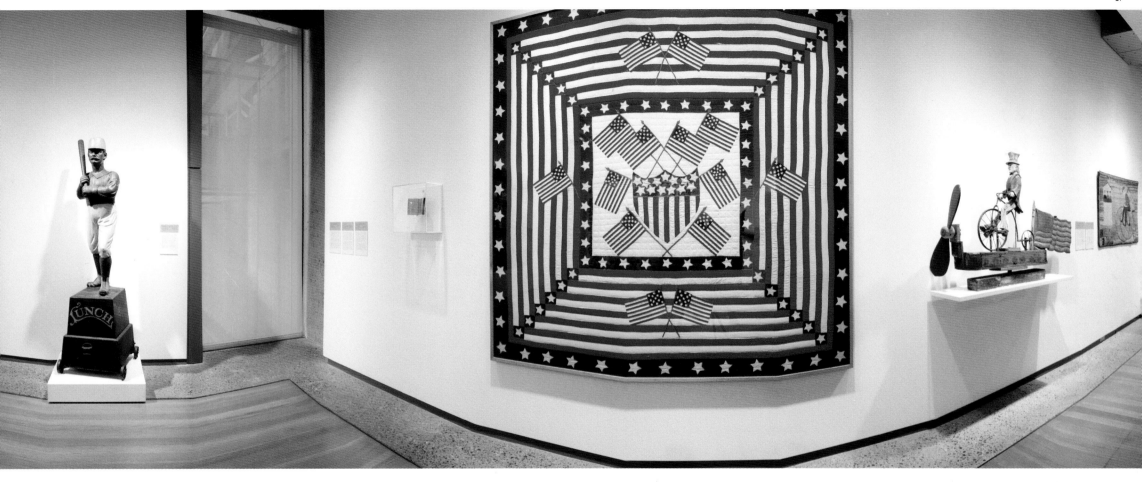

AMERICAN FOLK ART MUSEUM

IT IS NOT OFTEN in a city of elevator buildings that a staircase attracts as much notice as the one in the new American Folk Art Museum. Rarely has concrete, glass, and steel been used to better effect. The architects were Tod Williams Billie Tsien & Associates; the weathervanes come from the museum's permanent collection.

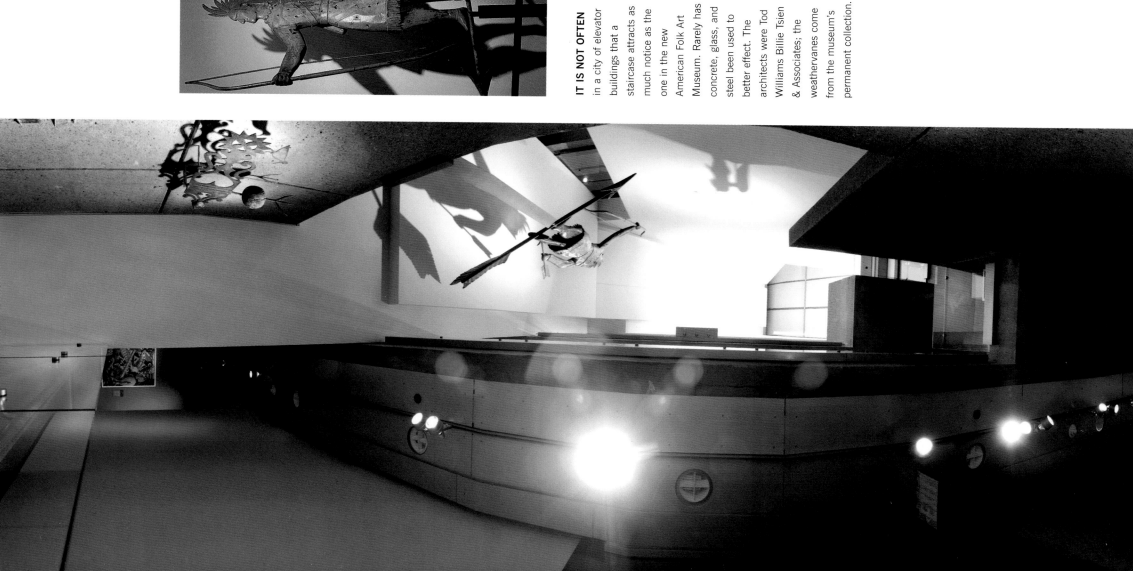

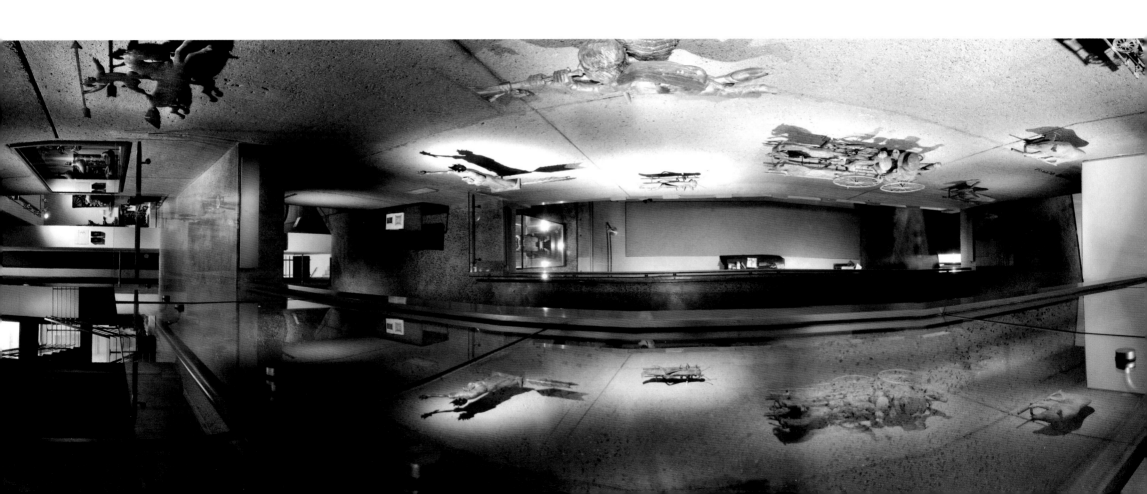

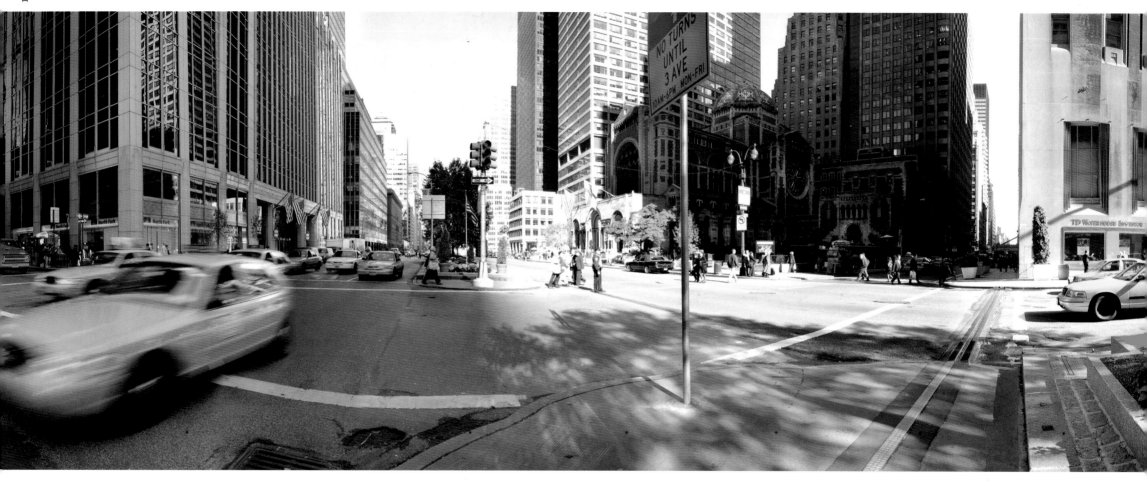

THE BUILDERS OF GRAND CENTRAL TERMINAL understood that engines belching smoke were incompatible with elegant palaces of commerce, and so they gambled on electricity rather than steam to keep the trains moving. This daring move made it possible to sink the tracks approaching the station under Fourth Avenue, creating a refined boulevard that the city renamed Park Avenue. The results are visible in this picture, which reveals evidence of at least three building booms, from the lovely St. Bartholomew's Church (1919), to the Waldorf-Astoria Hotel (1931), to glass and steel towers of the 1960s.

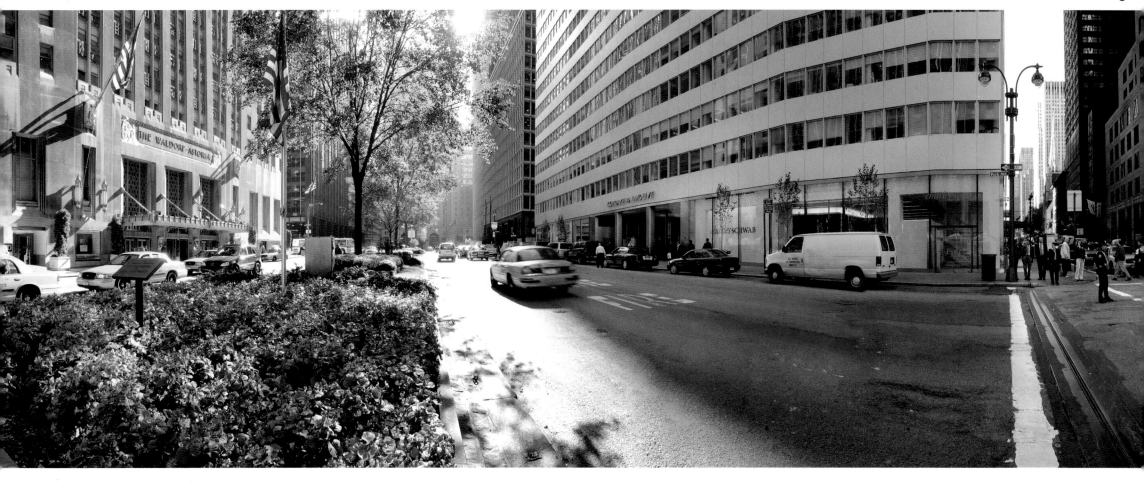

PARK AVENUE

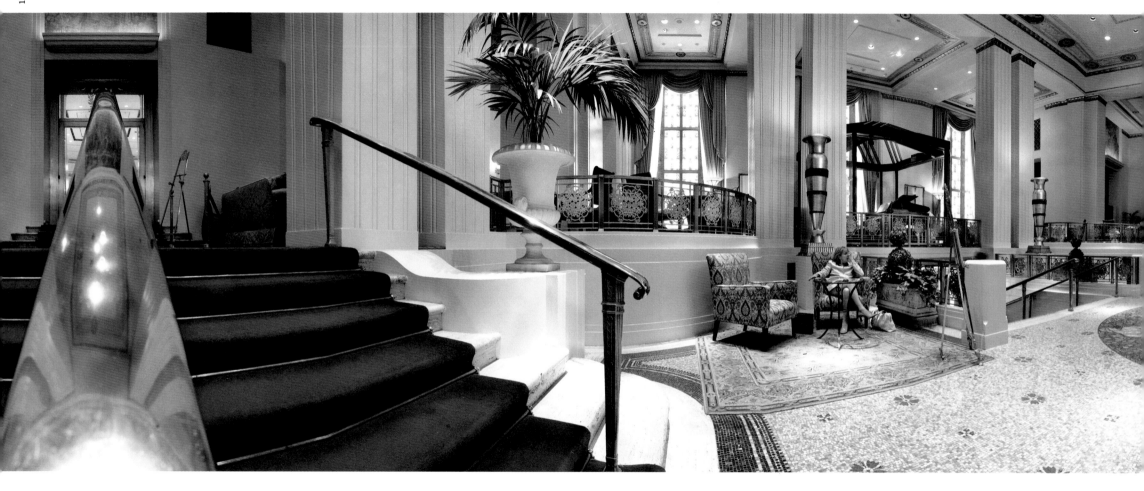

WHEN A CERTAIN KIND OF CELEBRITY—we're thinking presidents and kings—comes to New York, he stays at the Waldorf (30 Park Avenue). Recently, the city restricted turns on certain Midtown streets in an attempt to ease traffic. According to local gossips, the new rules almost caused a royal Waldorf guest to miss her flight home. Someone at the hotel discreetly complained, and the rules were changed. It's that kind of place. By the way, the Waldorf-Astoria is another venerable New York institution that has had more than one home—the original building was sold to the developers of the Empire State Building, who demolished it for their great project.

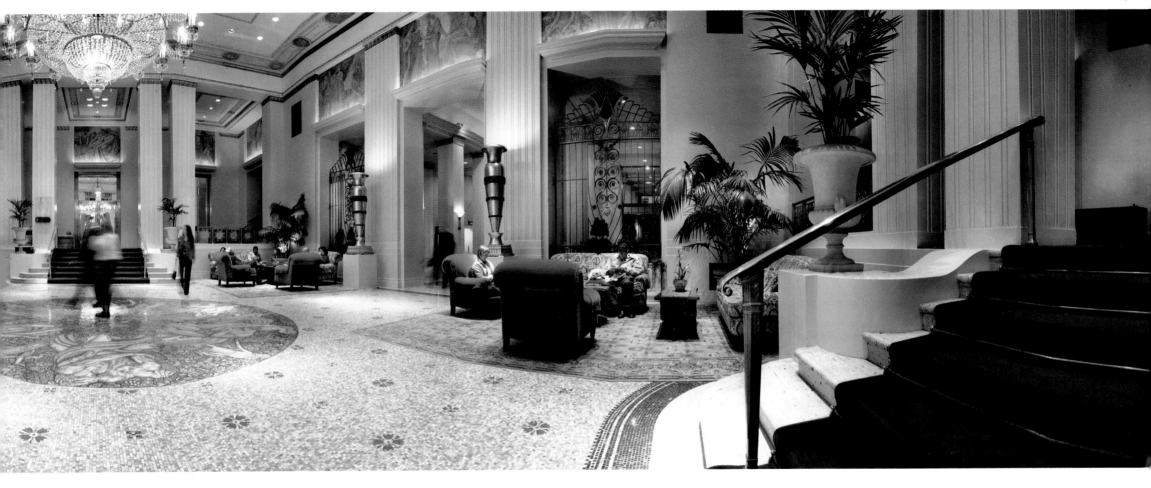

WALDORF-ASTORIA HOTEL

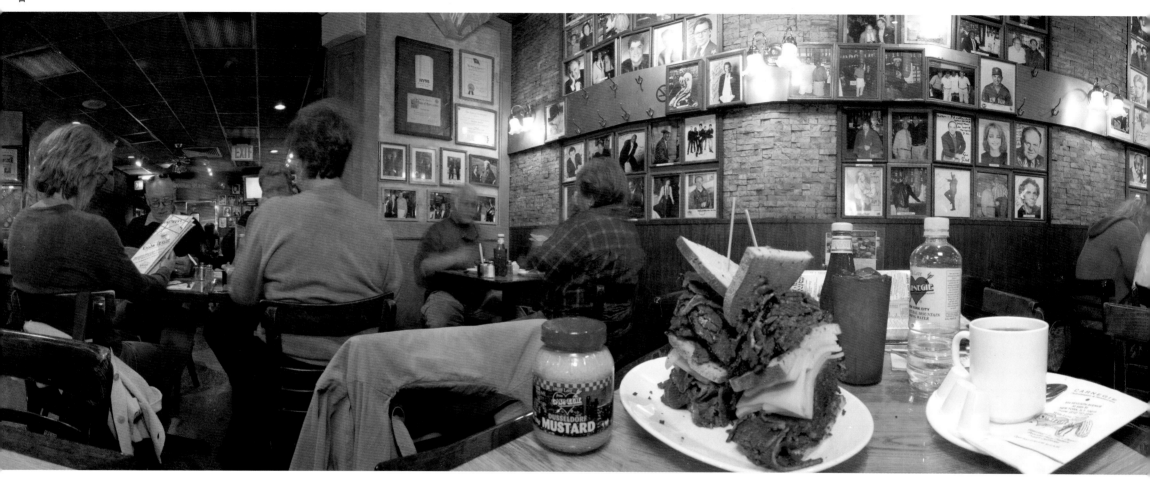

BIG-CITY REPUTATIONS tend to have staying power. Take the Carnegie Deli (854 Seventh Avenue), founded in 1934. There are thousands of Jewish delicatessens in New York City, but in 1975, an influential magazine rated the Carnegie's pastrami sandwich the best in the city, which is saying something. (Their secret was that they actually made not just the sandwich but the pastrami itself.) Since then, the restaurant has become a tourist mecca. Today, you will find those who say that pastrami sandwiches just as good can be had elsewhere in New York, but you won't find any as famous.

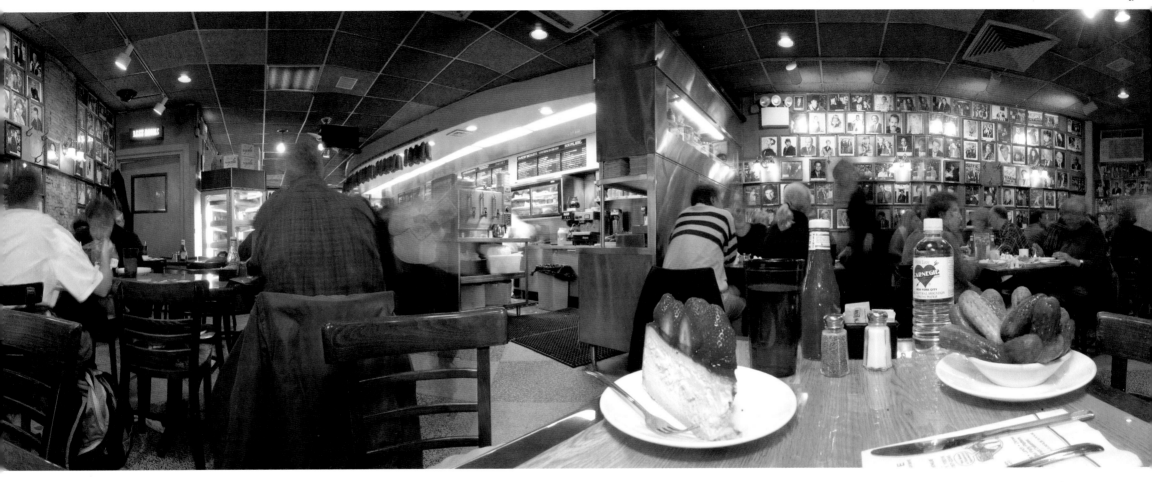

CARNEGIE DELI

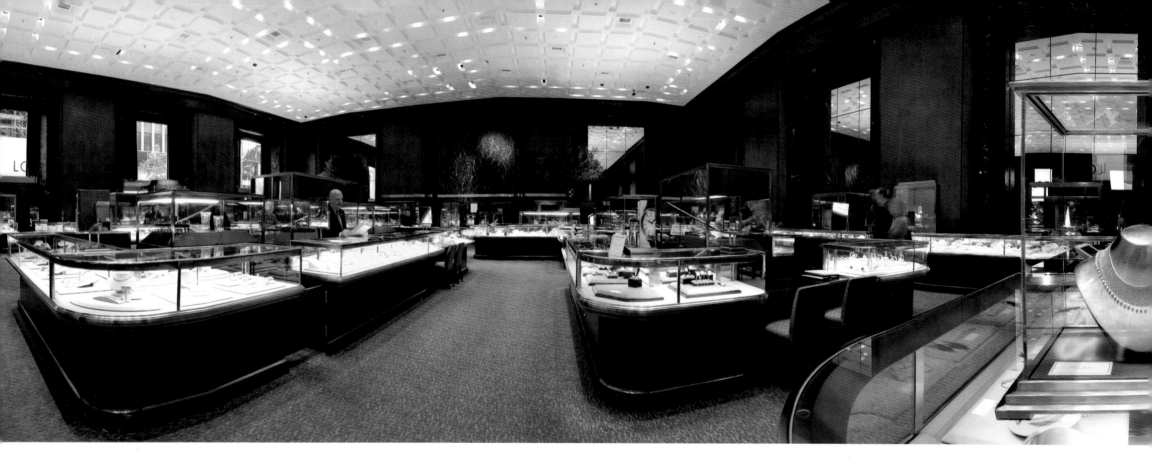

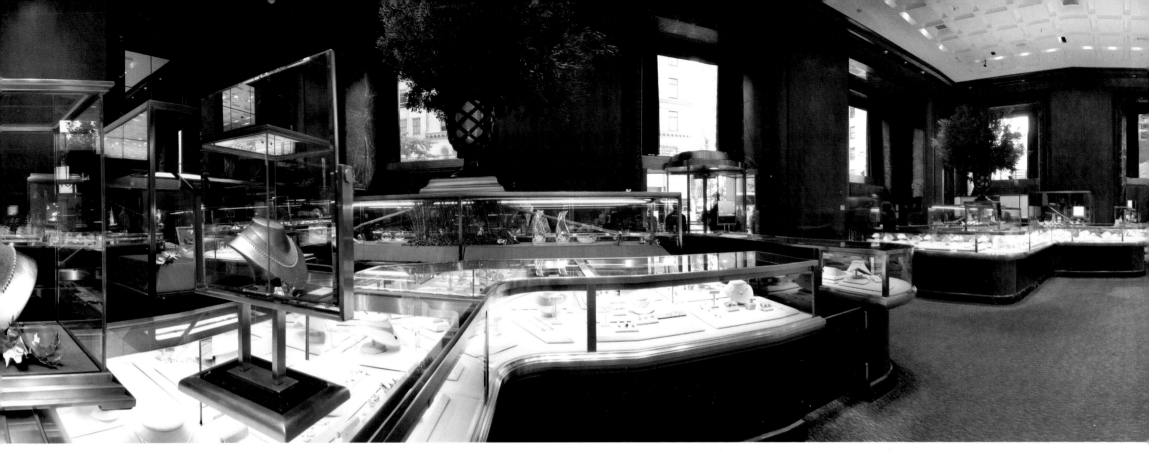

BY FOLLOWING TIFFANY'S UPTOWN, you could plot the moving epicenter of fashionable shopping in New York. The firm—specializing in fancy goods and stationery—began in 1837 at 259 Broadway, in what is now Lower Manhattan (the store was one of the first to mark merchandise with fixed prices). Across the decades, it moved to the Union Square area and then to 37th Street and Fifth Avenue, settling finally in its opulent present location at 57th and Fifth in 1940. In 1950, Truman Capote used the store as a symbol of elegance in his best-selling novella *Breakfast at Tiffany's*, and when Audrey Hepburn starred in the 1961 movie adaptation it got the kind of international publicity press agents can only dream about.

TIFFANY & CO.

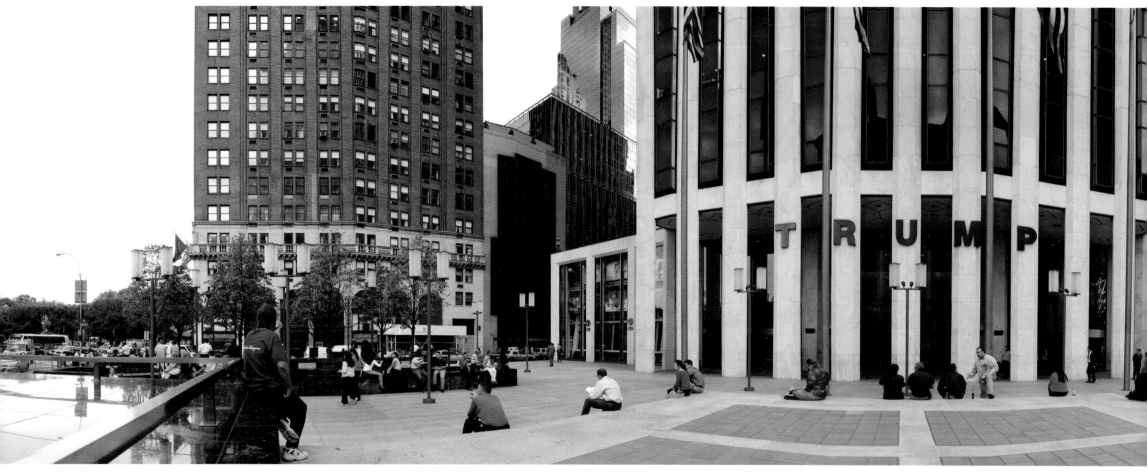

THE FORMER GM BUILDING (767 Fifth Avenue) was hijacked by Donald Trump in 1998. Like many skyscrapers from the 1960s, it came with an unnecessary plaza encouraged by a zoning law that allowed developers to build taller buildings if they were set back from the street. No one ever really figured out what pedestrians would do with broad expanses of stone and concrete without seating. Here's the answer: they perch on retaining walls. The genteel equivalent of urban warfare has been waged over those five letters on the façade of Trump's building, but he refuses to take them down. The man likes the neighborhood, and he wants people to know it. Indeed, the chateau-like Plaza Hotel, seen at right, was once bought, fixed up, and sold by Mr. Trump.

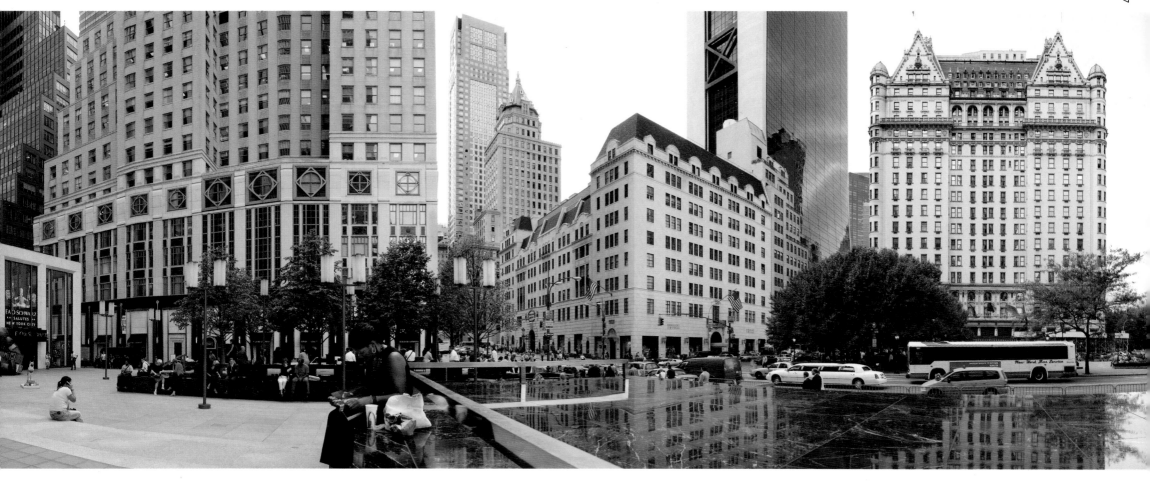

TRUMP PLAZA

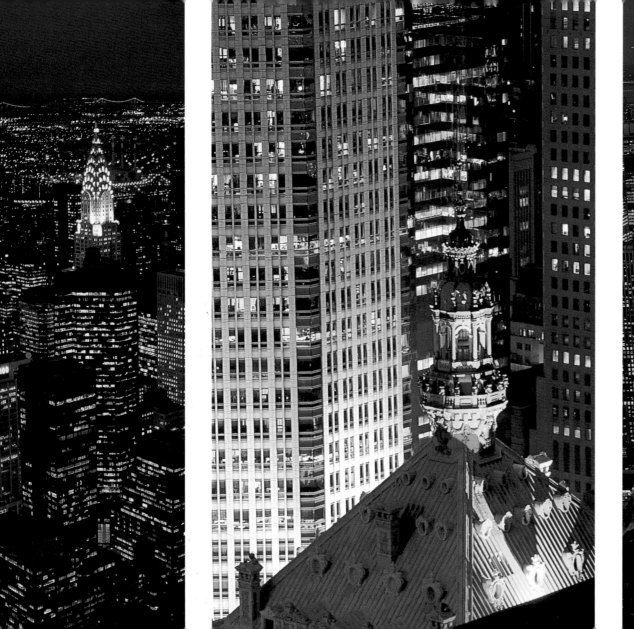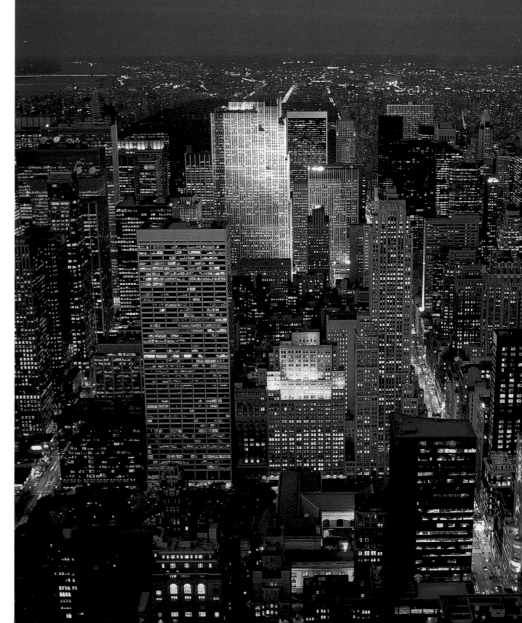

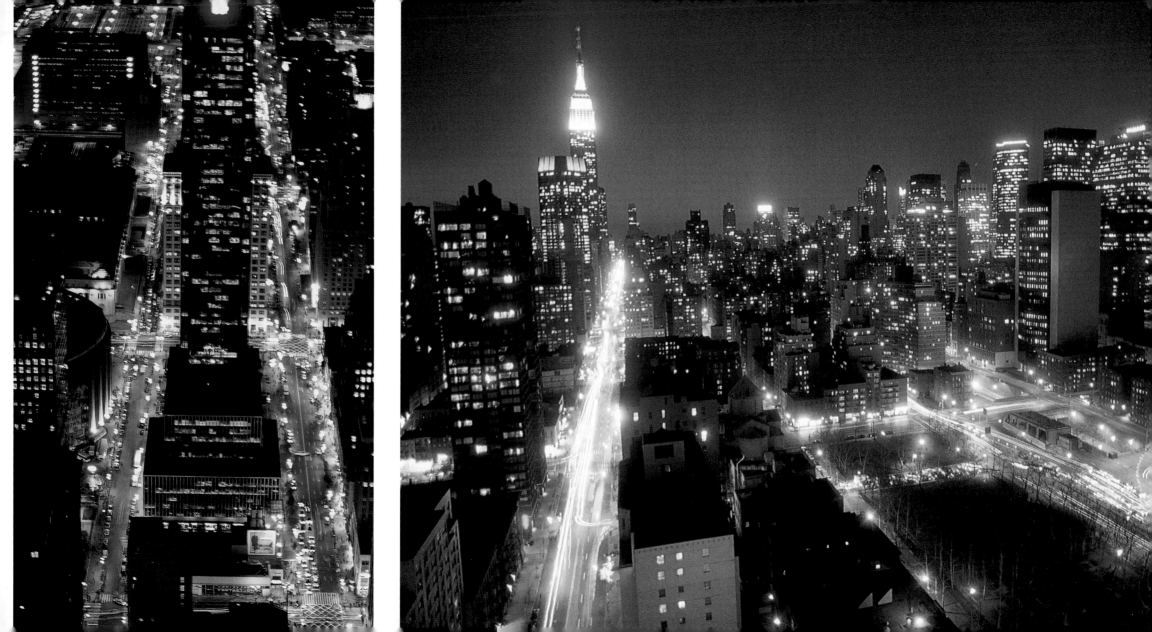

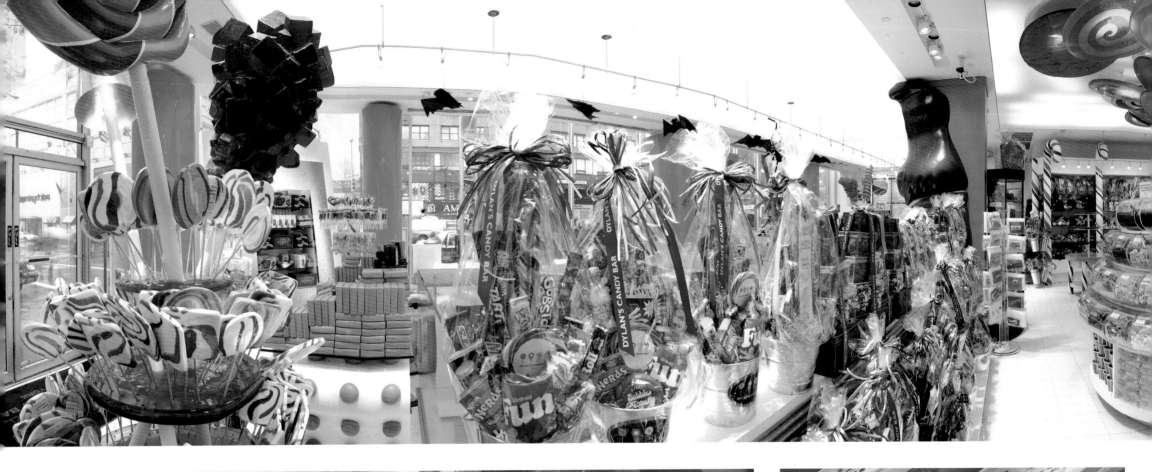

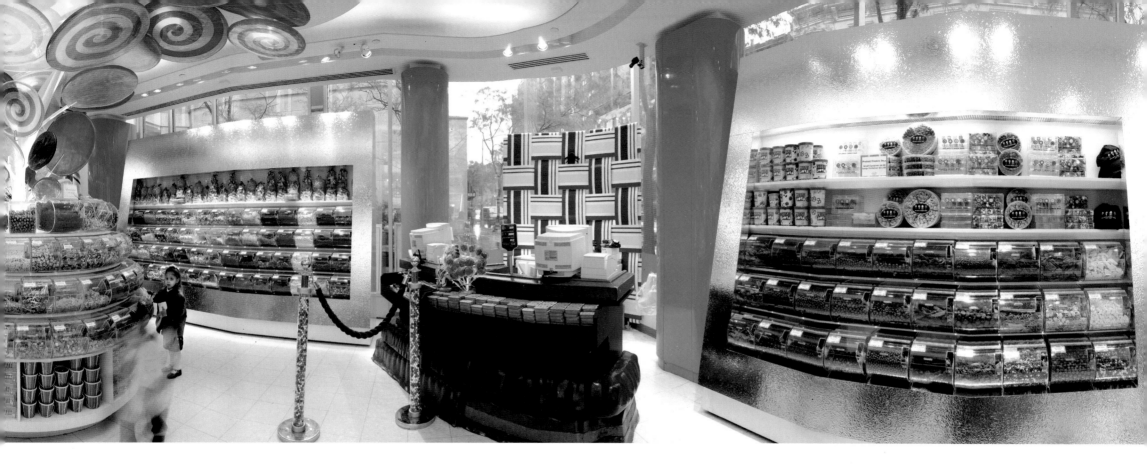

HEAVEN FOR THOSE WITH A SWEET TOOTH, Dylan's Candy Bar (1011 Third Avenue) is two stories of vivid color, fun, and—of course—candy. More than 5,000 different sorts of sweets in every size, shape, and form can be bought here. New Yorkers love the encyclopedic emporium that stocks virtually every variety of the goods it specializes in.

DYLAN'S CANDY BAR

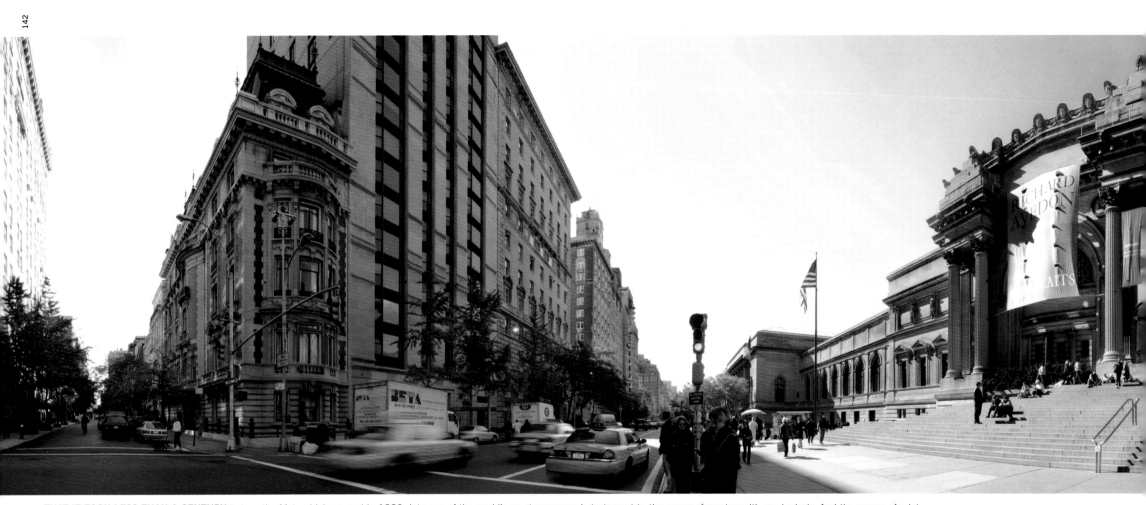

THAT IT TOOK LESS THAN A CENTURY to turn the Met, which opened in 1880, into one of the world's great museums is testament to the power of great wealth used wisely. And the source of a lot of that wealth was no further away than the other side of the street—the East side of Fifth Avenue, which seems to fold the museum in its embrace in this photograph. The museum's genteel founders would be astonished to see it today. It is rich in holdings—spanning five millennia of art and culture—beyond their wildest dreams and packed with more than ten million visitors each year. On a smaller note, that mansion to the left, 1009 Fifth to be exact, was until recently one of the last on the avenue to be occupied by a single family. A way of life ended when it was divided up into apartments.

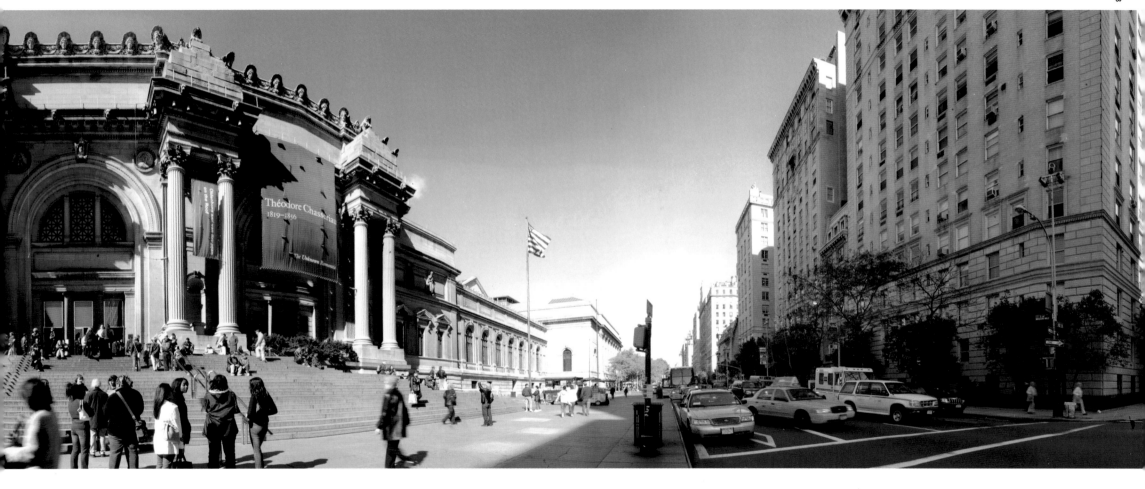

METROPOLITAN MUSEUM OF ART

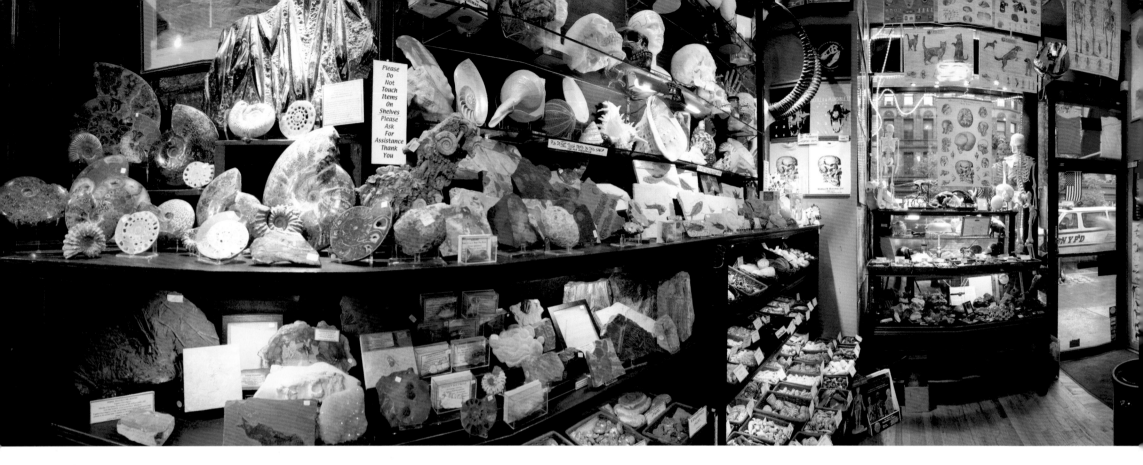

Please
Do
Not
Touch
Items
On
Shelves
Please
Ask
For
Assistance
Thank
You

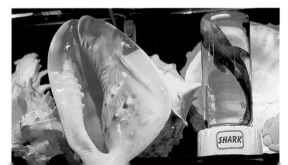

SHARK

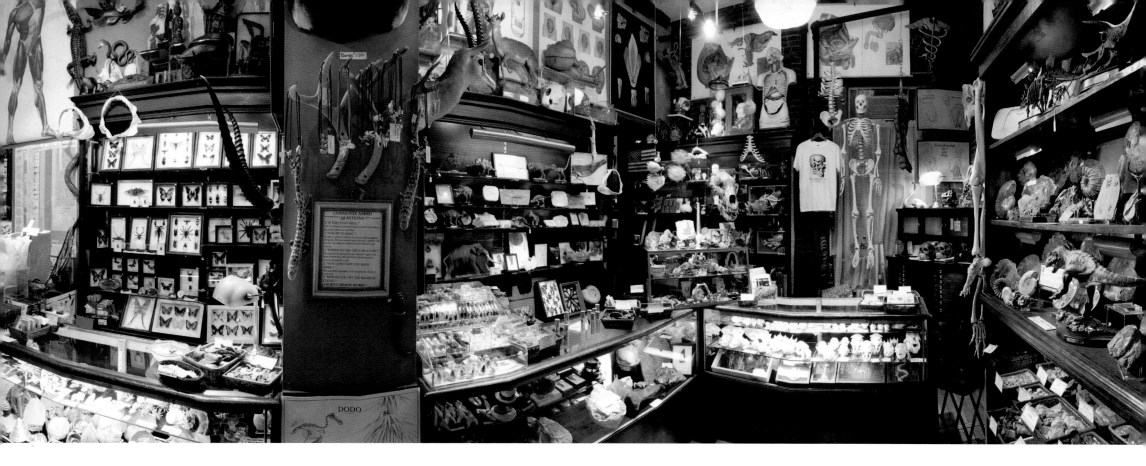

NOT FAR FROM the American Museum of Natural History is the remarkable Maxilla & Mandible, Ltd. (451 Columbus Avenue), which claims to be the world's first store dedicated to osteology—the study of bones. It contains an astonishing array of specimens, including fossils, skeletons, and insects, and employs paleontologists, entomologists, osteologists, anthropologists, sculptors, and craftsmen. This store, finally, is a one-off: there is, alas, no bone shopping district in New York City.

MAXILLA & MANDIBLE, LTD.

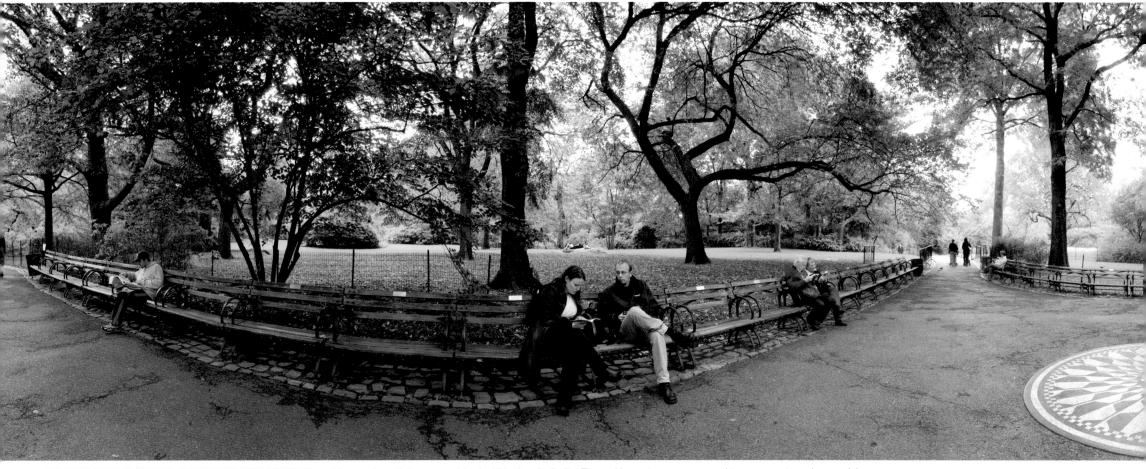

CENTRAL PARK IS SACRED GROUND TO NEW YORKERS, and the most carefully managed land within the city limits. The park's creators were opposed to monuments and memorials in their public park, and posterity has by and large been true to their vision. But when John Lennon was gunned down on the evening of December 8, 1980, in the vestibule of the Dakota Apartments, the outpouring of grief was universal, and it seemed appropriate to honor him. After much debate, a garden was planted not far from the site of his death: created by Lennon's widow, Yoko Ono, working with a landscape architect, Strawberry Fields is an oasis for meditation. Its only permanent artifact is this mosaic, donated by the Italian government.

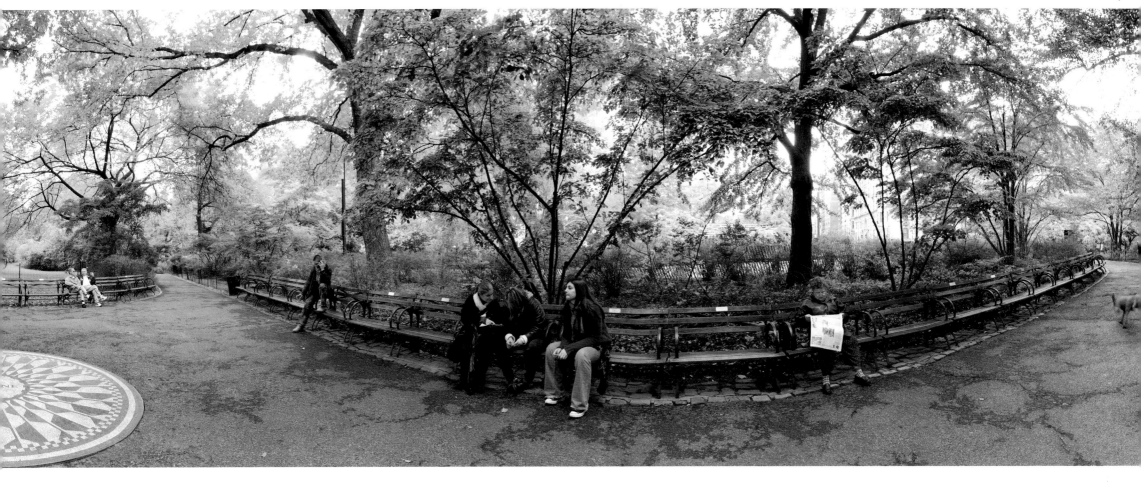

STRAWBERRY FIELDS

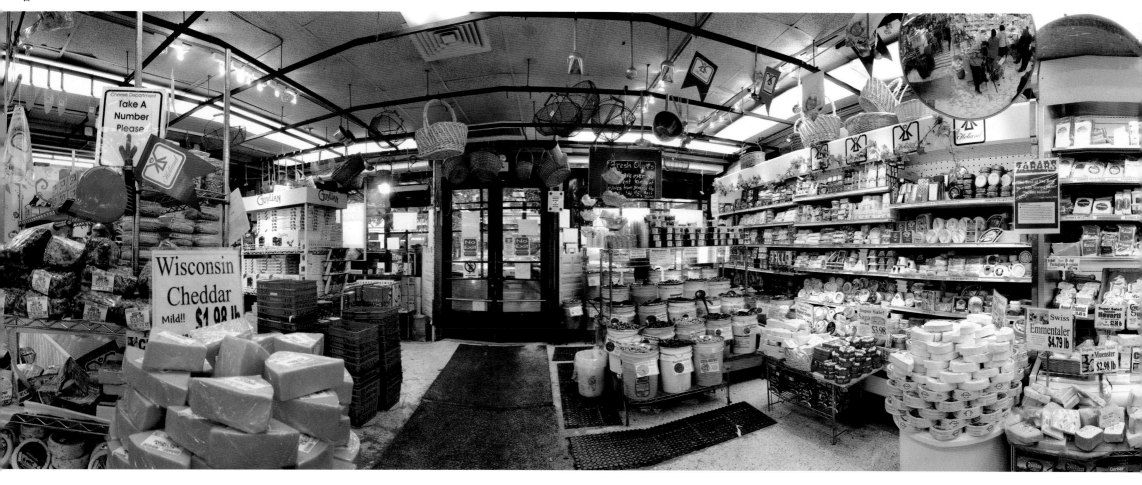

NEW YORKERS LIKE TO THINK that their city has eclipsed Paris as the world's great food capital. For evidence, they would point not only to first-class restaurants specializing in the cuisine of virtually every major culture, but also to the vast variety of foodstuffs sold throughout the city for home cooks. Take Zabar's, for example. Members of the Zabar family have been selling food on the Upper West Side since the 1930s; today, Zabar's, on Broadway and West 80th Street, sells produce from every corner of the globe—the cheese department alone stocks 600 varieties.

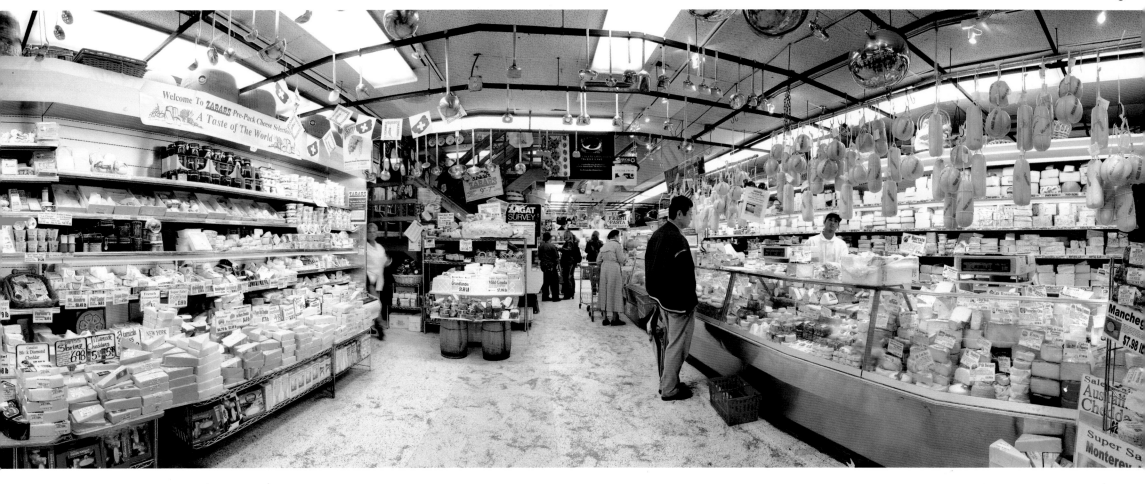

ZABAR'S

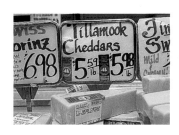

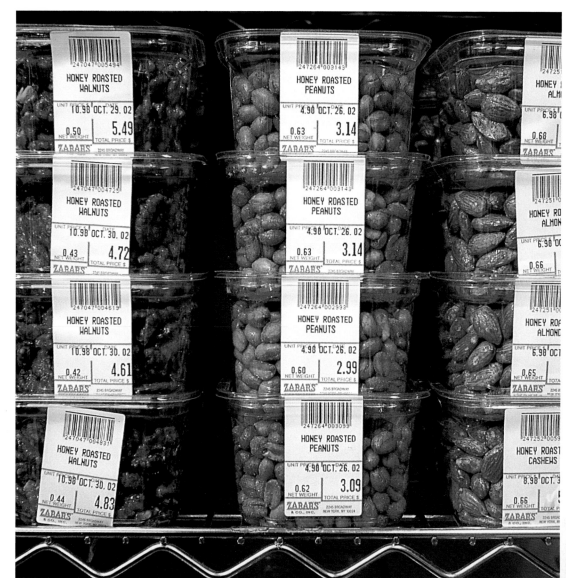

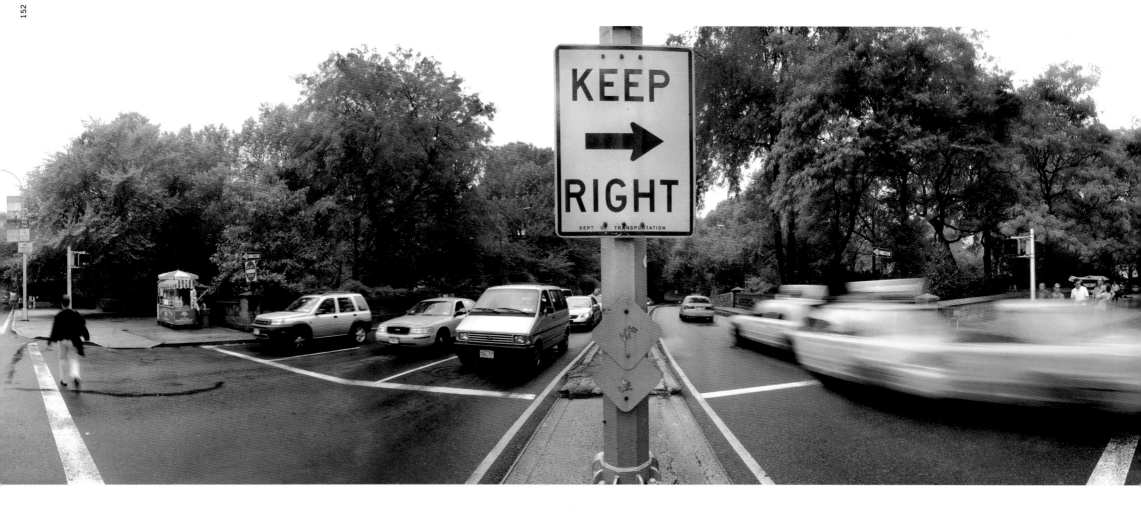

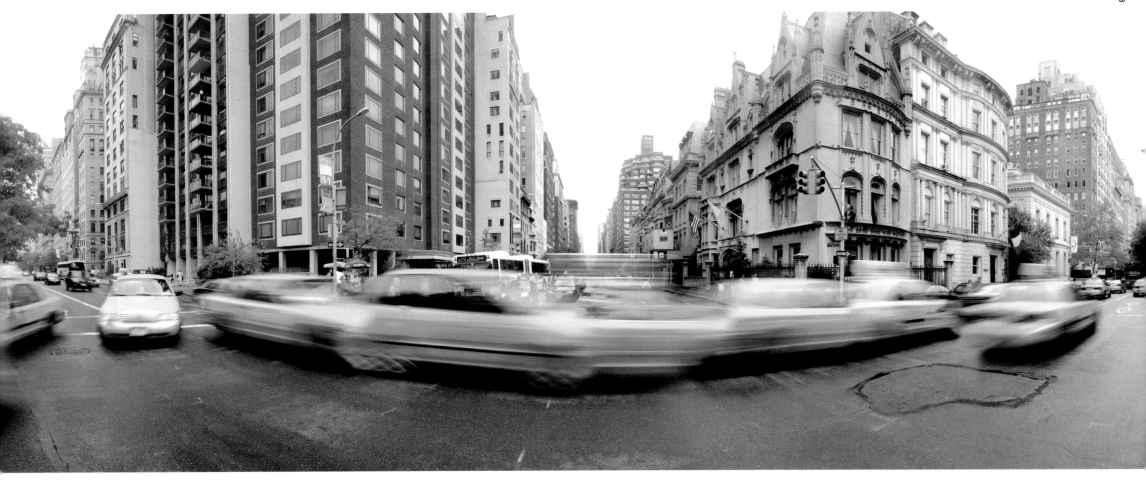

FIFTH AVENUE TAXISCAPE

TAXI FARE

$2**00** Initial Charge

30¢ Per ⅕ Mile

20¢ Per Minute Stopped or Slow Traffic

50¢ Night Surcharge

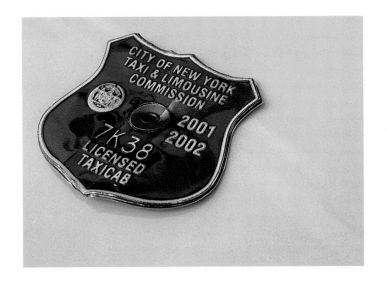

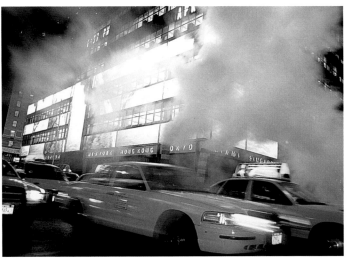

LOOK AT THE PREVIOUS SPREAD: you are standing at 79th Street and Fifth Avenue, within walking distance of the most expensive housing in the world, and so perhaps it is a good time to speak of New York's taxis. There are about 12,000 licensed yellow cabs in the city, and they are obliged to stop when flagged down and to give a smoke-free ride anywhere within the city's five boroughs: Manhattan, the Bronx, Brooklyn, Queens, and Staten Island. The taxi license is actually an aluminum medallion crudely bolted to the hood of the car. The number of medallions are fixed by law and they trade on the open market at more than $200,000, so a taxi represents someone's substantial investment.

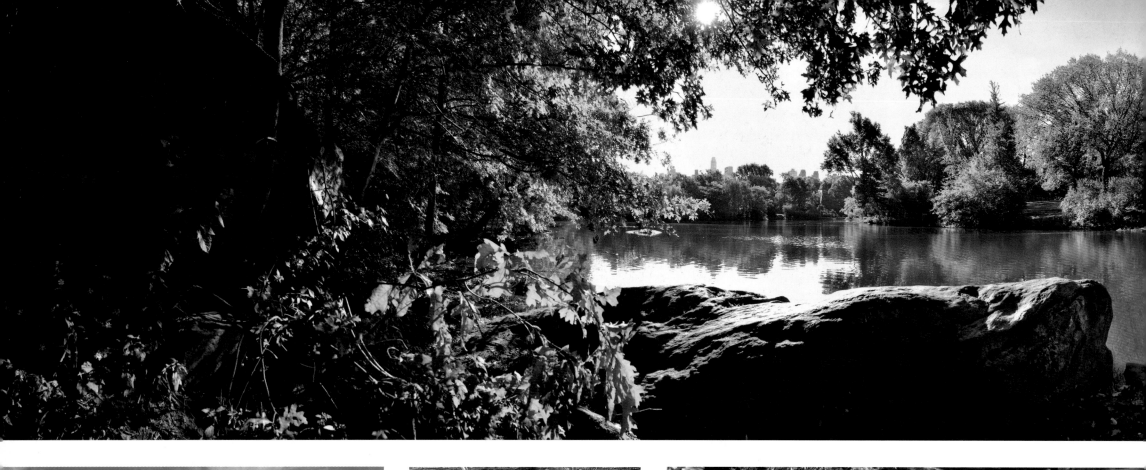

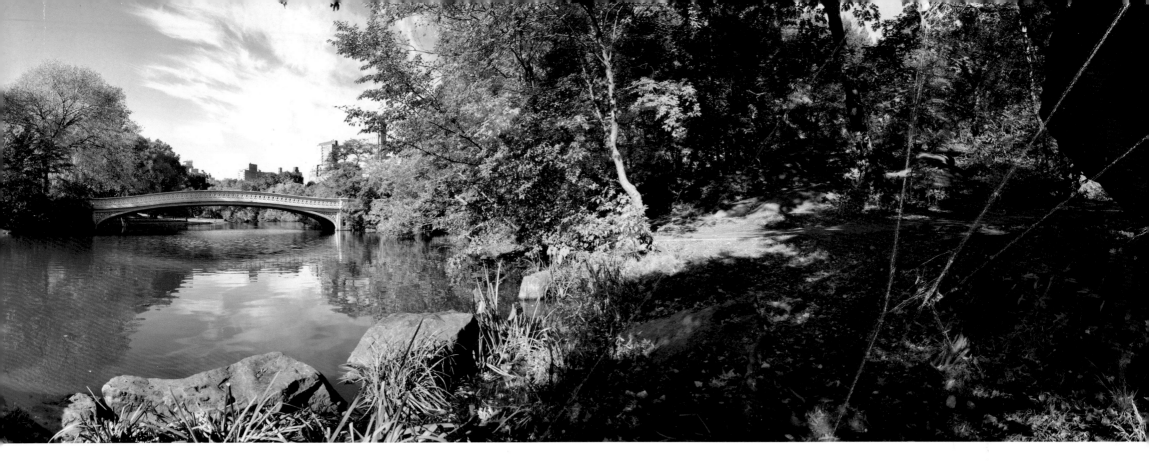

IT'S TEMPTING TO SAY that New York is the great city that it is because at crucial moments, important people made brave and farseeing decisions. Take Central Park, which was blithely planned to cover 840 acres of Manhattan Island in 1856, extending into territory where houses were few and far between. The city fathers bought the land, and then they compounded their foresight by hiring the brilliant Frederick Law Olmsted and Calvert Vaux to design their park. Fast forward some 150 years and presto, here you sit beside The Lake, with its graceful Bow Bridge, seeing pretty much precisely what Olmsted and Vaux intended you to see.

CENTRAL PARK LAKE

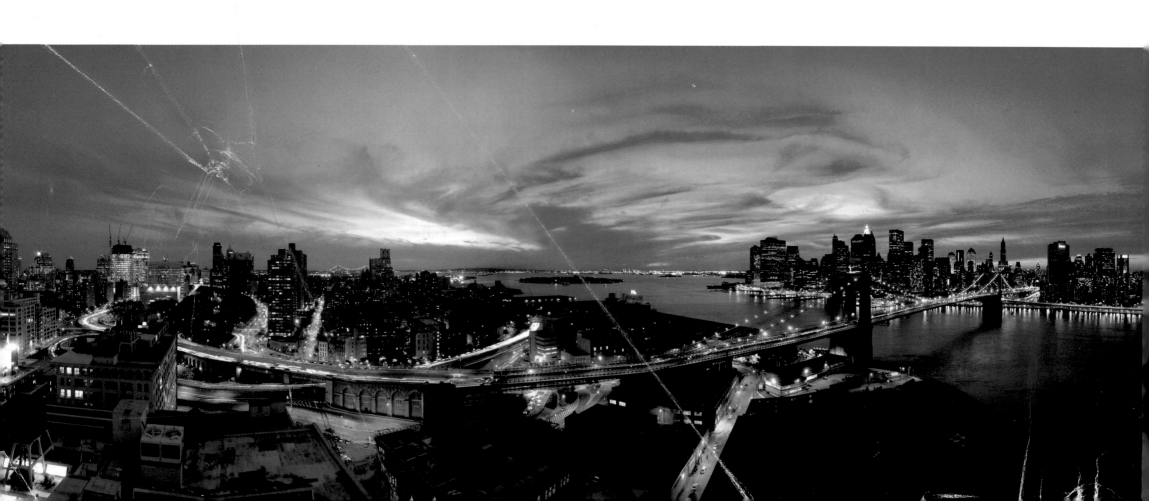

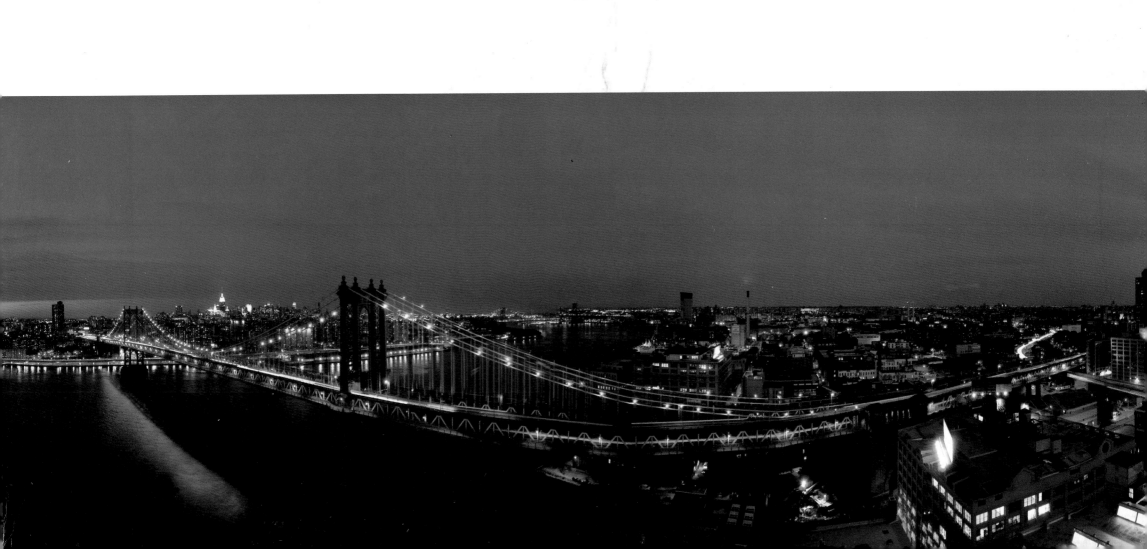

ACKNOWLEDGMENTS

THANK YOU...

To the many people who have helped me produce this book. To my assitants Graham Carlow and Clare Miller who helped me on various trips to New York. To my "local" New York friend, Wendy Sherry, owner of Aesops Tables, a fantastic restaurant on Staten Island that has always been a landing pad for me over the last 20 years of traveling to New York. To Clare Baggaley of Carlton Books for enthuasiam for this project, and to Kirsty Mclaren who helped in the post-production.

Thank you also to my editor, Sarah Larter, Penny Simpson, Lindley Boegehold, Aeone Wright, Michael Davis, Cathryn Bennion, David Walentas, Frank Spring, Ali Stillman, Zoë Ryan, Sam Bard and the staff at the Chelsea Hotel, Miron, Dan Courtenay and his guitar playing gang, Melissa Cacciola, Debbie Mules, Howie and Larry and their four-legged friends, Howard Somers, the Morley Family, Jim Freeman, Nick Genender, Renate Gonzalaz, Jimmy Glenn, Susan Flam, Rosaline & Jean Claude Cesar, Lt Bob Docherty and crew at the Chelsea Firehouse, Michael Makhavadze, Jeffrey Caimi, Tishman Speyer Properties, Irena, Debra Galiano, National Park Service, Lydia Ruth, Mohamed Allen, Elizabeth Ryder, Winston Lewis, Miki Higasa.

And lastly but by no means least the people of New York, who made this book such a pleasure to shoot.

Nick Wood 2003

www.nickwoodphoto.com

For further information about some of the people and companies who helped with this project:

www.aesopstables.com

www.michaeldavisarchitechts.com

www.doggiedo.com

www.fdny.com

www.tiffany.com

www.strandbooks.com

www.southstreetseaport.com

www.zabars.com

www.maxillaandmandible.com

www.carnegiedeli.com

www.folkartmuseum.com

www.nyccustomcycle.com

PROJECT MANAGER Sarah Larter

DESIGNER Clare Baggaley

PRODUCTION Lisa French

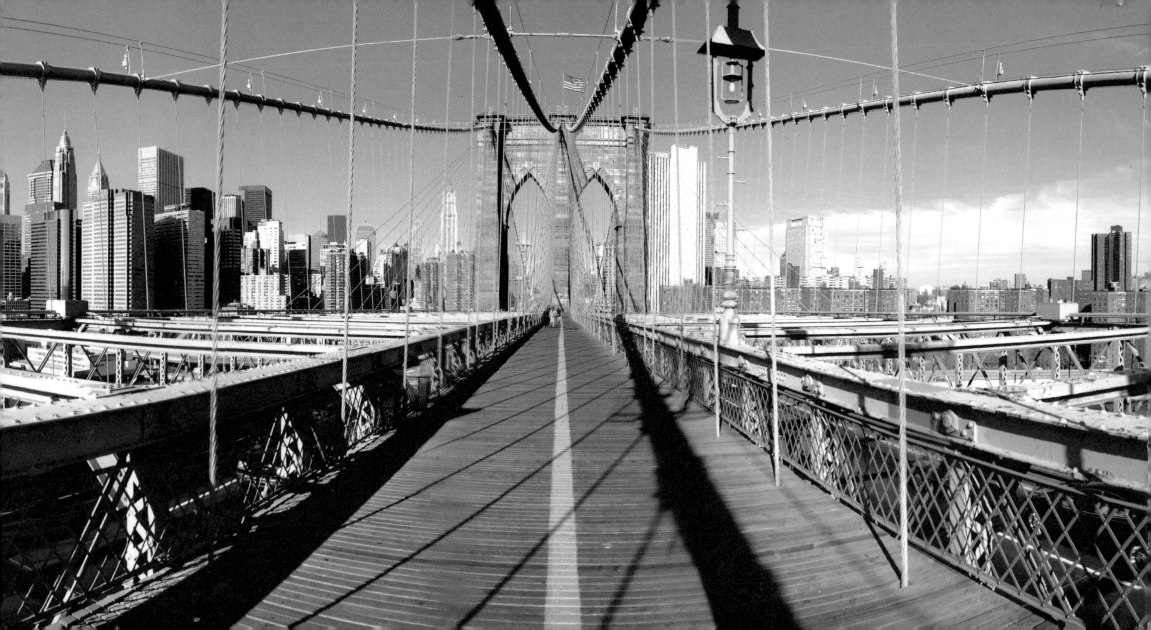